The Savage Mirror

THE ART OF CONTEMPORARY CARICATURE

The Savage

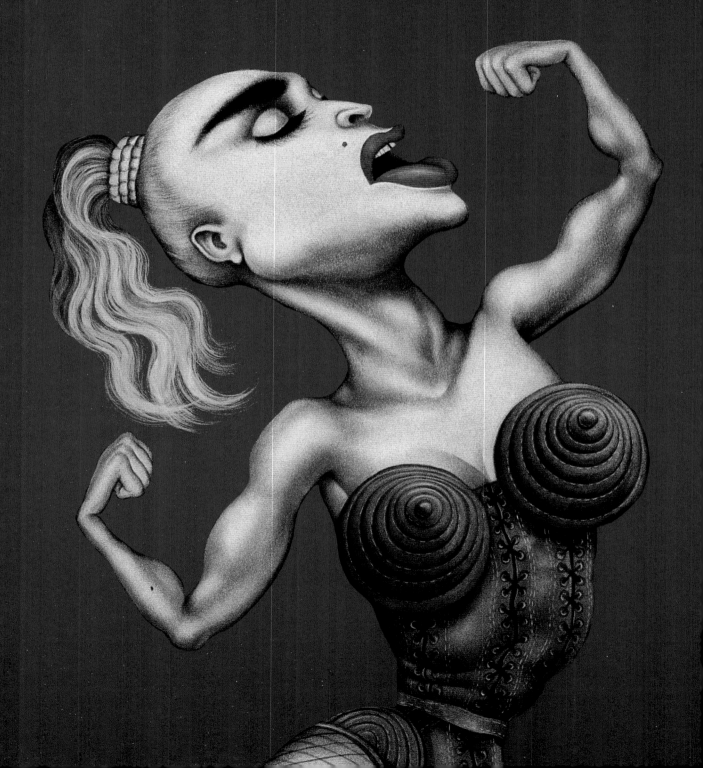

Mirror Mirror

THE ART OF CONTEMPORARY CARICATURE

—

STEVEN HELLER AND GAIL ANDERSON

Design by Teresa Fernandes

WATSON-GUPTILL PUBLICATIONS/NEW YORK

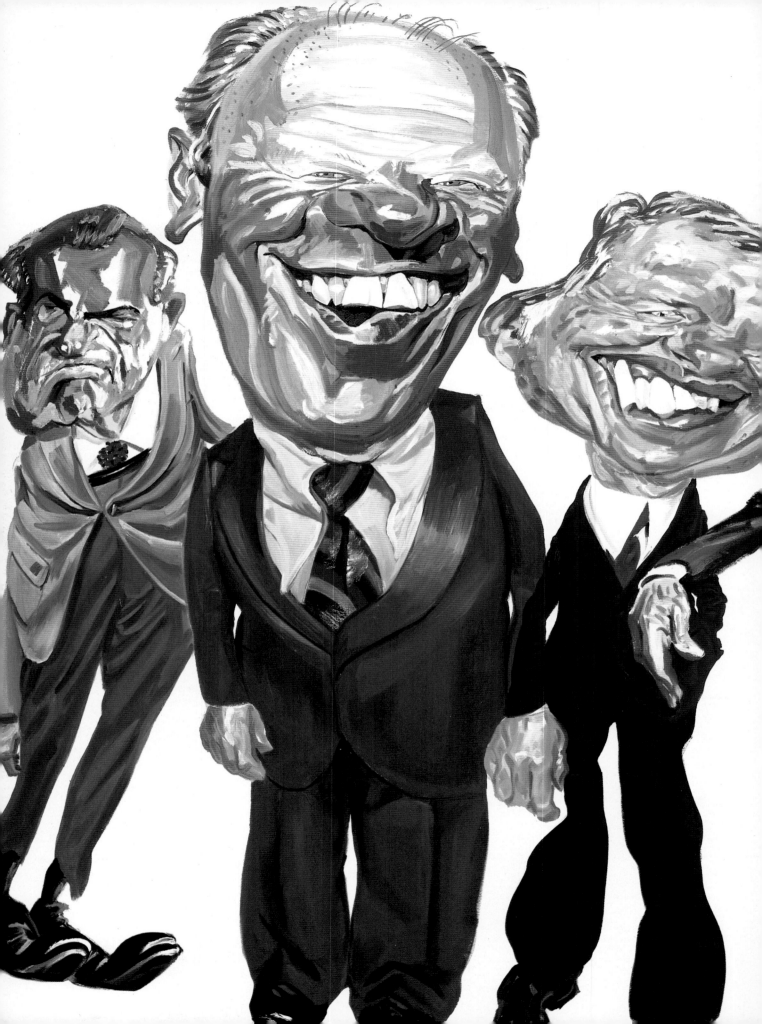

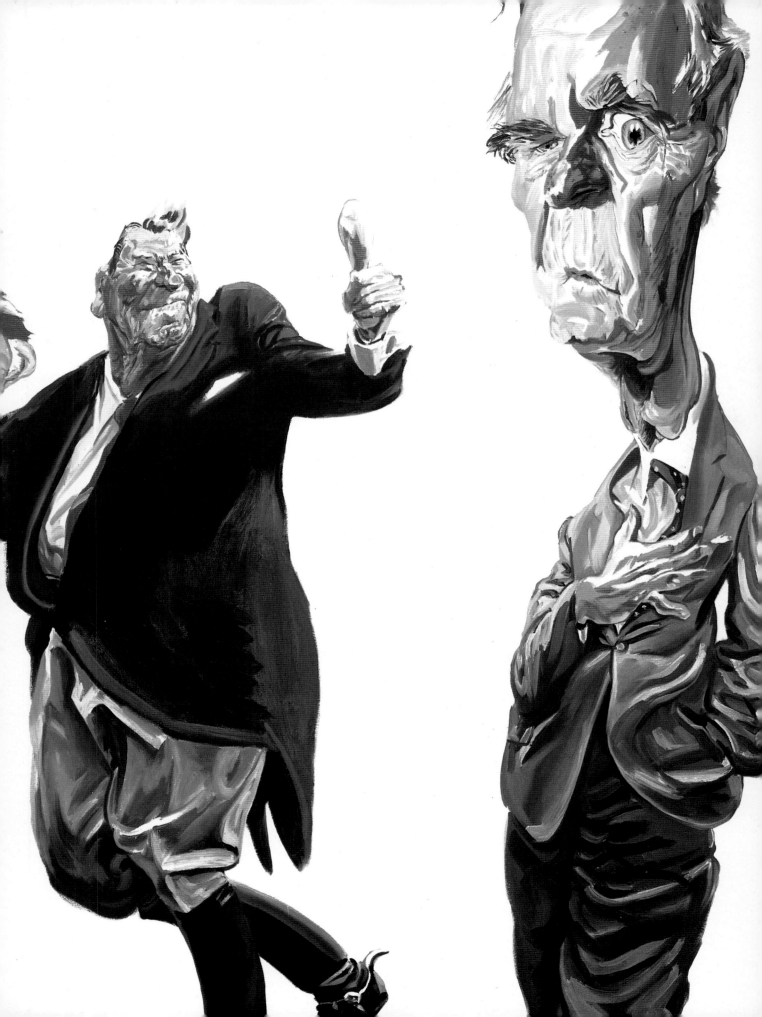

Library of Congress Cataloging-in-Publication Data
Heller, Steven.
The savage mirror: the art of contemporary caricature/Steven Heller and Gail Anderson.
p. cm.
Includes index.
ISBN 0-8230-4644-3

1. Caricature–United States–History–20th century.
I. Anderson, Gail, 1962-.
II. Title.
NC1426.H38 1992
741.5 0973 0904–dc20

Manufactured in Singapore

First printing, 1992

1 2 3 4 5 6 7 8 9 / 98 97 96 95 94 93 92

Edited by Paul Lukas
Senior Editor: Candace Raney
Graphic Production: Ellen Greene
Electronic Production: Dany Drennan, Luna Grafika Design, NYC
Art Assistant: Judy Sandford

Frontispiece:
ANITA KUNZ
Madonna
US: The Entertainment Magazine, 1991
Art Director: Jolene Cuyler

On the previous spread:
PHILIP BURKE
Presidents Nixon, Ford, Carter, Reagan, and Bush
Private commission, 1991
Collection of Garry Trudeau

On this page:
JOHN KASCHT
David Bowie
Washingtonian, 1989
Art Director: Lynn Mannino

On page 160:
ANITA KUNZ
Michael Jackson
Rolling Stone, 1987
Art Director: Fred Woodward

This book is dedicated to the memory of Ralph E. Shikes, who brought the indignant eye in clear focus and elevated the art of satire to the level of a cultural treasure.

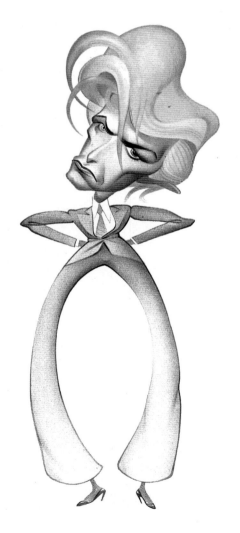

ACKNOWLEDGMENTS

Originally this book was going to be an analysis of past methods and veteran masters of political, social, and theatrical caricature. But as we began exploring the state of the art, we found that caricature is not really dead—it was only napping. In fact, during the past decade new outlets have opened up to young caricaturists, and the woeful political state of affairs has encouraged some of them to attempt political satire. For those, like ourselves, who are passionate about the art form and have a desire to see more effective political commentary in the media, this current renaissance is welcome.

The artists who have contributed to the renaissance are represented in this book, as is a new wave of cultural caricaturists who are focusing on the lighter side of the craft. We are grateful for all the cooperation these artists have given us, particularly those who consented to be interviewed, thereby providing many of the insightful quotations that appear throughout the text. But very special thanks goes to David Levine, Ralph Steadman, Robert Osborn, Al Hirschfeld, Robert Grossman, Roger Law, and Peter Fluck, for being the models for this new generation, and for making imagery that informs and entertains.

Thanks also to Paul Lukas, our editor at Watson-Guptill, whose attention to detail and enthusiasm were much appreciated; Candace Raney, our senior editor at Watson-Guptill; Teresa Fernandes, our book designer; and Dany Drennan, our electronic-production expert. Without their input and talents, this project could never have been completed.

Our thanks also to Garry Trudeau for his generosity and Mirko Ilic for his faxes.

Finally, thanks to Tom Bodkin and Fred Woodward—the former for wanting good caricature, the latter for making it happen.—SH & GA

Contents

CHARGED PORTRAITS

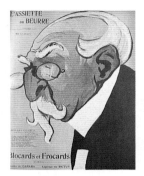

LEAL DE CAMARA
Edouard Combes
L'Assiette au Beurre,
1903

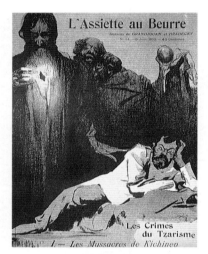

GRANJOUAN
Czar Nicholas II
L'Assiette au Beurre,
1903

ALFRED LE PETIT
Francisque Barcey
Les Contemporains,
c. 1886

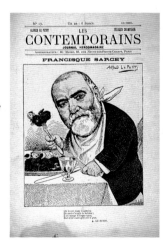

What is a caricature?

The origin of the word *caricature* itself is a good place to start. The term comes from the Italian *caricare*, to overload. "In that straw that might break the camel's back, we have the essence of the definition," writes C. R. Ashbee in *Caricature* (Chapman and Hall Ltd., 1928). This sense of piling on gets to the root of the matter, for a caricature is a picture that exaggerates, or overloads, physical traits and features for the purpose of absurdity. While this exaggeration is often used for humorous effect, it is worth noting that grotesquery for its own sake is sometimes employed as well. In the seventeenth century, for instance, when the word *caricature* was coined, caricatural grotesquery served as a reaction to (or respite from) the rigors of official painting and sculpture, and also as a critique of contemporary art, mores, and values. "Our view of grossness of the body," writes Ashbee, "and puritanism that made us screen and hide it, is not merely atavistic; it is a heritage from the Middle Ages and the Christian Church." The idea that art might reflect and represent the gross as well as the beautiful has a much deeper history than this—the notion definitely interested Leonardo da Vinci, for example, who labored daily at creating his beautiful art but spent his spare time making candid drawings that explored the irregularities and deformities of his fellow Italians by purposefully exaggerating their distinctive physical traits.

The word *caricature* came into English use in the eighteenth century. It was imported from Venice, where the artists who practiced anthropomorphism (the commingling of animal and human traits for purposes of making allegory) called their art *caricatura*. William Hogarth, the eighteenth-century English satirist whose *Harlot's Progress* remains a masterpiece of social commentary, is said to have anglicized the word and to have used it to describe his own work. A century later, a historian who was writing on Greek art used the term *caricature* to suggest the destruction of beauty and regularity by means of exaggerated characterizing. In art history terms, then, caricature signifies the opposite of the Hellenic ideal, the Aristotelian Golden Mean, and the Renaissance notion of classic beauty.

But what does caricature mean today? What differentiates satire, cartoon, and caricature? In a sense, these terms are flexible—caricature has been used to describe a variety of cartoons, and cartoon is often used to describe a humorous caricature. Today, however, caricature almost always refers to a drawing, painting, or sculpture where a *facial distortion*, rather than a situational exaggeration, is the primary attribute.

The use of what we now recognize as caricature predates the development of the word *caricature* itself, however. The first suggestion of a savage mirror in art is found in satirical depictions on Egyptian

Le passé. *Le présent.* *l'Avenir*

papyrus. As Ralph E. Shikes points out in his introduction to *The Art of Satire* (Horizon Press, 1987), ancient Egyptian artifacts reflect a touch of caricature in the creation of animals playing human roles. The Romans, too, portrayed animals acting out human foibles, and the gargoyles so common on Medieval cathedrals grotesquely parody human form as well, representing another stage of the evolution of contemporary caricature.

Caricature was further legitimatized in the late seventeenth century, when the French painter Charles Lebrun authored a manual that claimed to show painters the expression and gestures that best express emotion and character. Lebrun's guidelines were slavishly followed by uninspired painters for over a century, but nonetheless made artists understand that dramatic, subjective expression was possible. A century later, the Swiss theologian and mystic J. Lavater published a treatise demonstrating how external features could determine character, in which he revealed certain physiognomic relationships between humans and animals. Both of these works further added to the acceptance and development of caricature.

Yet perhaps the most significant exploration of facial distortion occurred in the late sixteenth century in Italy, when the painter Annibale Carracci, working with his brother, Agostino, invented a process that quickly evolved into what is now called portrait caricature. In his informal portraits, Carracci seized on a truly exaggerated facial feature for the first time in art, leaving the subject recognizable but distorted in a way that would offer insight into that individual's character. Speaking about this artistic development, Carracci purportedly said, "Is it not the caricaturist's task exactly the same as that of the classical artist? Both see the lasting truth beneath the surface of mere outward appearance. Both try to help nature accomplish its plan. The one may strive to realize it in his work, the other to grasp their perfect deformity, and thus reveal the very essence of a personality." This idea differed sharply with the prevailing mannerist trends in art—indeed, it was heresy to think that caricature could be anything more than a personal diversion—so Carracci's championing of caricature as a worthy artistic pursuit marks an important historical turning point.

Portrait caricature evolved quickly after the Carraccis revealed it to their contemporaries and followers, the most notable of whom was Gian Lorenzo Bernini, whose sketchy portraits of prelates and clerics are now preserved in the Vatican library. "Indeed, witty distortion was much appreciated by the enlightened connoisseurs who formed the international public in seventeenth and eighteenth century Italy," writes Ernst Gombrich in his essay "The Cartoonist's Armoury," from *Meditations on a Hobby Horse* (Phaidon, 1963). As this evolution continued, caricature, which began as a harmless pastime in the seventeenth century, became an international language by the eighteenth. In 1744, according to Werner Hoffman in *Caricature from Leonardo to Picasso* (John Calder, 1957), an English engraver named Arthur Pond published some two dozen engravings by Pier Leone Ghezzi and other Italian caricaturists, which effectively introduced the language of caricature to English painting. By the late eighteenth century, car-

icature had become perfected as satire in savage reflections of Britain's high and low society by William Hogarth, Thomas Rowlandson, James Gillray, George Cruikshank, and their contemporaries, whose satires were delightfully bawdy and scandalously irreverent. And by the nineteenth century, the *portrait chargé*—the critical depiction of a political or cultural personality by enlarging the head, exaggerating the salient characteristics of the face, and frequently tapering the body to achieve either gentle satire or ridicule—was in vogue.

Caricature, however, is not only a charged portrait, but a highly volatile art. The caricaturist wields the power to bring an individual—particularly one of stature—to his or her knees. "The reduction of the physiognomy to a convenient formula made it possible to keep certain politicians constantly before the public eye in all sorts of symbolic roles," Gombrich explains. And as Ernst Kris puts it *Caricature* (King Penguin Books, 1940), "With a few strokes, [the caricaturist] may unmask the public hero, belittle his pretensions, and make a laughing stock of him." One startling example of this is the work of Thomas Nast, America's leading political cartoonist of the late nineteenth century, who devoted many of his *Harper's Weekly* cartoons to caricaturing New York's infamous Tammany Hall boss William Marcy Tweed. So frequent and painful were Nast's graphic barbs that public opinion was swayed and Tweed was forced to abandon his seat of power, fleeing with the police in hot pursuit. One of Nast's infelicitous likenesses of Tweed in prison stripes was so accurate that, despite the caricature's physical distortion, Tweed was identified and arrested in Spain on the strength of this image alone. Tweed is purported to have said in a backhanded tribute to Nast, "I don't care what they write about me—my constituents can't read. But they can see those damn pictures!"

By the mid-nineteenth century, cartoon and caricature were the foremost media for social criticism, and being a cartoonist was a fairly respected profession, too. Nast was one of a handful of international masters to apply their talents in the service of politics. But others, owing to preference or circumstance, devoted themselves to social and cultural caricature. The fundamentals were the same: The savage mirror reflected those physiognomic traits that the human eye could not see but were nonetheless obvious when revealed. The only difference between the two genres is in the effect—in cultural caricature, the subject is more often the target of a mild jest than of acrimony or ridicule; in almost all political caricature, the personage is pilloried.

Since political caricature is inherently subject to the vicissitudes of politics, it has not always been a safe art. When caricature is deemed contraband, as it sporadically has been throughout history, it is often forceably stopped and its practitioners imprisoned. In medieval times, for example, princes and barons were satirized, but only through allusion, since punishment for overt dissent might have been as extreme as death. In the nineteenth century, social changes in Europe resulted in greater freedoms for art and press, and critical caricature was sanctioned, but sometimes reluctantly so, and only until that point where the criticism was perceived as too dangerous for those in power.

ANDRÉ GILL
Louis Napoleon
L'Éclipse, 1871

Quatrième année — N° 165 Un numéro : 10 centimes Dimanche 24 Décembre 1871

RÉDACTEUR EN CHEF
F. POLO
—o—
ABONNEMENTS
PARIS
52 numéros............ 6 fr.
26 numéros............ 3 —
—
Les abonnements partent du
1er de chaque mois
—o—
BUREAUX
16, rue du Croissant, 16

DIRECTEUR
F. POLO
—o—
ABONNEMENTS
DEPARTEMENTS
52 numéros............ 8 fr.
26 numéros............ 5 —
—
ANNONCES
Fermage exclusif de la publicité
ADOLPHE EWIG
10, rue Taitbout, 10

ENTRE LA POIRE ET LE FROMAGE, PAR GILL

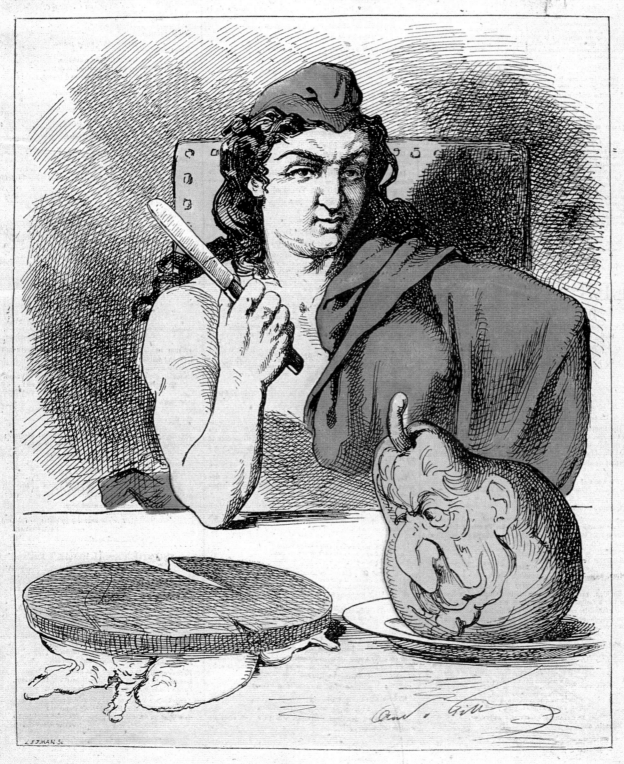

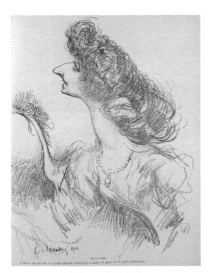

CHARLES LEANDRE
Cile Sorel
L'Assiette au Beurre,
1907

APE
John Ruskin
Vanity Fair, 1872

IS POLITICAL CARICATURE DEAD?

At present, with our high-tech electronic and digital media instantaneously and constantly spitting out imagery that is transmitted to millions of people simultaneously, is the art of drawn, painted, or sculpted caricature still a viable means of commentary and criticism? The Watergate scandal of the early 1970s, replete with a large cast of scurrilous and self-caricaturing politicians, was the last time that cartoonists and caricaturists truly lived up to the legacies of their brilliant cartoonist forebears and played a major role in swaying public opinion, thereby contributing to the downfall of an American President. A constant barrage of acerbic drawings in mainstream and alternative publications pilloried Richard Nixon and his factotums, and burned their indelibly ridiculous portraits into the public's collective mind.

Nixon provided a vivid target for all cartoonists. His physiognomy couldn't be better, and virtually drew itself: The high forehead with the widow's peak, the ski-slope nose, the hunched shoulders upon which his squarish head almost sunk, and the famed five o'clock shadow will haunt him forever. Just writing this description is such a pleasurable exercise— think of the fun caricaturists had drawing him. Even the lesser talents couldn't avoid doing good work with such a foolproof subject.

As the Watergate cover-up unraveled, cartoonists and caricaturists were given the kind of ammunition that comes perhaps once in a lifetime. With almost daily allegations of shocking Presidential intrigue, graphic commentators were given the license to write and draw almost anything about Nixon within the bounds of reasonable taste. None of this activity would have amounted to more than self-indulgence, however, if not for the opening of mainstream outlets for this kind of work. Newspapers had their traditional editorial cartoonists, but with the exception of a few strong mavericks, like Herblock (née Herbert Block) of the *Washington Post* and Pat Oliphant of the *Washington Star*, they routinely echoed their respective editorial boards' dictates. Some medium-circulation liberal magazines and smaller over- and underground newspapers had given their readers a healthy diet of critical graphic commentary since Nixon's arrival in office, but they were usually preaching to the already converted. But a unique forum called the op-ed page (so named because it runs on the page opposite from the editorial page) was introduced to newspapers around the nation during the period just prior to Watergate, and was already providing a new outlet for social and political discourse and graphic commentary.

The *New York Times* initiated the op-ed concept of publishing independent commentaries alongside the paper's staff columnists and using illustration, cartoon, and caricature that complemented, rather than mimicked, a text (and in some cases even stood on its own). The *Times* op-ed page, which debuted in 1970 under the art direction of Lou Silverstein and was later overseen by J. C. Suares, led the way in making Watergate-related political caricatures acceptable in otherwise conservative newspapers. Liberal magazines like *New York, Esquire,* and *Rolling Stone* were also wellsprings for the biting cartoon and caricature. Indeed so much extraordinary work was produced during the Watergate period that after Nixon's resignation in 1974, *Rolling Stone* published *Watergate without Words* (Straight Arrow Publications, 1975), an anthology of Watergate graphic commentaries from many publications around the world. Here was the evidence that visual commentary—and particularly political caricature—was still viable.

After Nixon's fall, however, most political caricature ceased, and so did other biting graphic commentary. In large part, this was due to changes in the publications business: Important magazines lost key

LEAL DE CAMARA
Kaiser Wilhelm II
L'Assiette au Beurre,
1901

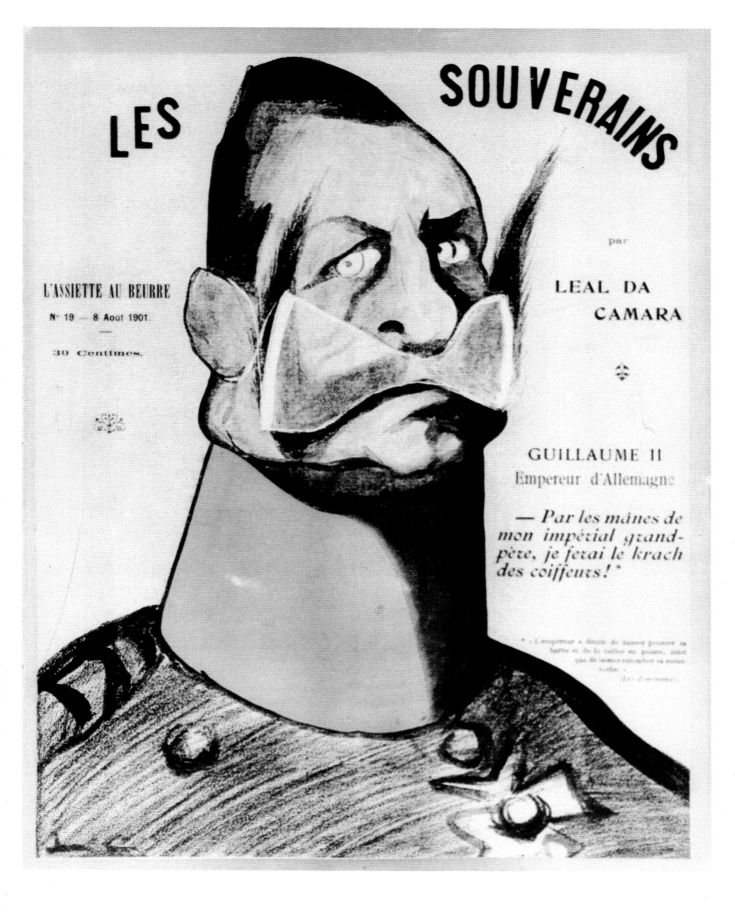

art directors, advertisers shifted from print to television, and alternative publications and political magazines were in decline. In addition, the focus of the American populace shifted away from politics toward a emphasis on life-style. And perhaps many artists felt that the wounds of Watergate, a genuine American trauma, should be allowed to heal. Most mainstream outlets for political criticism reverted to business as usual, which meant controlling or eliminating acerbic political caricature. While a survey of post-Nixon caricature reveals its share of funny drawings of Presidents Gerald Ford and Jimmy Carter, the number of truly inspired caricatures from this period are few. While Ronald Reagan got some cartoonists' engines revving again, resulting in biting caricatures by veterans like David Levine and Robert Grossman, the paucity of caricature outlets was discouraging to many newcomers, who were left without places to publish and consequently found it difficult to justify working in this genre. Only in the late 1980s and early 1990s have more outlets become available, and more politically conscious caricaturists are emerging, suggesting that perhaps a new generation is on the horizon.

PERIODS OF GREATNESS

The Watergate watershed of graphic commentary marked a convergence of an infinitely caricature-worthy event and a resulting torrent of extremely effective caricature. Scandals like Watergate and scoundrels like Nixon are not unique to the late twentieth century, of course—history has provided caricaturists with a litany of despicable leaders to criticize, such as the French King Louis Philippe, who was graphically attacked in the 1830s for abrogating free expression, and of course Adolf Hitler—but cartoonists have not always lived up to the promise of these circumstances. Reasons for this can vary—some caricaturists lack either the talent or the will to be equal to the historical moment at hand, and others may have their freedoms curtailed by law or decree. Sometimes only one or two major talents emerge out of a pack of kindred artists, which was the case prior to Hitler's rise to power in Germany, when George Grosz's satires excelled over those of many other anti-Hitlerites. The potential disparity between a dire political period and its corresponding caricature is aptly demonstrated by a 1933 book, *Hitler in Caricature* (Verlag Braune Bücher Berlin Carl Rentsch), which fails to exhibit work equal to that of Grosz.

The Watergate era, unlike many other fertile periods of caricature, ended in a clear victory: Nixon resigned in disgrace. Cartoonists and caricaturists could take some of the credit for their incessantly witty and acerbic imagery, which reminded the public that this was no laughing matter. Of course, even if Nixon had stayed in office, these cartoonists were not in danger; protected by the First and Fourteenth Amendments, they could say just about anything they wished. In contrast, Grosz's brilliant graphic commentaries, along with the remarkable photomontages from the same period by John Heartfield, did not forestall Hitler's election as Chancellor by even a single day. Prior to this, in 1928, Grosz had been tried and convicted of blasphemy for an antiwar cartoon showing a Christlike figure on a cross wearing combat boots and a gas mask, with the caption *Shut Up And Soldier On*. Grosz left Germany for America prior to

Hitler's rise to ultimate power and learned that, in absentia, he had been pronounced an enemy of the German state, which effectively barred him from returning to his homeland. Heartfield was also forced to flee Germany, to Prague, only a few steps ahead of the police. He continued to make anti-Nazi photomontages, and later emigrated to England when Czechoslovakia was no longer safe.

The essential history of political caricature (and, to a large extent, social caricature as well), therefore, can be written by focusing on those periods when tumultuous events required *and* inspired critical reaction—when the best artists were wed to the most effective vehicles of communication. These periods are instructive, not least because they demonstrate the symbiotic interrelationship between caricaturists and their public forums. Indeed, without a good artist, a magazine or newspaper is barely worth the paper it's printed on; conversely, without a courageous editor or publisher and a viable means of distribution, even the best artist is no more than an ineffectual scribbler.

Before the 1830s, when steam presses made mass periodical printing possible, graphic satires and caricatures—like those of Hogarth, Rowlandson, Gillray and Francisco Goya—were sold as etched prints. The quantities were sometimes relatively sizable, but nowhere near the print run of a periodical. After 1830, the primary outlets for powerful caricature were satiric journals and, to a lesser extent, more general publications. The journals were as common then as television is today—every country had at least one, and sometimes more. In England, France, Germany, Italy, Austria, and other European nations where even a modicum of press freedom was tolerated, the opposition and the ruling powers would each have their own journals. Caricaturists were not always on the same side, as typified by the infamous 1890s Dreyfus case, which polarized all of France into left- and right-wing camps. Two satiric publications were started specifically to attack the issues surrounding the case: *Pssst...*, edited by caricaturists Caran d'Ache and Jean-Louis Forian, was anti-Dreyfus, while *Snifflet*, edited by Theofile Alexandre Steinlein, was pro-Dreyfus. So close were their styles that the two publications would run versions of the same cartoon, but with different meanings. Meanwhile, the two leading nineteenth-century American humor journals, *Puck* and *Judge*, were also on opposite sides of the political aisle. *Puck* was the voice of the Democratic party (the entrenched party in those days), and *The Judge* reflected the Republican platform. Similarly, Italy in the early 1900s found two journals from Bologna, *Il Mulo* and *L'Asino* (both with donkey mascots), sniping at each other. The former represented the ruling party and the Vatican; the latter, the Socialist party.

Diversity within the ranks of critical caricaturists is to be expected, yet the most impressive polemical campaigns have been waged by satiric journals whose contributors were unified in the struggle against a corrupt leader or government. The most paradigmatic such example was published France in 1830, and was the wellspring of modern caricature.

The bloody revolution of July 1830, encouraged by the left and liberals who feared new censorship laws, ended the reactionary regime of King Charles X. As an alternative, the right announced that Louis Philippe, Duke of Orleans, would accept the crown as

A. M. CAY
Woodrow Wilson
1917

A·M·CAY

WILSON

~DE MENSCHEN~ ~VRIEND~

EEN MODERN SPROOKJE

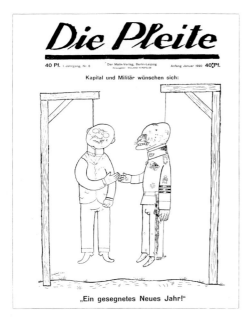

LEONETTO CAPIELLO
Kaiser Wilhelm II
La Baïonnette, 1917

Die Pleite

GEORGE GROSZ
"Capital and Military:
Happy New Year"
Die Pleite, 1920

King of France. Although he was a nobleman, he promised to be a Citizen King, and press freedoms were unhampered during his first year, as evidenced by the success of Charles Philipon's publishing house, Chez Aubert, which published France's most critical political cartoons using the new, inexpensive lithographic process. Philipon was an entrepreneur, editor, and cartoonist who in 1830 began *La Caricature*, a satirical weekly that promised to publish the truth about France's government and leaders. The journal was four pages—two were text and two were lithographs contributed by a stable of brilliant satirists, including J. J. Grandville, Gavarni, Traviés, Descamps, and Raffet. Philipon guided his artists in journalistic attacks on the government and the social structure. Later in 1830, a 28-year-old draftsman named Honoré Daumier began working for Chez Aubert. His first print for *La Caricature*—a portrait of Louis Phillipe as the glutton Gargantua sitting on a commode while swallowing gold from the poor—caused a scandal. Daumier was sentenced to six months in prison for this insulting depiction of the King. But his sentence did not begin until over a year following his conviction, and he spent much of the intervening time in the press section of the Chamber of Deputies, where he memorized the physical features of Louis Phillipe's ministers just well enough mold their likenesses in clay. These exquisite sculptures were later used as models for his critical lithographs. Prison was not particularly unpleasant for him either, since he served some of his time with Philipon, who had been sentenced for a *La Caricature* cartoon that ridiculed the King by transforming him into a pear, leading all of Paris to refer to Louis Philippe as the Pear King. Philipon used his free time planning the publication of the daily *La Charivari* (*The Commotion*), which would continue to fight social injustice even after harsh censorship laws were enacted.

The unceasing graphic assaults on the King, his ministers, and his policies, despite attempts at ad hoc censorship, bred such discontent with the monarchy that Paris expected an attempt on the King's life. When this finally occurred in 1834, slightly wounding Louis Phillipe and killing almost 20 others, press restrictions (known as the infamous September Laws) were quickly enacted, making contempt of the monarchy a treasonable offense. Caricatures had to be approved by censors, which effectively ended the era of political cartooning and forced *La Caricature* to cease publication later that year. *La Charivari*, however, continued to satirize bourgeois society as a mask for political satire. In fact, neither Daumier nor the other contributors were stifled—they just redirected themselves to metaphorical social caricature. Daumier, for example, created a series based on the character Robert Macaire, "a swindler who victimized the poor and rich," which was very popular in France. He also did a frequent feature satirizing influential professions, including law and medicine. *La Charivari* continued to be popular during the final years of Louis Phillipe's reign, through the period following the revolution of 1848, and during the Second Republic, when press freedoms were briefly resumed.

The 1852 coup d'etat that made Louis Napoleon the emperor of the Second Empire once again forced caricaturists to resume fighting press restrictions. Two journals that survived the clampdown were *L'Eclipse* and *La Lune*, whose principal artist, Andre Gill (the

GEORGE GROSZ
"The German Pest"
Die Pleite, 1919

Die Pleite

40 Pf. 1. Jahrgang, Nr. 5 Der Malik-Verlag, Berlin-Leipzig 15. Dezember 1919 40 Pf.
Herausgeber: WIELAND HERZFELDE und GEORGE GROSZ

DIE DEUTSCHE PEST

pseudonym of Gosset de Guisne), created extremely funny caricatures of Parisian politicians, actors, poets, and writers through insightful exaggerations. Gill, in fact, perfected the big-head-on-little-body conceit, but he was no Daumier—he often steered clear of political commentary. But his work, which today is celebrated for its economy and acuity, served the much-needed function of allowing the public to let off steam during a critical period of French history.

Louis Napoleon met his end when he entered the disastrous Franco-Prussian War in 1870 and was taken prisoner, after which Paris was besieged by the Prussians for four months. In the throes of crisis, the French caricaturists unified as they had in 1830, and, by one historian's count, produced over 6,000 caricatures and cartoons. These were often hand-colored, and were generally printed on loose sheets, in small journals, and as broadsides (single-sided posters). After the war, scores of small journals came out of the woodwork. Unlike *La Caricature* and *La Charivari*, these new journals eschewed a national focus in favor or a new worldliness, which was associated with a sharpening of the political consciousness of Europe.

THE NEW HUMANISM

By the turn of the century, political caricature had evolved into a force that taught by interpretation. Although a fair number of "joke books" were published, the great satirical journals raised caricature to new didactic and aesthetic levels. Indeed, consistent with the radical humanist and formal developments in art, such as Impressionism and Post-Impressionism, caricaturists rejected certain timeworn comic and drafting conventions for radical, new approaches. Of course, most caricaturists were not members of the avant-garde; in fact, many were scornful of the new directions in painting and sculpture. But two German satire publications led the way into the twentieth century: Munich-based *Jugend* and *Simplicissimus* were outlets for cartoonists and caricaturists who wanted to push their form closer to the fringes of art. *Jugend*, which first published in 1896, was a satire, art, and culture magazine from which Jugendstil, the German art nouveau movement, took its name. *Simplicissimus*, which began that same year, was exclusively satirical, and unabashedly merciless in its attacks on the Kaiser, the military, and the church. Although some of its artists also adopted Jugendstil as the foundation of their visual language, they did so to achieve maximum graphic impact, not as fashion.

Simplicissimus was the most significant of the late-nineteenth-century publications for its devotion to art in the service of society. Although its publisher, Albert Langen, was not an artist, and its editorial board included such writers as Thomas Mann, Hermann Hesse, and Frank Wedekind, its co-editor, T. T. Heine, was a caricaturist and poster artist. And since *der Simpl*, as it was colloquially known, was primarily pictorial, it was largely governed by its artist contributors. "Its design and philosophy both were thoroughly modern and avant-garde," writes Mark Rosenthal in an essay for the exhibit catalog *The Art of Simplicissimus* (Die Aktion Productions, 1979), "yet it clearly struck a vein of deep need in the German public and became an influential force that lasted for decades." Yet *der Simpl* was not simply a popular journal that subverted its way into the Germans' hearts and minds; it was a stepping stone of German Expres-

sionism, particularly the critical and polemical aspects of the movement during World War I. "So dependent was the development of German Expressionism on the opening of French artistic innovations by this and other periodicals," continues Rosenthal, "and so rooted was Expressionism's orientation in the attitudes initially propagated in *Simplicissimus*, it can be argued that German Expressionism was born on the pages of this publication."

While *Simplicissimus*'s impact was huge, the changes it heralded did not come smoothly and easily. Throughout the nineteenth century, German arts had been dominated by venerated academic verities that prohibited emotion or expression. By definition, caricature supposedly freed art from these strictures, but in Germany even caricature was bound by many of the same academic rules of drawing and painting. German academies rejected the French experiments in color and form and, more tragically, ignored the complex sociological changes in society itself, such as the rapid transition from agrarian to industrial order that caused profound class distinctions and polarized the nation for decades to follow. The initial publication of *Simplicissimus* in 1896 threatened the sanctity of the academy while simultaneously exciting the German people, who welcomed its stridency and courage and actually formed political clubs around the journal. During 1896–1908 (what Rosenthal calls *Simplicissimus*'s "Heroic Years"), discontent increased on all levels of German society, but especially among the disenfranchised who formed the journal's initial readership.

From its inception, *der Simpl* was aggressively anti-social. Its artists, masters of graphic insult and insight, exposed the folly of German urban life and the pomposity of the aristocracy (as well as petty functionaries). It attacked the new oligarchy, ridiculed outmoded sexual mores, condemned the overstocked military, and showed no mercy to decadence and sentimentality. Each cartoonist and caricaturist had his own speciality. Among the most notable, Rudolf Wilke created a vagabond philosopher displaced by social flux who was nevertheless a sage, all-seeing and knowing. Heine constantly skewered injustice in the military, policy, and business realms. Eduard Thöny brilliantly captured, with only the slightest physical exaggeration, the persona of the German elite. Bruno Paul, who later became a leading furniture designer and director of the Berlin Kunstgewerbeschule, and whose style is the missing link between Jugendstil and Expressionism, skillfully interpreted populist themes, representing the "little people" who were being quickly displaced by industrialization. And the most facile of all the caricaturists, Olaf Gulbransson, a Norwegian who worked for *der Simpl* even through the Nazi years, combined the economy of his pen stroke, the acerbity of his ideas, and his ability to transform Art Nouveau conceits into a personal language to become the foremost portrait caricaturist of the era.

Each of these artists had a different style, but all shared a common talent: the ability to tap into the psychology of their subjects and reveal the innermost emotion, expression, and motivation. While most graphic commentators created symbols, *der Simpl*'s artists developed characters. The publication began to unravel after 1908, when Langen died and some artists left, and was a shell of its former self during World War I, when it became patriotic. But during

OLAF GULBRANSSON
Leo Tolstoy
Simplicissimus,
c. 1909

WILLIAM COTTON
Gertrude Stein
Vanity Fair, 1934
Art Director:
M. F. Agha

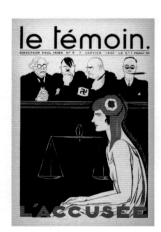

PAUL IRIBE
Lloyd George, Hitler,
Mussolini, FDR
Le Témoin, 1934

NEFF
Jesse Owens
Ringmaster, 1936

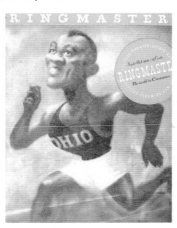

the the Heroic Years, when these artists played in concert, they created a melody of visual satire that was unsurpassed for its courage and profundity.

Only one publication can be considered to have been *der Simpl's* peer: its French counterpart, *L'Assiette au Beurre*. At the turn of the century, over 20 years after Daumier passed on the stylus to another generation of political and social caricaturists, a French republic, responsible to the needs of its citizens, was still not altogether realized. "The state, instead of being an instrument of the people," explains Ralph E. Shikes in an essay for *Art and Architecture in the Service of Politics* (M.I.T. Press, 1978), "was a huge, bureaucratic machine dominated by '*l'assiette au beurre*'—the butter dish—the nice, fat job with the prerogative of dispensing favors for a price." Despite this often oppressive environment, artists migrated to Paris from all over the world, some to find fame and fortune, others to escape artistic repression elsewhere. As in Germany, it was a time when rapid social, economic, and technological change wrecked havoc on human lives. Radical political philosophies, such as anarchism, offered alternatives to the antiquated and unresponsive systems then in place. With a tradition of dissent firmly entrenched among young artists, "it was a masterstroke of timing," continues Shikes, "when Samuel Schwarz launched *L'Assiette au Beurre* on April 4, 1901." For this weekly satiric journal offered an outlet that the socially minded artist could not find in the comic newspapers, which only infrequently devoted space to political issues. For most of its 12-year duration, *L'Assiette au Beurre* was entirely visual, with full-page images on almost all of its 16 pages, half of them in color.

L'Assiette au Beurre was not exclusively polemical, offering its readers a well-rounded diet of acerbic caricatures of public personalities, attacks on social injustice and government abuse, and lighthearted jibes at innocuous subjects, such as mothers-in-law, airplanes, and the medical profession. The most frequent targets were capitalism, colonialism, the judicial system, the church, monopolies, and the crowned heads of Europe. Prostitution, another frequent theme, symbolized the degradation of civilized society. No subject area was taboo, as *L'Assiette* gave free reign to its 50 or so contributing artists. Shikes says their mission was to "bare what lay behind the facade of the Belle Epoch." Most issues were devoted to a single theme, and were often illustrated by one artist. Some of the finest issues were on sensitive subjects, such as the war in the Transvaal (South Africa) between France's enemy, England, and the Dutch colonists, the Boers. Graphic commentaries depicting inhumane treatment of Boer civilians in British internment camps heightened awareness of this, history's first guerrilla war. An issue devoted to Christ's return to contemporary society was a savage indictment of Christianity run amok. And an issue devoted to homosexuality marked one of the first times a popular magazine opened up this taboo subject to public scrutiny.

L'Assiette au Beurre's stable of artists included some future giants of Modern art. Before immersing himself in painting, Juan Gris worked on at least five issues. Felix Valloton contributed to many others, including his solo tour de force, an indictment of official brutality entitled "Crimes and Punishments." Other future Post-Impressionists were Kees Van Dongen, and Louis Marcoussis. And Franz Kupka, who

JOHN HEARTFIELD
Hermann Göring
AIZ, 1933

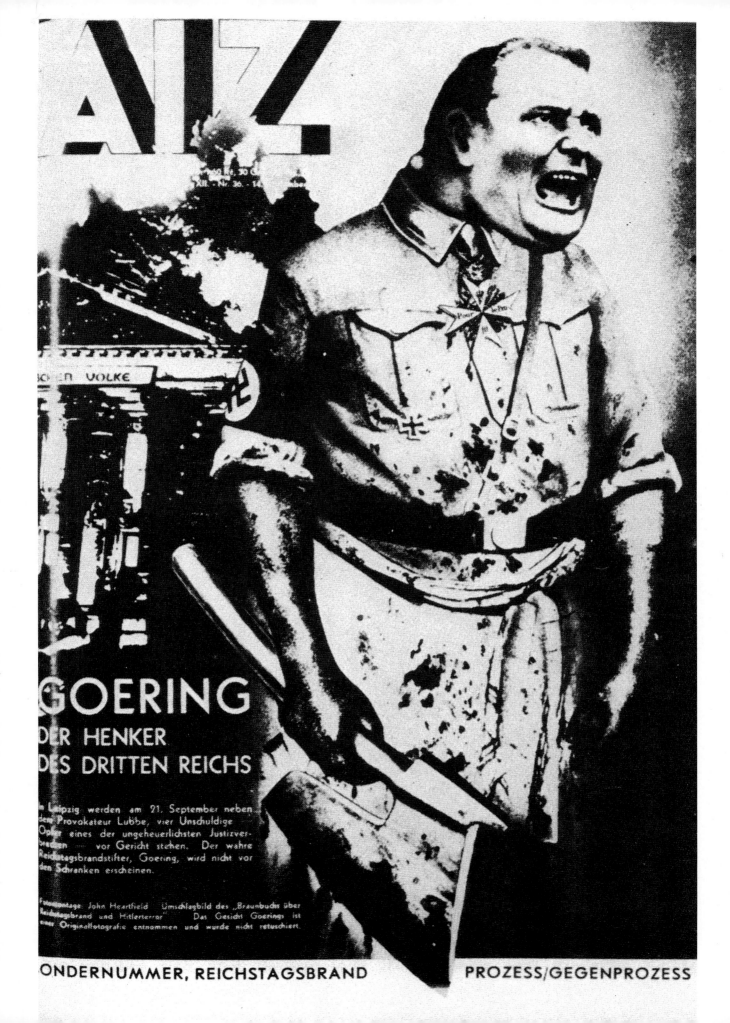

GOERING
DER HENKER
DES DRITTEN REICHS

In Leipzig werden am 21. September neben dem Provokateur Lubbe, vier Unschuldige Opfer eines der ungeheuerlichsten Justizverbrechen — vor Gericht stehen. Der wahre Reichstagsbrandstifter, Goering, wird nicht vor den Schranken erscheinen.

Fotomontage: John Heartfield. Umschlagbild des „Braunbuchs über Reichstagsbrand und Hitlerterror". Das Gesicht Goerings ist einer Originalfotografie entnommen und wurde nicht retuschiert.

SONDERNUMMER, REICHSTAGSBRAND PROZESS/GEGENPROZESS

went on to explore the limits of abstraction, produced the most virulent anticlerical, anticapitalist, and antimilitarist issues of the magazine through incisive visual exposés of greed and exploitation.

Consistent with the dominant French style, many of *L'Assiette*'s artists were influenced by Art Nouveau conventions, and though some employed the flourishes of its curvilinear form, they rarely allowed it to devolve into style for its own sake. The light, airy style of Toulouse-Lautrec also had an impact. In addition, the relatively free press of the period affected how the artists worked—having free outlets for polemics raised the qualitative level of cartoon and caricature throughout France. The painter Jacques Villon, who drew vignettes mostly for the more socially oriented *Le Courrier Francais* but also did a fair share of cartoons for *L'Assiette*, wrote in the 1920s about the milieu in glowing terms: "At that time the influence of the press on art was incontestable. It helped to speed up the liberation of painting from academicians....And let's make it clear that the press of those days just doesn't compare with today's papers. The press had a most advanced spirit and cartoons were done with love, and not just dished out as today."

L'Assiette ran afoul of French authorities in 1907, after which it faced financial problems; it ultimately folded in 1912. But unlike *Simplicissimus*, which devolved into a sufficiently unthreatening and emasculated form to survive the vicissitudes of politics until the end of World War II, *L'Assiette* left the public arena with its reputation intact, having set a standard for political caricature that is hard to surpass even today. Like the early *der Simpl*, which exerted an influence on Expressionism, *L'Assiette* had a catalytic function in French Modern art. A hint of Gris's Cubism, for example, came out in his polemical drawings; Kupka's radicalism translated into a painting style that flew in the face of convention. The Cubists as a group were probably reacting to Art Nouveau's curvilinear form, which became a symbol of bourgeois decoration. Finally, the journalistic aspects of *L'Assiette*—its coverage of real-life issues—had an effect on the Cubists, who brought a certain grit into their abstractions by including newspaper fragments and other quotidian objects.

With *L'Assiette*'s demise, some artists scattered to other papers. New journals were also started to fill the void—quite a few of them published during World War I as anti-German propaganda, such as *La Baïonnette* and *Le Mot*)—but these were decidedly less strident and critical of France.

Political caricature lost some of its bite for a while, but *L'Assiette*'s demise and *Simplicissimus*'s decline did not spell the end for this type of work. After World War I, *der Simpl* continued its graphic criticism with a repertory of new artists, most notably Karl Arnold, whose razor-sharp line pierced the thick skins of once and future demagogues and politicians (as well as the thin skins of entertainers). During the mid-1920s, caricature was revived as a weapon in the fight against incipient fascism and Nazism. While George Grosz and John Heartfield were the masters, Arthur Szyk was another uniquely gifted caricaturist, who built his reputation on a series of chilling antifascist caricatures collected into two books, *The New Order* and *Blood and Iron*, the latter a lavish limited edition. Szyk was Polish by birth, but in 1934 he came to the United States, where, in addition to illustrating books and

bible stories, he made a series of devastating anti-Axis caricatures for *Collier's*. Using watercolor, he would painstakingly and precisely render every onerous detail of his subject's face and costume, exaggerating those characteristics that exposed the most vicious side of Hitler, Göring, and Goebbels. His cartoons of the Japanese warlords were alternately monstrous and buffoonish, often exhibiting the stereotype of the Yellow Peril that sadly is being reprised in today's surfeit of Japan-bashing. During World War II, caricature served the Allied propaganda effort, yet most of the work was perfunctory. The requirements of wartime propaganda—to demean and dehumanize the enemy through oversimplification—made caricature into a childish game.

PORTRAIT CARICATURE AS ENTERTAINMENT

In Martin Scorsese's 1982 film *The King of Comedy*, Jerry Lewis poses for the resident caricaturist at Sardi's, the famous New York restaurant where celebrities congregate. On the walls are hundreds of other *portraits chargés* dating back to the 1920s, all of prominent customers. These are not biting, stinging, vicious, or insulting caricatures, but celebrations of the famous, distorted ever so slightly for purely comic effect. And this brings us to the other side of the caricature coin: As insulting as a caricature can be, it can also delight and entertain. Caricature as a mild jest has a long history as the tool of commerce in advertisements and posters—some stars even use them as trademarks. In fact, to be caricatured at Sardi's in the spirit of good fun is a rite of passage—what wannabe star would decline a position on this wall of honor?

Of all the outlets for entertaining portrait caricature, the original British *Vanity Fair* was the most influential. For nearly 50 years, from 1868 to 1914, write Roy T. Matthews and Peter Mellini in *In "Vanity Fair"* (University of California Press, 1982), "*Vanity Fair* displayed its political, social, and literary wares weekly for the nineteenth-century Pilgrim. Inviting its readers to recognize the vanities of human existence, the publication, through its original format, process, and coloured caricatures, became the envy and model of other Society magazines." The original *Vanity Fair* was founded in Britain, and was written by and for an Edwardian establishment. It was by no means radical or threatening to social convention. Members of the "Smart Set" were delighted to find themselves the subject of a caricature or ditty. Today, *Vanity Fair* is best remembered for its chromolithographic caricatures, so exquisitely executed that tearsheet versions are framed and sold to contemporary interior decorators for use as accents in drawing rooms and studies.

Not all of *Vanity Fair*'s portrait caricatures were of sportsmen and artists, but most were of men, and all were accepted in the mainstream of British social life. In 1869, Thomas Gibson Bowles, the magazine's founder and editor, proposed to "add...some Pictorial wares of an entirely novel character" to the mix of his journal. The magazine's first caricature (of over 2,300, as tabulated by Matthews and Mellini) of prime minister Disraeli was indeed unique in both technique and style—the exaggeration was subtle, but nevertheless forcefully tweaked the subject's salient physical characteristics enough to achieve a humorous look. This was followed by a regular diet

**MIGUEL COVARRUBIAS
Benito Mussolini
Vanity Fair, 1933
Art Director:
M. F. Agha**

ITY FAIR

OCTOBER 1932
35 CTS.

CONDÉ NAST
PUBLICATIONS, INC.

STAGE PEOPLE

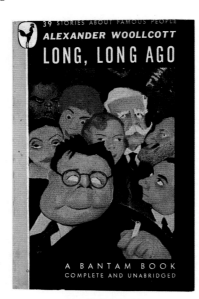

WILLIAM COTTON
Alexander Woollcott
Bantam Books, 1939

MIGUEL COVARRUBIAS
Hedda Hopper
Vanity Fair, 1933
Art Director:
M. F. Agha

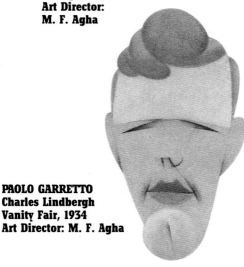

PAOLO GARRETTO
Charles Lindbergh
Vanity Fair, 1934
Art Director: M. F. Agha

of dignitaries both foreign and domestic, and later by depictions of judges, journalists, criminals, sportsmen, artists, actors, and Americans. "At first, some people were reluctant to be seen in the pages of *Vanity Fair*," explain Matthews and Mellini. "However, as the popularity of the caricatures grew, they became less hesitant." Most subjects consented to be caricatured in good humor, but some refused, perhaps aware that some who accepted were unhappy when their reflection in the savage mirror turned out to be somewhat less benign than they had anticipated. But for the most part, being represented by a caricature in *Vanity Fair*, like being immortalized by Al Hirschfeld today, was considered to be acceptance into a very exclusive club.

The magazine's artists adopted an air of mysterious celebrity. Most used *noms de crayon*. The most influential member of the stable was its first caricaturist, Carlo Pelligrini, who initially worked under the pen name Singe, which later he changed to Ape—perhaps because he aped the traits of his subjects. Pelligrini was born into the Italian aristocracy but ventured to England because of political uncertainty and a failed love affair at home. He developed a close friend of the Prince of Wales, which became his ticket into high society. As Disraeli's biographer wrote, Pelligrini was so accepted despite his eccentricities because "the aristocracy has always been tolerant of individual oddities. It has been prepared to put up with entertainers, buffoons, jesters and freaks as long as they gave good value." In addition to being quite a character, Pelligrini captured the character traits of others in his witty caricatures. Though little appreciated today, Pelligrini was considered a genius of English caricature, which except for Max Beerbohm and David Low was not known for the same vitality or vigor as caricature in France, Germany, and Italy.

Other *Vanity Fair* regulars included Spy (née Leslie Ward), who was called a "tame ape." Sic (née James Jacques Joseph Tissot), who later turned his attention to painting, brought an unerring color sense to his caricatures. And on occasion the American master Thomas Nast drew less stinging caricatures of prominent Americans. With few exceptions, *Vanity Fair*'s caricatures, even at their best, exhibited the form but not the content of their European counterparts. As esteemed and honest to their subjects as they were, *Vanity Fair*'s caricatures were no more than drawing room diversions.

An American *Vanity Fair* was published in New York between 1859 and 1863, and despite the editing talents of Artemus Ward, America's leading humorist, it failed to achieve the same status as its younger English cousin. In part this was because its art was anemic; but perhaps more importantly, its editorial policy was too anti-Lincoln and antinegro to survive the Civil War. In fact, no other comparable American magazine came close to earning the same social status as the English *Vanity Fair*. Many of the innocuous American satire periodicals were poorly modeled after the English *Punch*, which was founded in 1840 (and was where the term *cartoon*, connoting a humorous drawing, was coined). But when contrasted with *La Caricature* and *La Charivari*, which fought the French crown, *Punch*'s refined and decorous Whiggism was indicative of a much freer society, in which the artists had little argument with the crown. *Punch*'s sometimes brilliant political cartoons were usually

ARTHUR SZYK
Adolf Hitler
Collier's, 1942

Collier's

RCH 28, 1942 FIVE CENTS SEVEN CENTS IN CANADA

LLIER PUBLISHING COMPANY—PUBLISHERS OF COLLIER'S—THE AMERICAN MAGAZINE—WOMAN'S HOME COMPANION

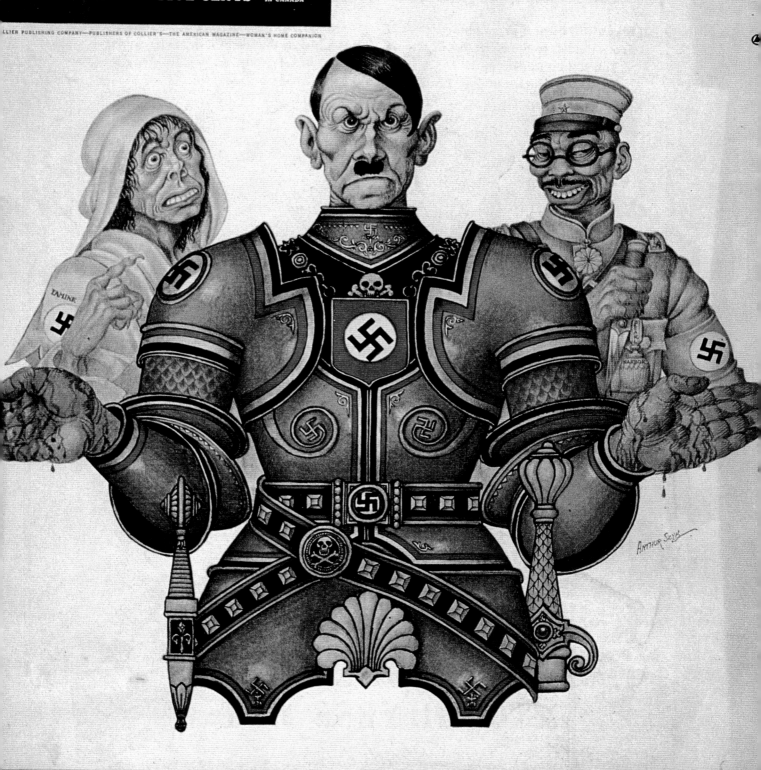

MOVING FINGER
A NEW MYSTERY STORY BY AGATHA CHRISTIE

aimed at foreign targets, while at home the journal was more concerned with the comedy of manners. But even these satires were not as acerbic as the works of Daumier or Gill.

C. R. Ashbee writes: "When we look at the work of John Leech and Charles Keene…there is a softening of the exaggeration, a satirising that is delicate—we are never hurt." Leech and Keene were both brilliant draftsmen, acknowledged by their peers as the two greatest masters since Hogarth; but unlike him, they captured the human comedy with sympathy and love. Neither showed evidence of a rapier wit, perhaps in keeping with the tight-laced sensibility of the Victorian era. "The Parisians say of our Victorian caricaturists that they smile rather than laugh, and it's true," continues Ashbee, noting that, for example, "the skirts are not drawn above the ankles, [and] the caricature is casual and tenderly suggested." Victorian caricature was reflective, not rebellious—the morals and mores of the genteel English society were respected, while at the same time they were teased for their obvious foibles. Though eighteenth-century English caricature was often bawdy and grotesque, the nineteenth-century Victorian cartoonists in *Punch* left that kind of thing for more discontented artists to pursue.

JEST AND JAB

Punch was mimicked without success in part because magazines with titles like *American Punch, Southern Punch* and *Punchinello* simply didn't reflect the tastes of the American public. America, after all, was a hotbed of rabble-rousing, so it's not surprising that many troublemakers, including not a few caricaturists, found their way to the United States from points east. Before the mid-nineteenth century, and before the waves of immigration hit America's shores, several dozen American humor periodicals were attempted, with scant success. Some of these, like the American *Vanity Fair*, were too controversial, others not controversial enough. Alan Fern, in his *They Made Them Laugh and Wince and Worry and…*(Library of Congress, 1977), cites the policy of the short-lived periodical *Uncle Sam*, which announced that "nothing immoral or scurrilous will ever appear in its columns"—does this sound like the formula for a winning humor publication? Indeed, most of the early humor periodicals failed simply because they were not humorous. Commenting in an 1862 issue of *Harper's New Monthly* on the sorry state of humor in these ventures, Richard Grant wrote, "Many funerals are conducted in a manner far better calculated to minister to the sense of the ridiculous."

This was the state of the art until *Puck* was founded in 1877. *Puck*, which lasted in various forms until 1918, was the first of three New York–based satiric journals—*The Judge* and *Life* were the others—that forever changed political and social caricature in America, and influenced cartooning for decades to follow. *Puck* was founded by Joseph Keppler, a Viennese immigrant who was tutored in the fine German arts of lithography and academic drawing. After publishing a German-language weekly in St. Louis that failed almost immediately in 1871, he resettled in New York in 1876. A year after publishing the first issue of his German *Puck*, he added an English edition, which became an overnight success and the cornerstone of a publishing empire that included scores

of *Puck's Librarys*—little magazines of situational cartoons on every subject that offered readers a plethora of racial and ethnic stereotypes. From the outset it was different from other comic publications, since every issue had a different illustration on the cover, while those following the *Punch* style reused the same cover motif issue after issue. In addition, *Puck* always published at least four pages in color, making it one of the first mass periodicals in America to take advantage of chromolithography.

First and foremost, *Puck* was designed to entertain the public through a mix of acerbic and benign portrait caricatures and humorous situational cartoons. It lived up to its slogan, "What Fools These Mortals Be," with caricatures that placed the prominent from all walks of life into ridiculous and often embarrassing situations. Not all of the content could be dismissed as good, clean fun, however—*Puck* attacked current issues, like immigration, with a strident jingoism that seems frighteningly reactionary by today's standards. The magazine's use of cultural stereotyping as a means of conveying these critical viewpoints contributed to the public's misperception of certain ethnic and racial groups for years to follow.

In 1881, *Puck* cartoonist James A. Wales had a quarrel with Keppler and left to found a rival publication, *The Judge*, which would endure until 1947 (albeit in a markedly different form). A year later, however, he sold out to William J. Arkell and returned to *Puck*, having resolved his conflict with Keppler. Arkell brought in Bernard Gillam, another of *Puck's* leading cartoonists, as editor, and, as Fern points out, "they turned the weekly into a Republican journal to counter the influence of the Democratic-oriented *Puck*." For the next decade or so, the two magazines had very similar formats and contents, leaning heavily toward the detailed, lithographic Keppler style. The menu was also the same: political and social caricature mixed with situational cartoons. During this period, both *Puck* and *The Judge* became the spawning ground for cartoonists, like Fred Opper and R. F. Outcault, who became pioneers of America's most important indigenous visual art form, the comic strip.

In 1883 the first issue of *Life* was published. This initial incarnation of the magazine, which lasted until 1936, after which Henry Luce bought the name for his new picture magazine, was a smaller-format publication than its competitors. It was printed entirely in black and white, and had a more well-to-do social and cultural bias. The editors, Edward S. Martin and John Ames Mitchell, a cartoonist himself, succeeded in giving *Life* higher artistic and literary value than *Puck* and *The Judge*. It was closer in spirit to the British *Vanity Fair* in commenting and satirizing American manners and customs, but its format and artwork were altogether different. In its first decade, the magazine excelled in linear illustration, especially the work of Charles Dana Gibson, who published his first famous pure-looking, Anglo-Saxon female, the Gibson Girl, in *Life*'s early issues. (In the 1920s, he became the magazine's owner and publisher.) Other masters of the comic line included James Montgomery Flagg and Harrison Cady.

Life also helped refine the new halftone technology by reproducing many tone drawings and paintings, and in 1905 *Life* began running full-color covers by Gibson, Flagg, Tony Sarg, Coles Philips, and others.

**WILLIAM COTTON
Marlene Dietrich,
Katherine Hepburn,
Greta Garbo, and
Anna Sten
Vanity Fair, 1933
Art Director:
M. F. Agha**

MIGUEL COVARRUBIAS
John D. Rockefeller
and Joseph Stalin
Vanity Fair, 1933
Art Director:
M. F. Agha

Many of these featured mild caricatures lampooning celebrities, as well as fashion-style illustrations. "*Life*'s pictures were often referred to as 'buttericks,'" explains Fern, "because of their resemblance to the illustrations in the well-known fashion magazine. But it was the reflection of fashionable life as never before shown in a comic paper that made *Life* popular from the start." *Life*'s cartoons and caricatures exposed the pretensions and prejudices of the Gilded Age better than any of its competitors.

Other comic and satiric magazines were published in America, with titles like *Truth, Success, Chic,* and *Wasp,* but none represented the American bon ton like the British *Vanity Fair* mirrored the English upper crust. At least not until a new American *Vanity Fair* made its debut in 1914. It went through a number of titles, like *Sport, Music, Drama* and *Saturday Standard* and *Vanity Fair and the Saturday Standard,* before *Dress and Vanity Fair* was shortened to *Vanity Fair* in 1915. At first the magazine did not offer or encourage caricature, but after a while, as Fern explains "the editor was beginning to realize that caricature...was a method by which vanity could be revealed. By 1920 the contents listed 'Satirical Sketches,' thus indicating that comic drawings would no longer be considered mere additions to articles." Full-page—often full-color—cartoons and caricatures became one of *Vanity Fair*'s defining traits.

In the 1930s, *Vanity Fair* became known for four visual innovations proffered by its art director, M. F. Agha: the emphasis on white space as a design element; the consistent use of lowercase sans serif headlines, a radical departure from conventional magazine layout; the use of dramatic, full-page portrait photography by the leading artists of the day; and the use of cover and full-page caricatures by three of the world's finest practitioners: Miguel Covarrubias, Paolo Garretto, and William Cotton.

During the 1930s, these artists worked for a wide range of magazines in addition to *Vanity Fair.* Of the three, Miguel Covarrubias, a Mexican who gave up caricature later in his life to pursue a career in anthropology, is the most famous today. In an essay appearing in *Miguel Covarrubias Caricatures,* (National Portrait Gallery, Washington, 1985), Bernard Reilly writes that Covarrubias already possessed a remarkable level of sophistication when he arrived in New York at the age of 18 in 1923: "His linear economy...and his use of abstract elements such as arrows, spirals, and various graphic patterns suggest the symbols and characters incorporated into the cubist compositions of George Braque and Pablo Picasso. In fact they were more likely inspired by geometric motifs found in Mexican Indian crafts and decorative arts." His caricatures conformed to the dominant style of Jazz Age known as Art Moderne, a hybrid of Modern art—Cubist, Constructivist and Bauhaus elements—and ancient Egyptian, Mayan, and American Indian decorative motifs. His line drawings were not just caricatures but emblems of the age. He eventually rejected line work, however, in favor of beautifully modeled pastel and crayon illustrations that transcend stylistic categorization even today.

By the time Covarrubias debuted in New York, the press and the stage had given new life to caricature. A symbiotic relationship existed between the leading theatrical caricaturists, such as William Auerbach Levy (in the *Brooklyn Eagle*) and Al Freuh (in the *New Yorker*), and the theatrical community—the theater made the artists' careers, and they in turn celebrated the stage's finest actors. Virtually every newspaper and magazine that covered New York's nightlife had a caricaturist on staff. "That a caricature attracts reader attention, more than a tame portrait does, is obvious," wrote William Auberbach Levy at the time. "One of the pleasures of caricature is recognition... [and] stars of stage and screen are well known to everyone, which is why the theatre is a natural field for the caricaturist." Recognizing the *portrait chargé* became a popular public pastime. Reilly explains that "Magazines such as *Vanity Fair* and *Harper's Bazaar,* their coffers bursting from recent heady circulation growth, were the Medicis of the era. The page space that these journals gave over to cartoons and humorous drawings attested to their enormous popularity." It was the golden age of the magazine as cultural wellspring and molder of opinion. The devoutly cosmopolitan editor of *Vanity Fair,* Frank Crowninshield, maintained a high level of style and taste, and with Agha's progressive art direction leading the way, *Vanity Fair* was also in the forefront of Modern design. No longer did an art director merely procure illustration—he was now an arbiter of visual style.

From the moment he was introduced to magazines, Covarrubias was well prepared to take his place in the refined publishing milieu. Within three years he was called the most terrifying caricaturist of the American face—although he was clearly loved, not feared, by readers and subjects alike—and was one of the most sought-after artists of the age. His caricatures were often highly stylized, sometimes to the point of total abstraction. They were never so good-natured as to be toothless, but could hardly be categorized as cruel. Covarrubias kept a certain distance from his subjects; in fact he never drew from life. "This distance was a valuable asset in his work," says Reilly. "At his best, Covarrubias was capable of piercing the carefully constructed shell of a celebrity's public image." In

PAOLO GARRETTO
Gandhi
The Graphic, 1930

his color work no obvious physical detail was overlooked in an attempt to get close to his character's true personality. This skill was put to particularly good use in his well-known *Vanity Fair* "Impossible Interviews" series, in which he employed word and picture to introduce two antagonists in fictitious debates—John D. Rockefeller versus Joseph Stalin, for example, or Huey Long versus Benito Mussolini.

Covarrubias rejected certain *laissez faire* comic conventions in favor of a very deliberate and calculated rendering method. But despite the intense effort put into his drawings, they did not come across as labored or self-conscious. He was the genius of gesture: More often than not, a character came alive through the shrug of a shoulder, the slink of a hip, or even the wink of an eye.

Covarrubias's *Vanity Fair* colleague Paolo Garretto was an Italian caricaturist and poster artist (on a par with poster maestros A. M. Cassandre and Jean Carlu) who lived in Paris and worked for magazines. His distinct style relied less on gesture than on profound facial exaggeration. Garretto was so facile with the airbrush that he used it like a pen to streamline his subjects' features. He smoothed out faces with pastel blends, and on occasion used collage to accent a hairline or moustache. But this was not graphic tomfoolery for its own sake—every form had a function. Garretto was a minimalist in the best sense, and rarely added an unnecessary wrinkle or dimple. Yet even the most economical of his characterizations unmistakably captured their subjects.

Garretto did illustrative design for many magazines, including covers for the beautiful behemoth of the 1930s, *Fortune*, but he reserved his caricatures for *Vanity Fair* covers and the "Profiles" section of the *New Yorker*. Here he developed a style so emblematic of the Art Moderne era that when he attempted to work in the same style in the 1980s, then in his 80s himself, his work seemed nostalgic, locked in a certain time and place despite its application to contemporary subject matter. (Ironically, in this period of Post-Modern revivalism, Garretto's work has been reappreciated and reapplied by some of the young artists shown whose work is in this book.)

Less is known about William Cotton, the third member of the *Vanity Fair* triumvirate. He is ignored in most contemporary books of caricature, perhaps because his subtle pastels toed the fine line between portrait and *portrait charge*. Nevertheless, he was as prolific as the others, and his work was prominently featured on covers of the *New Yorker*—an honor reserved only for the finest cartoonists of the Jazz Age. Some of Cotton's portraits look as though the muted pastels were applied with a wad of cotton, resulting in a gauzelike effect. His medium didn't allow for the occasional brutishness accomplished by his colleagues; his precisely modeled faces were subtle distortions of just the right physiognomic details to highlight recognizable character distinctions. Like Covarrubias and Garretto, Cotton did some political caricature when the need arose, but his favored subjects were artists, writers, and actors.

HUMOR AND THE DEPRESSION

Social and political flux brought on by the Depression influenced the course of humor during the 1930s. On the one hand, cartoonists and caricaturists attacked mounting social ills with great urgency;

on the other, wit for its own sake was a placebo to take people's minds off their woes. The mid-1920s to early '30s also saw an increase in college humor magazines, a tasteless stew of the bawdy and puerile. The editorial and artistic quality of *Life* and *The Judge* had also sunk by this point, creating a void that allowed a new type of humor magazine to emerge. In 1925, Harold Ross, a former editor of *The Judge*, founded the *New Yorker*, a mix of urbane writing, virtuosic fiction, witty "gag" cartoons, and from time to time enjoyable caricatures by some of the best. "Ross set a new course in the field of humorous publications," writes humorist Alexander King. "He discovered the unique talents of [E. B.] White, [James] Thurber, and the early Peter Arno. Unlike other magazines, the prose of the *New Yorker* became significant despite the excellence of the pictorial material, and although Ross aimed definitely at class circulation, he created a popular success." The sophisticated character of the *New Yorker*, nurtured in the 1920s and 1930s, survives to a great extent today with an entirely new cast of artists and writers. The other leading humor magazine of that age was *Ballyhoo*, founded in 1931, which by 1933 boasted the largest circulation of any American humor magazine at the time—1.7 million. Its content was almost exclusively the silly and savage parody of advertisements. Every issue skewered these tools of American capitalism, to the delight of Depression-weary Americans.

Other humor publications born in late 1920s and '30s that employed cartoon and caricature made only brief appearances, in part because advertisers did not find humor magazines a suitable vehicle for their wares. *Ringmaster*, founded in 1930, not only failed to develop artists good enough to earn a healthy following, but could not attract any advertising. But *Americana*, founded in 1932 and edited by Alexander King, e.e. cummings, and Al Hirschfeld (before he became the *New York Times*'s theatrical caricaturist), was published on such a small production budget that it did not need advertising to stay afloat. It proved to be a safe haven for satirists, like George Grosz, who fled Nazi oppression. But its humor was quite crude when compared to the well-bred journals. "It has frequently shrieked when a whisper would have been adequate and is often raucous beyond good taste," wrote King at the time. "But its policy, that many things are evil and all things are funny, has relevance—and never more than today."

By World War II, portrait caricature was used for propaganda purposes by both sides—Hitler, Mussolini, Tojo, Churchill, Stalin, and FDR each lent themselves well to facial distortion. But with few exceptions, the art of caricature on both sides of the Atlantic fell far below the standard established by the previous maestros. After the war, as free presses began running again, caricature began a slow rise back to prominence. But it was not until the early 1950s, as anti-Communist hysteria infected the United States, that political caricature began to make something of a comeback, notably in the hands of editorial cartoonist Herblock, who used it as a weapon in the fight against Senator Joseph McCarthy. Even this work, however, was only a herald for the full-fledged resurgence that would take place in the 1960s, when portrait caricature enjoyed a renaissance. The next chapter explores the masters of this golden age.

PAOLO GARRETTO
David Lloyd George
The Graphic, 1927

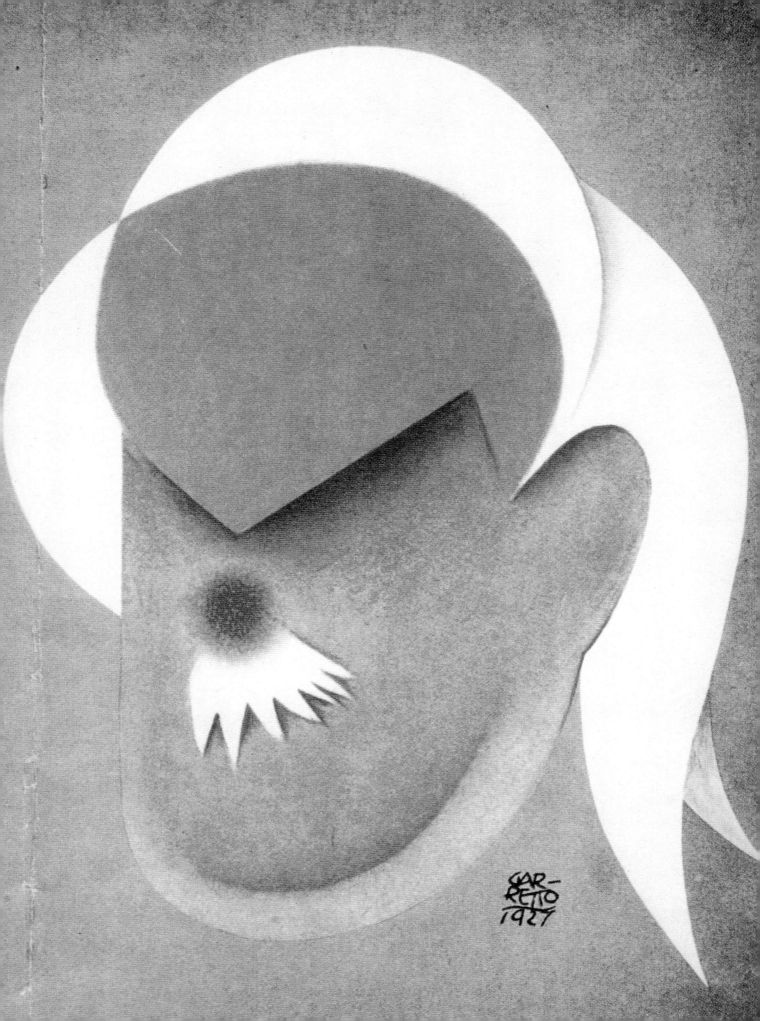

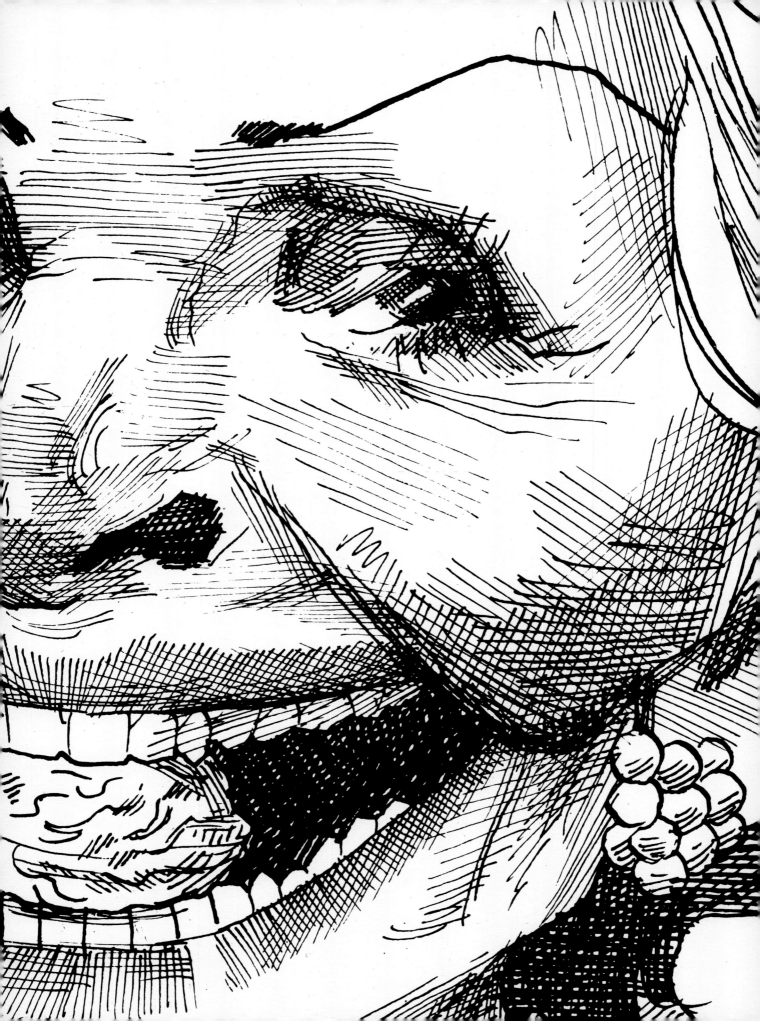

MASTERS OF THE RENAISSANCE

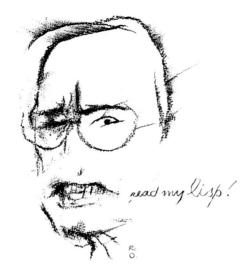

read my lisp!

ROBERT OSBORN
George Bush
Unpublished, 1991

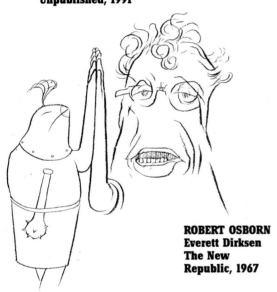

ROBERT OSBORN
Everett Dirksen
The New
Republic, 1967

ROBERT OSBORN
Lyndon Johnson
The New
Republic, 1967

I decide!

Commander

Portrait caricature lost its charge after World War II, in part because many of the veteran artists' batteries had worn down. Having spent the Nazi years in America, George Grosz lost the anger that informed his Weimar-era caricatures. Without the Axis leaders to ridicule, Arthur Szyk turned from biting caricature to benign book illustration. After returning to East Germany, John Heartfield became a devoted member of the Communist party. Miguel Covarrubias turned his attention from distorted anatomy to South Seas anthropology. And Paolo Garretto, repatriated to Italy in 1941 and interned in Yugoslavia during the war, drew mild editorial cartoons for European newspapers.

Moreover, many of the publications that once encouraged these and other artists had now folded or given up on caricature. Realistic illustration, which had always been the visual mainstay of most American magazines, became aggressively romantic and sentimental; in addition, some magazines turned almost exclusively to photography. Despite some attempts at acerbity, many postwar cartoonists veered towards the lighter side of life.

After four years of bitter struggle through the war, Americans, like the rest of the world, deserved a long hiatus from conflict. In fact, the brief intermission between the hot and cold wars was reflected in the often benign, business-as-usual content of the most mainstream national magazines, which probably contributed to a general malaise in illustration and a paucity of biting caricature. Yet when peace was shattered with the flare-up of historical animosities between former Eastern and Western allies, the postwar struggle for power forced the more critical cartoonists and caricaturists to reevaluate their roles as commentators, if not activists.

In the late 1940s and early 1950s, however, insipid red-baiting in America made being a political and social critic a treacherous profession. Anyone harboring, to say nothing of publicizing, "radical" views could at any time be subpoenaed before the House Un-American Activities Committee (HUAC), where rules of law were ignored in favor of stern witch-hunting measures. The mass media, supposedly the country's first defense in the protection of liberty, was curiously the weakest link in the free-expression chain, succumbing to outside pressures to rid its own ranks of communists and their sympathizers. Many publications, fearing governmental harassment, refused to publish cartoons and caricatures critical of American policies abroad and the anticommunist movement at home, but had no qualms about running anticommunist graphic statements that usually included heavy-handed caricatures of Stalin and other Soviet leaders. Some artists, finding they could not get their critical work published, were forced to settle for benign illustration assignments just in order to make a living.

ROBERT OSBORN
Joseph McCarthy
The New Republic,
1952

Despite these developments, some mainstream and opposition publications weathered the storm land actually published a fair number of cartoons criticizing HUAC and Senator Joseph McCarthy, whose televised investigation of alleged communists in government had become a cruel spectator sport. Some of the more courageous cartoonists for the mainstream press attempted to sway public opinion by answering the barrages of ludicrous anticommunist propaganda with equally ridiculous caricatures of the red-baiters.

Three cartoonists stood above the crowd for expressing their convictions: Walt Kelly, Herblock, and Robert Osborn. Kelly, the creator of "Pogo," a comic strip that has outlived him, was a remarkable draftsman and storyteller, as well as a powerful satirist. During the witch-hunting era, his introduction of swindler Seminole Sam's cousin, Simple J. Malarkey, into "Pogo" was a transparent attack on Senator McCarthy. Few comic strip artists went as far to help pry open the public's eyes to see this dangerous demagogue.

Herblock, a syndicated editorial cartoonist who followed the American tradition of labelling and captioning, also hounded McCarthy and other political bêtes noires with biting characterizations and caricatures. Although his drawing was only adequate—in fact, much less virtuosic than the work of previous masters of the litho-crayon—he had an uncanny ability to extrapolate a character trait into an enduring icon. His McCarthy caricatures' exaggeration of an innocent five o'clock shadow was enough to crystalize the image of an evil buffoon. But Herblock's most unforgettable caricature, as indelible as any cartoon symbol invented over the past century, was his atomic bomb depiction—the black conical shell, topped with the helmet of Mars, the war god, with its etched-in face that was coincidentally the spitting image of McCarthy, was a brilliant way to kill two birds with one stroke. Its graphic power was equal to that of a mushroom cloud, and it endures as a frightening reminder of the specter of nuclear horror.

ROBERT OSBORN: HUMAN NATURE EXPOSED

Robert Osborn, like Kelly and Herblock, did not use portrait caricature exclusively. But unlike the others, Osborn was the first of the postwar cartoonists to imbue cartoon, caricature, and illustration with raw expression—a blend of abstract and representational form. This single contribution and its influence on others is why Osborn merits such special attention here. Of course, the Rumanian-born Saul Steinberg was beginning to strut his wonderful sense of the surreal around this same time, but one has come to expect stridency from the East Europeans; Osborn was a homegrown American, born in Oshkosh, Wisconsin, and educated at Yale. His vision of America was that of a native son, and he saw American political problems without the innocence of a newcomer. He became the undisputed father of contemporary graphic commentary, redefining the cartoon by stretching it to its abstract limits, and at the same time giving new meaning to its timeworn symbols. As a regular contributor to the *New Republic* magazine, Osborn alternated between stinging social and biting political commentaries, some of these images pushed portrait caricature towards new directions.

By the end of World War II, Osborn had made over 40,000 drawings for United States Navy aviator training manuals. Eight months after the bombing of Hiroshima, which effectively ended the war, he published *War Is No Damn Good!* (Doubleday, 1946), a collection of single-page drawings with terse captions that was the first antiwar book of the nuclear age. Almost 38 years later, he completed a powerful series of drawings and lithographic prints that was published as *Osborn on Conflict* (University of Connecticut, 1984), an acerbic visual critique of mankind's ultimate folly.

It is not hard to rationalize the apparent incongruity of Osborn's early training manual work and his later efforts. While he is a vociferous critic of war, he is also a committed democrat. His progressive principles are rooted deep in the soil of his Wisconsin upbringing, and in 1938 their limits were tested during a brief stay in Austria, where he was tutoring two young Austrian girls in a small town near the German border. There he witnessed an unforgettable scene: "My students took me to a Hitler rally," he later recalled in an interview. "The large stadium was draped with huge swastika banners; the crowd was packed like sardines; and as the frightful sound of bugles was heard announcing the arrival of the Führer, the audience flew into an orgiastic frenzy....I was sickened and convinced that before us was a demon. At that moment, I was determined to go to war if that was the only way to rid the world of this evil."

The Spanish Civil War confirmed Osborn's belief that fascism would destroy art and culture. Like many other Americans, he was pleased when Spain elected a republican government to replace its longstanding monarchy and was outraged when the ousted oligarchy waged war against its own to regain power. He volunteered to fight, but was told by members of the republican cause that he could be of greater use by helping the war effort at home. A few years later, when America entered World War II, Osborn enlisted in the Navy, determined to become an aviator. Instead he was assigned to an information unit headed by photojournalist Edward Steichen, where he mastered the art of speed drawing for training manuals. For this work, Osborn was forced by necessity to render scores of pictures showing all kinds of potential aircraft disasters in a single sitting. "I would spend hours with pilots and mechanics making shorthand drawings of every error, problem, complaint, and other bits of useful information they would tell me about combat flying," he later related. He created a comic character named Dilbert, whose flubs and near-fatal pratfalls were object lessons for the young flyers. The humor, however, was deadly serious. He was, as he put it, "a teacher, and my curriculum was designed to keep the men alive."

This wartime work built up Osborn's confidence in his medium and helped him develop his emblematic calligraphy and swift, expressionist line. Most importantly, however, he acquired the rare ability to teach through art. Viewed in this context, the only difference between the wartime manuals he produced and his postwar *War Is No Damn Good!* lies in the circumstances in which they were made—both were lessons in survival, for in *War Is No Damn Good!*, Osborn followed in the tradition of the great artist-commentators like Callot, Goya, Daumier, Grosz, and Masereel, who recorded and commented on the

ROBERT OSBORN
Richard Nixon
Unpublished, 1973

AL HIRSCHFELD
Judy Garland
The New York
Times, 1969*

AL HIRSCHFELD
Faye Dunaway and
Kirk Douglas in "The
Arrangement"
The New York
Times, 1969*

unspeakable battlefield horrors of their ages. He cautioned—eloquently, stridently—against further war, since he saw the birth of a terrifying specter: the atomic bomb. The final image in *War Is No Damn Good!* is a caricature of an atomic blast, with the mushroom cloud shaped like a skull. This simple picture was the first critical icon of the nuclear age.

After World War II, Osborn became one of the most influential and prolific graphic satirists of the 1950s and '60s. In portrait caricatures he attacked McCarthy, Richard Nixon, and Lyndon Johnson. He worked for a wide range of important American magazines, including the *New Republic*, for which he provided a diet of cartoons and caricatures that needled

proponents of the America-first campaigns and the red scare, and *Life*, for which he made satires on such social issues as alcoholism and greed. But war recurred in Osborn's art as much as it did in life. During the Vietnam War, he was vengefully prolific, continuing to criticize the government's folly even after the peace was signed.

Osborn's indignation does not come out only in the drawing; the graffitilike scrawl in many of his pictures adds bile to the image. In a typical Osbornian turn of a phrase, he captioned a picture of President Gerald Ford (a "thug shot," he calls it) *That slow custard brain.* Even as he entered his 70s, he had lost none of his youthful indignation. The arms buildup orchestrated by President Ronald Reagan spurred Osborn to begin drawing images of protest for what would become his opus: *Osborn on Conflict.* Many of the pictures were resurrected pieces from earlier in his career, but the old icons were imbued with new expressions of anger—new symbols emerged, and an overall intelligence took over. In his drawings of primeval beasts, Osborn saw the beginning of human conflict; in those of Roman gladiators, he saw the basis for contemporary military regalia; in a skeleton dressed as a bullfighter, he described all violent sports and, by extension, the psychosis of war.

"I have a certain knack so that I can transpose my feelings into pictures," he says about his ability to touch universal chords about conflict. While the dissolution of the Soviet Union may have lessened the fear of nuclear war, Osborn's images are reminders that war, large or small, is hell. "In my lifetime," he continues, "65 million soldiers have been killed. Wars have just gone on, one after another, each one getting worse and worse." Osborn's later work focuses on war fever—not the erotic frenzy ignited by governments and fanned by false patriots, but the disease that is ever-present, yet dormant, in most of us.

AL HIRSCHFELD:
THEATRICAL CARICATURE'S LAST MASTER

Theatrical caricaturists made icons out of legends. Sometimes the most memorable pose an actor took was that imposed on him or her by an artist. In the 1920s and '30s, scores of newspapers and magazines throughout the country employed staff or freelance theatrical caricaturists. The public loved them, in part because they enjoyed the game of recognition these images provided, and because during the Depression, Americans wanted to see their stars in every pose, through any telescope. Moreover, even the most vain thespians were not insulted by this decidedly distortion-oriented art.

Despite the diversity of styles among the various theatrical caricaturists, certain formal conventions developed. The linear simplicity of Al Freuh, for example, was copied by many; the Moderne accoutrements of Paolo Garretto defined an age; the subtle distortion of William Auerbach-Levy became a standard. Out of this period came one extraordinary artist whose uniquely timeless style remains the quintessence of theatrical caricature today, over six decades after he began attending Broadway openings. He persevered through theatrical caricature's nosedive in the 1960s—a result of the decline of newspapers, the shift from Broadway to Hollywood, and the emphasis on art photography of the stars—and is as acute as ever. His signature reads *Hirschfeld.*

AL HIRSCHFELD
J. Edgar Hoover
The New York
Times, 1971*

Al Hirschfeld is more than a survivor from the golden era; Hirschfeld *is* the theater. Since 1925, he has used pen and ink to document America's plays and players for the drama section of the *New York Times*, and he can still be found at many Broadway premieres in a first-row aisle seat, making feverish sketches in the dark. He is the last of the Broadway caricaturists, and the odds are that no one will be able to fill his shoes in the future.

In the 1940s, New York City had more morning, afternoon, and evening newspapers than could fit on a newsstand at any one time; now there are only four. Similarly, the city once had more theatrical caricaturists than these many newspapers could absorb; now there is only one, and he is the master. Those who have attempted to cover the same beat have lacked the panache of this leading practitioner. As the newspapers and magazines that regularly published caricature have folded or merged, only the *Times* has maintained its commitment to the tradition of this form, thereby preserving an outlet for Hirschfeld's engaging work.

"I never wanted to be a cartoonist," Hirschfeld says. "Actually, I started out as a sculptor and then a painter. I don't consider myself a cartoonist, either. You see, a cartoon is something that has a literal idea—a point of view. I've done them, but as the years went on I just worried about line and form and space." For Hirschfeld, the distinction between the cartoon and caricature is profound. "A cartoon doesn't depend on the quality of the drawing so much as on the idea. If it's a good idea, anyone can do it. But a caricature has another quality. The word 'abstract,' I suppose, is the only one I can use. Are Picasso, Lautrec, and Hokusai caricaturists, graphic artists, or painters? They were all caricaturists, in my view."

Hirschfeld was born in 1903 in St. Louis. After a long sojourn in Paris during the early 1920s, he began his career as a journalist, contributing political cartoons to left-wing periodicals, including *The New Masses*, a communist journal of art and politics. In 1926 he was offered the chance to replace Caesar, the last political cartoonist for the *New York Times*, but declined because the constraints of the form worried him: "For me, doing political cartoons was a great responsibility to the reader. You're influencing a lot of people, particularly young people. And unless you really believe in what you are saying, be careful." Though he had never joined any political party, he was an ardent supporter of labor unions and fervent enemy of fascism, and was not afraid to make his sentiments public. Unlike some of his artist colleagues who used pseudonyms to circumvent the reach of the congressional committees, Hirschfeld proudly signed his name to all his work. His disillusionment with politics came when one of his drawings—a caricature of Father Coughlin, the Depression-era America-first firebrand—was censored by the editors of *The New Masses*, who, despite their antipathy toward Coughlin's racist principles, feared that Hirschfeld's drawings would be offensive to the Catholic unions that the publication was courting.

For Hirschfeld, the hypocrisy was intolerable. "I realized that to do political things, you have to be able to switch with the times," he says. "You can be pro-union one day and anti-union the next. I'm no good at that....I'd much rather have the villains and heroes made by the playwright. That's his worry, not mine. My worry is to do a decent drawing, and interpret what the playwright intends to say."

In 1927, Hirschfeld spent a year in Moscow, reporting on the Soviet theater. He found that a decade after the Bolshevik revolution, there was still an air of excitement, albeit short-lived, on the streets and stage. Under the auspices of Anatoly Lunacharsky, who was the architect of cultural education and leading advocate of Russian avant-garde art, he drew interpretations of the productions by Meyerhold and others, which were printed in the Russian newspaper *Izvestia* and sent back for use in the *New York Herald Tribune*. He also wrote and illustrated a book on Soviet theater, but the manuscript and art were lost by the American publisher, Boni and Liveright, and never found.

Hirschfeld cannot pinpoint when his fluid, linear style developed—probably sometime in the late 1920s or early 1930s—but he knows his style was definitely a response to the constraints of the media. "I discovered that the safest way to reproduce on the toilet paper that newspapers are printed on—which they haven't improved since the process was invented—was to stick with pure line," he explains. "I kept eliminating and eliminating, and getting down to the bare essentials. I still do, in a way." In so doing, his caricatures become ever more distinctive, owing to the elegant complexity of his line.

While plying his craft as a caricaturist for many New York newspapers during the early 1930s, Hirschfeld co-edited with Alexander King a satirical journal called *Americana*, which included contributions by Nathaniel West, e.e. cummings, George Grosz and S. J. Perelman. In 1946, he collaborated with Perelman on a musical, called *Sweet Bye and Bye*, which had lyrics by Ogden Nash, music by Vernon Duke, and sets by Boris Aronson—a wonderful combination that nonetheless resulted in a forgettable flop. Shortly after this Perelman and Hirschfeld had lunch with Ted Patrick, the editor of *Holiday* magazine, who suggested that they travel around the world together, recording their experiences in picture and word. The expedition lasted two months, and the resulting *Westward Ha!* became a runaway bestseller in 1948.

Hirschfeld drew for most of the major American magazines, including *Life*, the *Saturday Evening Post*, the *American Mercury*, *Collier's*, and *TV Guide*. His long-running relationship with the *New York Times* began in the late 1930s, when the Sunday editor, Lester Markel, who was annoyed that Hirschfeld appeared elsewhere with such frequency, offered him a job. As Hirschfeld recalls it, Markel was concerned that the *Times* was beginning to look like all the other newspapers, and presented him with an exclusive deal with the paper, which the artist readily accepted.

Regarding his original approach (made even more personal by his ritualistic multiple camouflaging of the name of his daughter, Nina, within his drawings, with the number of *Nina*s in a given piece indicated by a numeral next to his signature), Hirschfeld says, "I try to communicate to the reader pretty much what the play is about, if it's possible. If not, just some kind of witty juxtaposition of lines in itself is reason enough for the drawing." But he now admits that in the early days, "I don't know why the *Times* ever printed my drawings. When I look back, it was pretty daring, since it wasn't in their spirit at all."

AL HIRSCHFELD
Jimmy Carter,
Music Man
The New York
Times, 1977*

*© Al Hirschfeld. Drawing reproduced by special arrangement with Hirschfeld's exclusive representative, The Margo Feiden Galleries Ltd., New York.

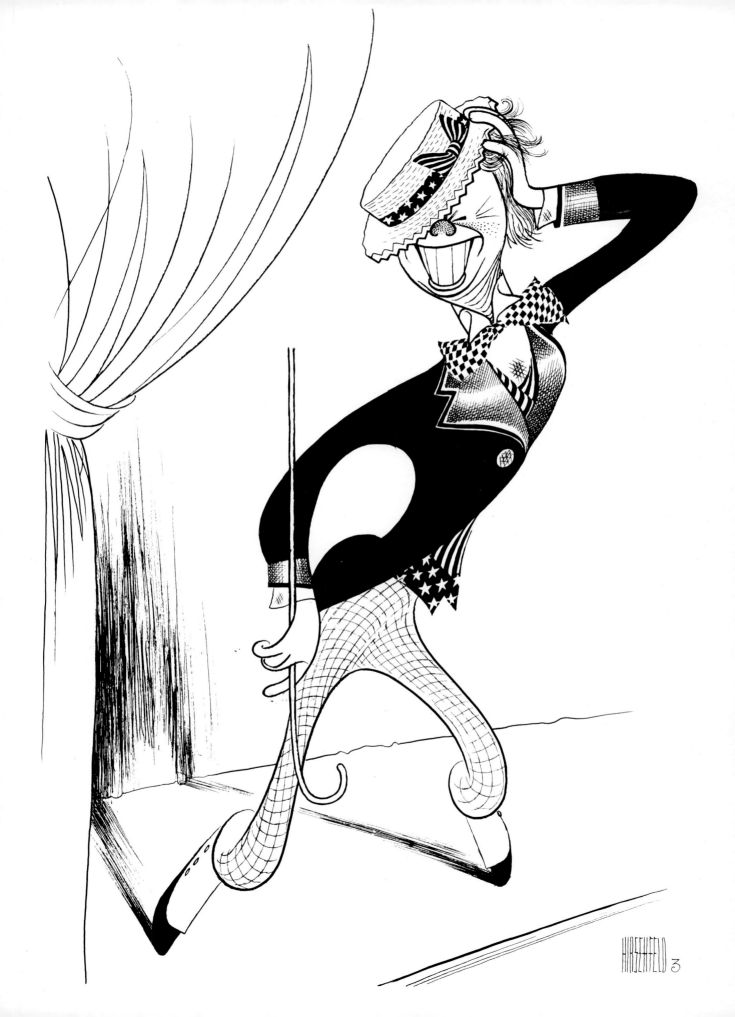

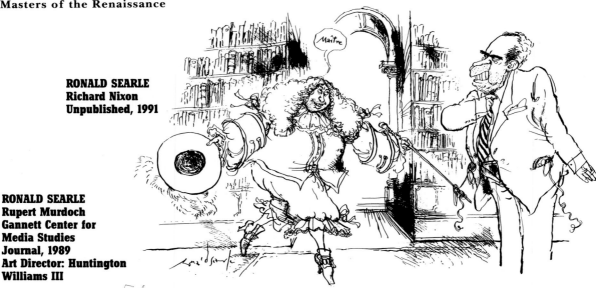

RONALD SEARLE
Richard Nixon
Unpublished, 1991

RONALD SEARLE
Rupert Murdoch
Gannett Center for
Media Studies
Journal, 1989
Art Director: Huntington
Williams III

Half a century later, "apparently it's been accepted, and it's almost become conventional by now." This, of course, is an understatement. Hirschfeld's portrait caricatures are so indelible that one cannot even think of Broadway without picturing his curvilinear magic.

RONALD SEARLE: A COMEDY OF MANNERS

The best cartoonists and caricaturists do not make gags just to satisfy some immediate need for gratification. The most astute see right through masks of convention and expose the myths of civility. In the eighteenth century, William Hogarth was the master of this art, drawing detailed vignettes with exquisite precision, yet keeping them just grotesque enough to suggest the underbellies of high and low society, and thereby critiquing the entire human comedy.

A few twentieth-century English cartoonists were heirs to Hogarth's legacy, but none has kept the torch so bright for so long as Ronald Searle. While a comparatively small percentage of his work is devoted to *portraits chargés*, his comedies of manners, like Hogarth's, are indeed caricatures of real people whose anonymous visages become universal faces.

Living under deplorable conditions for almost seven years as a prisoner of war would be enough to break any human being's heart and spirit. For Searle, who as a 19-year-old Cambridge University student and cartoonist was sent off with other British lads to fight the Japanese in 1939, incarceration in a hot Burmese military prison became a time of spiritual uplift. Under the noses of his often cruel captors, he maintained his morale by sketching his fellow prisoners and their guards, using found bits of charcoal on scraps of paper. He did not, however, draw the bitter caricatures one might expect of a tormented man; instead, his portraits were done with the objectivity of a journalist and the sensitivity of a saint. For Searle understood that behind his enemies' warrior masks were other human beings, caught in their own torment. In fact, a young Japanese officer later encouraged Searle's art by secretly giving him drawing materials and forbidding the guards from disturbing Searle's cache of drawings, which survived and were exhibited in Cambridge after the war. The exhibit marked the end of a solemn stage in Searle's art, and the beginning of the satiric one.

With the exception of a few assignments, such as covering the trial of the Nazi Adolf Eichmann for *Life*, Searle rarely drew as solemnly after his release. Humor became his primary weapon in the fight against the demons of his past and present. And as an admirer of George Grosz, Searle borrowed the German's expressive, agitational line but rejected his acerbity in favor of comedic gestures. Though interested in world politics, he favored more localized social commentary. And he used exposure to the masters of British art in such fields as caricature (Rowlandson), drawing (Blake), and painting (Turner) to synthesize his own style, which was popularized in the 1950s and '60s through his comic travelogues of Paris, Germany, and Russia, and his semi-autobiographical *The Rake's Progress* (Perpetua, 1955), about a struggling artist's evolutionary climb from a dank basement garret to fame and fortune as a social panderer.

The Rake's Progress and Searle's other books put him on the map as an illustrator and cartoonist. His caricatures in the American magazine *Holiday* earned him many followers. In 1961, he left England for provincial France, where he remains today. Although Searle is a consummate satirist on social issues, he

RONALD SEARLE
Lyndon Johnson
The Saturday Evening
Post, 1968

Saturday Evening Post · February 10, 1968

POST

35c

Underground traffic in
CANCER 'CURES'

New hit play by
ARTHUR MILLER

Secrets of
BECOMING A FASHION MODEL

How goes the campaign to
DUMP LBJ ?

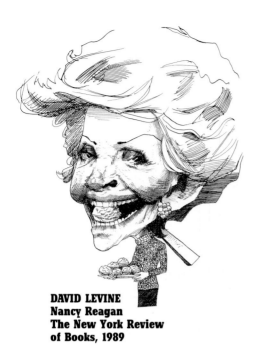

**DAVID LEVINE
Nancy Reagan
The New York Review
of Books, 1989**

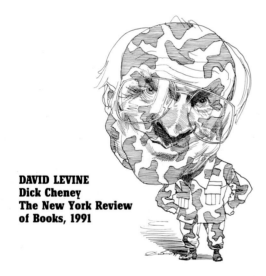

**DAVID LEVINE
Dick Cheney
The New York Review
of Books, 1991**

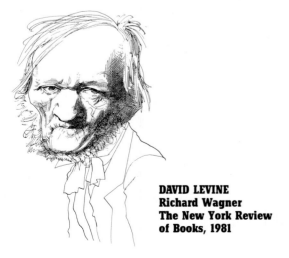

**DAVID LEVINE
Richard Wagner
The New York Review
of Books, 1981**

keeps as far away from the political fray as his conscience allows, choosing more accessibly humanist themes. However, he is nonetheless sanguine about the sorry state of the satiric arts, particularly the paucity of political savvy in contemporary caricature. "It is a wonderful period, you might say, of total nonentities as far as politics is concerned," he says. "There are practically no statesmen or true politicians. And owing to such a vacuum there is no strong opposition either....Apart from saying that much of the human condition today is disgraceful, what do you do? What most have done, regrettably, is play with the red spot on Gorbachev's head."

Searle recalls the 1989 French national election as exemplary of the frustrations that the contemporary satirist encounters: "Twenty-three percent of the people in this village voted for the fascists. Not because they are fascist in the strict sense, but because there is a lot of xenophobia and racism throughout Europe today....[Satirists and cartoonists] are hard-pressed to combat candidates like [right-wing French nationalist Jean-Marie] Le Pen, because he can be very articulate, and talk his way out of anything. This kind of personality is the bane of a satirist because the more he is satirized, the more seriously people take him." So rather than fighting the unwinnable battles, Searle opts for indirect confrontation.

Some artists are born for politics; others are born into profoundly political times. Sometimes these elements coincide to produce a master. Searle was born in 1920, during a critical period in world history. Yet his birthright, he insists, was simply to make humorous pictures, political or otherwise: "There was always the irresistible impulse to draw. I cannot remember wanting to be anything other than an artist, although I had no idea in which direction I should point." As he matured, the direction became clearer, his satire more accessible. By aiming at targets on the ground, so to speak, rather than those too high up, Searle hits his mark squarely most of the time. And in the process of imparting visual critiques about manners and mores, he gives his audience things to ponder, and some good laughs to boot.

MAKING THE WORLD SAFE FOR CARICATURE

Presidents John Kennedy and Lyndon Johnson opened a new frontier and a great society for caricature. With few exceptions, however, usually in opposition newspapers and magazines, Kennedy was not the object of insulting caricatural attack. Was he the first Teflon President? His remarkably handsome features—that distinctively toothy grin and youthful fluffy hair—would seem to have been readymade for the *portrait chargé*, but most depictions of him were reverentially flattering. During his three years in office, he was spared the barrage of negative caricatures that his successor, Johnson—also a readymade caricature—was forced to endure. Johnson was the flip side of Kennedy: His perfectly exaggerated features, including the bulbous ears, drooping nose, and baggy face, were excellent raw material. And he obligingly engaged in ridiculous behavior that any caricaturist could exploit with the barest of effort, like the time he lifted his shirt to show the press corps the scar from his recent abdominal surgery, or when he held up the ears of his pet beagle during another infamous photo opportunity.

**DAVID LEVINE
Lyndon Johnson
The New York Review
of Books, 1967**

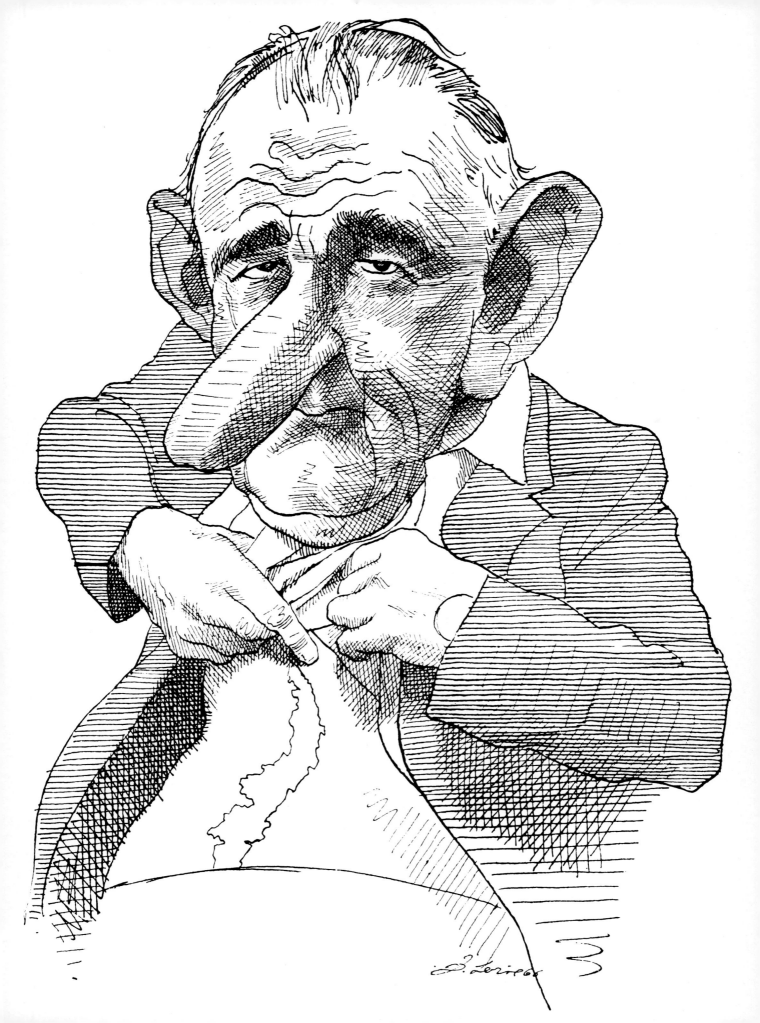

Johnson, however, was a tragic figure, the right President at the wrong time. If not for the Vietnam War, David Levine still might have drawn Johnson revealing his scar—it was, after all, a comic scene—but he would not have drawn the scar in the shape of Vietnam, literally branding Johnson with the affair that became his undoing. Johnson's vanity did not allow for dissent, and according to one of his biographers, Levine's caricatures really hurt the President's pride. And indeed, today it is the negative caricatures of him, preserved for posterity, that we remember, rather than the progressive domestic initiatives he championed as Senator and President.

Perhaps it came as some solace to Johnson that Richard Nixon became the most caricatured President in American history—no mean feat, given such worthy subjects as Abraham Lincoln and Theodore and Franklin Roosevelt in the country's past. The image of Nixon, perhaps the ultimate readymade caricature, was engraved in the public's mind by the most potent caricatures of the era. Edward Sorel's *Milhouse I* (an allusion to Shakespeare's tragic figure Richard III), David Levine's *Nixon Mutiny* (referring to Captain Queeg's trial in *The Caine Mutiny*), and Robert Osborn's depiction of Nixon in a straitjacket (playing on the President's own paranoia) each embody enough truth of the man's inner and outer character that they remain as memorable as Nixon's famous crying scene, where he said to the press "You won't have Nixon to kick around anymore." after losing the 1962 California gubernatorial election.

Nixon was not the only one to come under harsh cartoon scrutiny during his years as President. Spiro Agnew, who was forced to resign the Vice Presidency under the cloud of a criminal investigation dating back to his years as Governor of Maryland, was a prime target for all those "eastern-establishment" caricaturists, as he called them. During the Watergate affair, Nixon's henchmen became fair game, too. Since Nixon's closest aides, H. R. Haldeman an John Ehrlichman, had German surnames, some caricaturists appropriated Nazi stereotypes in portraying them, including Edward Sorel, who depicted them taking part in a Bavarian beer-hall gathering. Also notable was Brad Holland's illustration for the *New York Times* op-ed page, showing Nixon precariously riding pig-gyback on the shoulders of Haldeman, Ehrlichman, and other members of his inner circle, as their collective totem pole, representing the chain of command, begins to fall. Holland's drawing is a good example of subtle caricature in which the faces are referred to but not distorted. Conversely, Ralph Steadman's eyewitness coverage of the Congressional Watergate hearings for *Rolling Stone* employed radically distorted representation, not so much to ridicule as to express the artist-journalist's sense of indignation and despair during the proceedings.

Thanks to a convergence of explosive political and social machinations, a receptive marketplace, and a battery of excellent artists, the ten years between the mid-1960s and the mid-1970s represented a renaissance of caricature, during which the genre almost equalled the heights reached during the nineteenth century. Caricaturists on both sides of the Atlantic joined the fray, and even the relative malaise in caricature from the mid-1970s to the mid-1980s did not stem these artists' outpouring of critical commentary. The most noteworthy were David Levine, whose drawings were the most elegant; Edward Sorel, the most angry; Ralph Steadman, the most expressive; Robert Grossman, the most entertaining; and Roger Law and Peter Fluck, who collaborate under the name Spitting Image, the most inventive.

DAVID LEVINE: THE FACE AS NATURE ORIGINALLY MADE IT

No other postwar caricaturist has made as many molehills into mountains as David Levine has done since he began making *portraits chargés* in 1958. In doing this, however, Levine does not just make something out of nothing—he has a genius for pinpointing a benign physical feature and metamorphosing it into a fatal character flaw. A Levine cartoon reveals the naked truth about a character or situation. Levine thereby allows his audience to see his subjects as they truly are, resulting in visual breakthroughs that rival the impact of that awful moment each morning when we wake up and see ourselves in the savage bathroom mirror, looking as nature had originally intended, without the buffer of cosmetics and grooming. Because Levine eliminates the artifice, his subjects do not always become lifelike, but they are always vulnerable. Indeed, some are so highly perched that nothing could bring them down to Earth but the kind of demystification that Levine so assuredly practices.

Levine achieves this through a kind of exorcism, in which he uses his pen and ink to draw demons from their hiding places into the open. They may try to hide, but rarely is a politician skilled enough to crawl back into his skin after Levine isolates and exposes that unforgettable physical trait. But Levine's skill does not rest entirely on metaphysical proficiency. First and foremost, he is a cartoonist—an artist with ideas, a satirist with wit. For Levine, the distorted portrait must stimulate the intellect as it entertains the eye (and, perhaps, make the viewer act). At its most effective, it must employ such an inextricable marriage of sense and nonsense that it captures the essence of both the individual and the event or policy that the individual represents.

Levine relies heavily on convention, yet transcends it in unconventional ways: His signature big head–little body motif is a reprise of a common graphic

DAVID LEVINE
George Bush
The New York Review
of Books, 1989

DAVID LEVINE
Richard Nixon
The New York Review
of Books, 1973

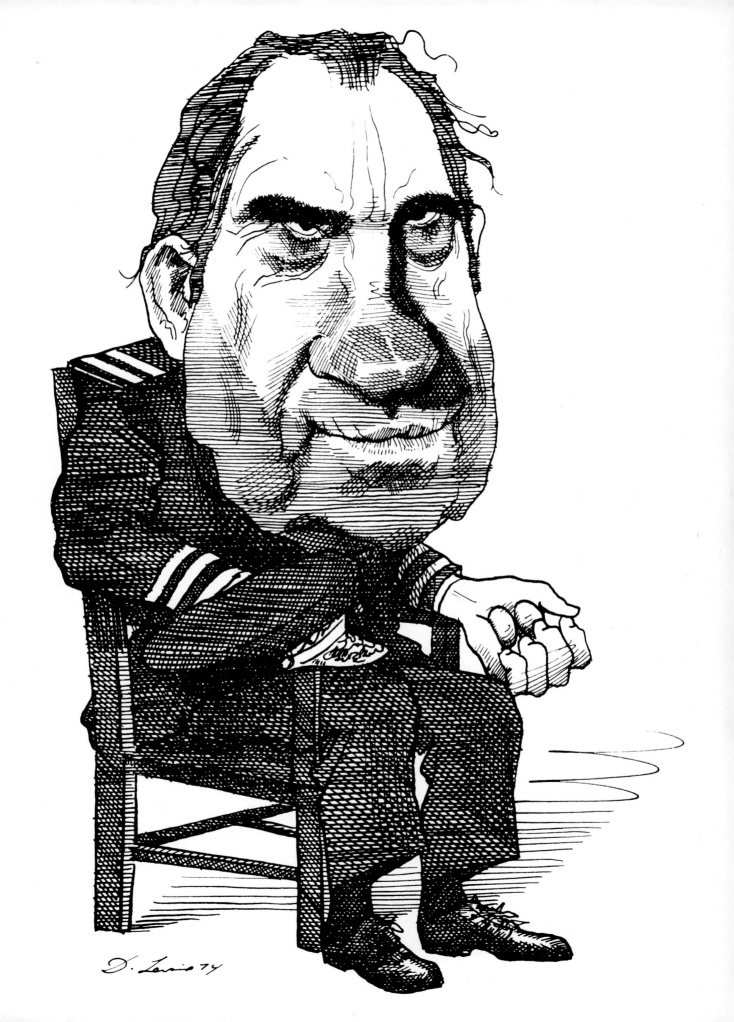

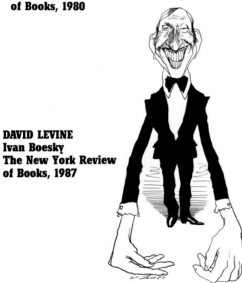

DAVID LEVINE
The Duke and
Duchess of Windsor
The New York Review
of Books, 1980

DAVID LEVINE
Ivan Boesky
The New York Review
of Books, 1987

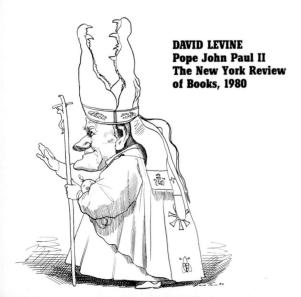

DAVID LEVINE
Pope John Paul II
The New York Review
of Books, 1980

conceit from the nineteenth century, for example. Yet his work is neither nostalgic nor clichéd, and not all his caricatures conform to this formula—sometimes a small head on a big body captures a venal personality better than a large head, and showing tiny features on a large head with no body at all is sometimes called for.

Levine rejects convoluted metaphors in favor of an economical symbology. One of his many caricatures of Lyndon Johnson, for example, shows the President crying crocodile tears, a timeworn reference that nonetheless captured Johnson's capacity for melodrama quite nicely. And his caricature of then-candidate Jimmy Carter with halos falling around his head was an efficient comment on the Carter's fall from grace in the wake of his candid *Playboy* interview. In these pieces, and throughout his work, Levine's graphic eloquence is rooted in a complete understanding of the average political beast.

Levine's political interest came from his parents, who in the 1930s were fervent Communists. His first real exposure to art, however, came from the Sunday comics, which he had to read surreptitiously—his parents had banned comics from the house, believing them to be part of the "fascist press." He picked up other cartoon influences from left-wing pamphlets and publications around the house, including portraits and polemical drawings by Hugo Gellert and Boardman Robinson. But the most influential outlet for art was the comic book, particularly Will Eisner's *The Spirit.*

After high school, Levine went on to the Tyler School of Fine Arts in Philadelphia, where he was introduced to the Realist tradition. In fact, he became a very orthodox realist. "At that time, I was very critical of Daumier prints," he recalls. "I thought they were absolutely horrible, weird little things, and his paintings were terribly unfinished and very experimental." Levine began to rid himself of the constraints of orthodoxy when he realized that Daumier's realism "was in the subject and the feeling, more than the actual execution." He was further informed by the work of The Eight and The Ash Can School, two groups of painter-journalists whose example made Levine realize that an artist could work for the gallery and for the press simultaneously. Levine still follows this two-tiered path today, making portrait caricatures for publication and watercolors for exhibition.

His earliest assignments in the late 1940s were for the *Gasoline Retailer*, a small trade magazine, and the *Daily Worker*, a left-wing newspaper. His nineteenth-century impulse, which ultimately contributed to his signature style, came to him in the early 1950s, when he was involved with a failing Christmas card business. "We emulated the Dickensian look. And I started looking at Richard Doyle and Gustav Dore," he explains. Levine's first major work came in 1957, when he was commissioned by Clay Felker, then an editor at *Esquire*, to make witty, anecdotal illustrations for the magazine's front-of-the-book columns. "Every month I did about seven drawings," he says. "When I couldn't come up with an idea, I resorted to drawing a personality that had been famous in the field—as a writer, singer, whatever. And that led to the caricatures. I had never thought of caricature before." His method was born of necessity: Levine's allotted space was a mere 4-inch square, so to get a likeness and something funny, it was necessary to enlarge the head and condense the body. When he became a regular

DAVID LEVINE
George Bush
The New York Review
of Books, 1990

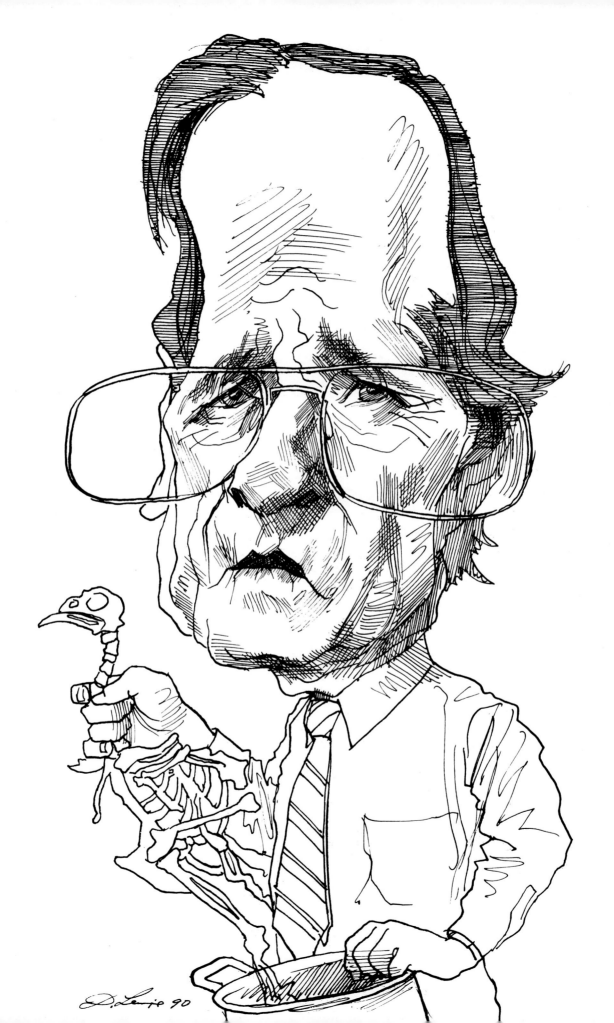

contributor to the *New York Review of Books* in 1963, "it grew into bigger space, but that convention just remained."

Levine had never directly covered politics in *Esquire*, but the *New York Review of Books* encouraged him to do both political and literary caricature (the latter of which Levine would singlehandedly revive). The *Review*'s editors allowed him to chart his own course with the political work, only rarely objecting to or suggesting revisions in Levine's sharp-edged barbs. The results have been beneficial for both artist and publication—most of Levine's strident and memorable Watergate- and Nixon-inspired caricature was originally published in the *Review*. At the nadir of the Nixon Presidency, some people bought the *Review* just to see, tear out, and save Levine's latest caricature.

Levine is the leading American contemporary caricaturist, so it is not surprising that his work has been a significant influence on other cartoonists. His signature style is often forged, resulting in imitations that Levine does not find so flattering. "I think that too often young cartoonists imitate the easy parts, the fun parts, which are the nose, eyes, and face, rather than taking a total look at drawing and style—how to handle hands, details, and other things that give it consistency."

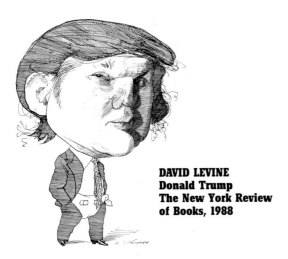

**DAVID LEVINE
Donald Trump
The New York Review
of Books, 1988**

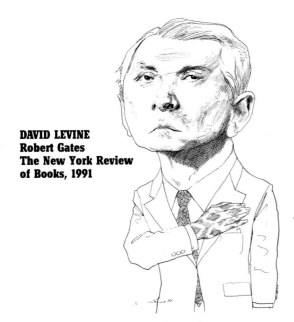

**DAVID LEVINE
Robert Gates
The New York Review
of Books, 1991**

Another of Levine's peeves is the cavalier attitude today's politicians have about caricature. Too many satiric artists are simply playing harmless games with the politicians, he believes, leading the subjects to accept caricature as celebration, rather than as critique. Levine himself has had one of his targets call to request a drawing to hang as a trophy. Some artists honor such requests, but Levine is unwilling to develop such a cozy relationship with his subjects. "It's just kissing ass," he says. For Levine, the adversarial relationship is too important to jeopardize, especially in the current political milieu. Yet despite his continued assaults on power, Levine questions the effectiveness of political caricature in really influencing policy. "I'm not saying give up, but there are periods when what we do you is like howling in the wind. The politicians generally have a very good sense of it. The artist needs some sense of it too."

EDWARD SOREL: THE ANGRY LINE

During the Vietnam and Nixon eras, Edward Sorel was one of the leading artists producing cartoons that revealed the idiocy and immorality of our haughtiest leaders. Sorel began cartooning in the late 1950s, in response to President Dwight Eisenhower's complacency about civil rights, the cold war, and nuclear proliferation, and later as a reaction to what he believed was John Kennedy's liberal fantasy, the New Frontier. His work achieved prominence when Lyndon Johnson's deleterious foreign policies left an increasing number of politically frustrated Americans in need of good critical rallying points.*

Sorel's mordant (sometimes black) comedies reminded his audience that dissent was possible and necessary. His nationally syndicated "Sorel's News Service," and later his weekly cartoons in New York's *Village Voice*, demystified and ridiculed those sanctimonious leaders of government and religion who once commanded blind loyalty, and whose faces had been left unscarred by more conservative cartoonists. The personally expressive drawings collected in *Making the World Safe for Hypocrisy* (Swallow Press, 1972) and *Superpen* (Knopf, 1978) are rooted in a nineteenth-century graphic language, but the ideas are fresh and vital.

The key to Sorel's potency is anger. It shows up in his expressive line and unmistakable calligraphy. The trick, he says, "is not to show your hand when you express your point of view. You can't be heavy-handed. It's got to be funny even to those people who might not otherwise agree with you." Although known for his biting *portraits chargés*, Sorel insists that he is a cartoonist, not exclusively a caricaturist: "Caricature doesn't interest me as a pure art form; it is a tool of communications. I only learned to do likenesses in order to depict specific people without writing names on their chests."

Sorel's work is informed by the nineteenth-century masters James Gillray and Thomas Nast. In "Sorel's Bestiary," a regular feature for *Ramparts* magazine in the late 1960s, he grafted the heads of luminaries onto the bodies of animals, much like early French caricaturists had done a century before. Sorel also

* Unfortunately, owing to permissions-related difficulties, we were unable to include any of Sorel's work in this volume. For a representative sampling, readers are encouraged to consult *Making the World Safe for Hypocrisy* (Swallow Press, 1972) and *Superpen* (Knopf, 1978).

RALPH STEADMAN
Cabinet of the Mind
The Observer, 1988

RALPH STEADMAN
Spiro Agnew and
Richard Nixon
Rolling Stone, 1973
Art Director:
Robert Kingsbury

fancies the elegance of Art Moderne and the vernacular of 1940s movie posters, two influences he has incorporated into parts of his work. He sometimes puts well-known personalities into imaginary movie roles, for example, to heighten the satiric message. If Sorel could live in the past, he might choose the 1930s, and to be working for *Vanity Fair*. He might even choose to be Covarrubias, from whom he has borrowed the "Impossible Interviews" technique for a regular feature in the *Atlantic Monthly*, called "First Encounters," an illustrated feature about real meetings of the most unlikely duos. For Sorel, however, quoting the past is not an end in itself, but rather a starting point from which original ideas spring forth.

Despite the righteousness exhibited in some of his work, Sorel denies being a teacher or moralist: "A political cartoonist is important because he is working out his own frustrations publicly," he says. "Most of us are not in control of our destiny, and are powerless politically. A humorist corrects this in comic fashion while opening the door for others to express themselves. The indignation I exhibit represents the rage of many people."

Although Sorel was influenced by David Levine, he admits he did not have the temperament for the kind of meticulous, mannered work turned out by his good friend. The velocity of Sorel's pen, and the sketchy renderings that result, are needed to achieve the requisite bite that characterizes his working style. Yet the sudden-death quality of pen and ink has certain inherent problems: "My artistic struggle has been with technique, not with caricature or ideas. I have never been able to redo a drawing by tracing over it without having it die."

Since he loathes routine, Sorel has been his own boss for over 30 years. But being a political animal over the long haul tires him out, and he speaks realistically about the effect of his cartoons: "You can't keep yelling without getting hoarse. It is frustrating to realize that the drawings done about El Salvador in 1988 are basically the same as those I did about the Dominican Republic 20 years before." Today's political corruption, hypocrisy, and paranoia, he says, are the same as yesteryear's. Hence he often leaves politics for nonpolitical diversions. Yet even his nonpolitical work is colored by the anger that makes Sorel who he is. "What upsets me even more than [corrupt government] is that life is not as pleasant as it was when I was young. This could be called nostalgia, but it is really anger at the devaluation of life. I'm as angry at not having real wood on my car dashboard, or at not having milk in real bottles, as I am about ITT being in South America."

RALPH STEADMAN: CHARACTER AND CARICATURE

There was a period during Ralph Steadman's career when he found the anticipation of drawing a politician almost like sitting down to eat a good meal. But in 1988, well over two decades after he first began ripping the guts out of his political prey, Steadman decided never again to caricature another living politician. In a manifesto he wrote for the Sunday magazine of London's *Observer*, entitled "The Cabinet of the Mind," he urged that other political cartoonists and caricaturists make the same pledge: "I have sworn darkly to avoid drawing real live politicians at all costs," he wrote, "and if all cartoonists did

RALPH STEADMAN
Richard Nixon
Rolling Stone, 1973
Art Director: Robert
Kingsbury

RALPH STEADMAN
Environment
Unpublished, 1990

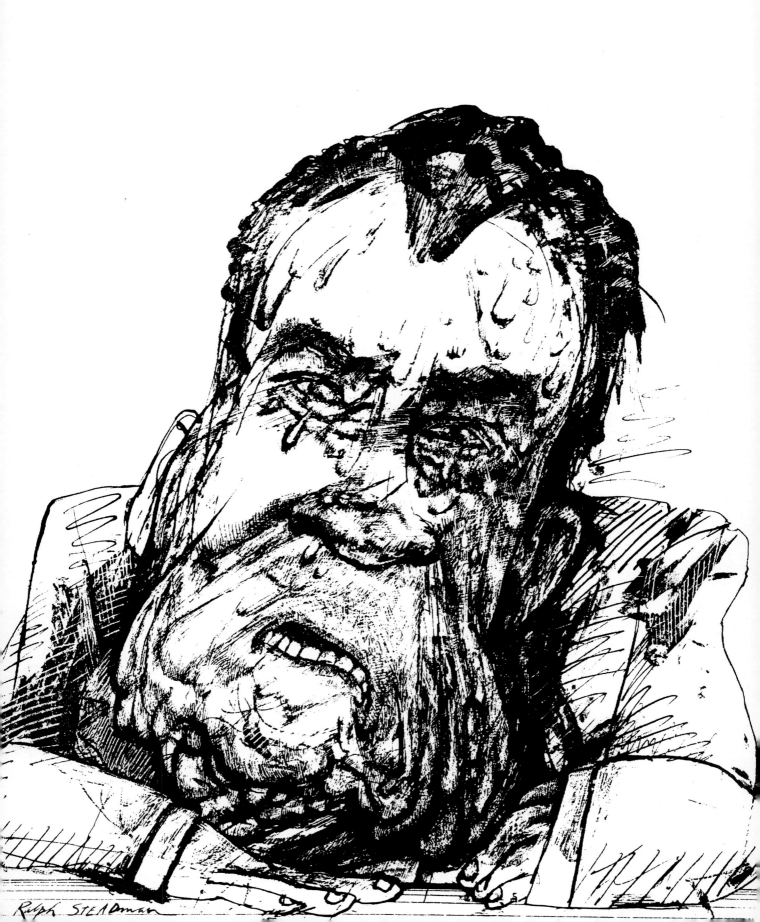

Ralph STEADman

**RALPH STEADMAN
Arnold
Schwarzenegger
Tempo, 1990**

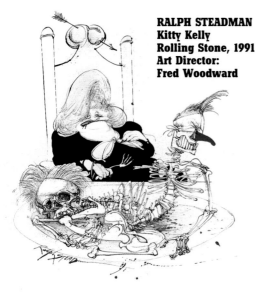

**RALPH STEADMAN
Kitty Kelly
Rolling Stone, 1991
Art Director:
Fred Woodward**

connected to both church and state) returned to factional disputes and corrupt behavior. This led him to become a cartoonist, and for many years his art was a good outlet for his outrage. In 1973, however, yet another awakening challenged even this. While covering the Senate Watergate hearings for *Rolling Stone*, he realized that the investigators and the investigated "were all sitting on the same branch as someone was sawing it off. Everybody, by association, was guilty, because they were all part of one huge institution. I realized then that there's nothing one can do without making revolution, and I preferred a quieter life than that. I couldn't be a real revolutionary—I'm a cartoonist."

For Steadman, the cartoon serves as a multifaceted release. "In a funny way, cartooning is a means of forgiving man's worst qualities, by exposing and laughing at them." Although cartooning is sometimes referred to as the "ungentlemanly art," it is certainly a more gentlemanly way of settling disputes than war or murder. Steadman admits that he actually felt like shooting Reagan before he drew him, but never after. The act of carving up his subject's face, distorting his body, or rendering him otherwise ridiculous defused his violent tendencies. Reagan was actually the last political leader Steadman hung in his rogues gallery—he'd grown tired of the game. His visual memoir, *The Scar Strangled Banner* (Simon and Schuster, 1988), is a "receptacle for all things I felt that I didn't want to do any more. After I did Reagan for the [umpteenth time], as a subject for my attention politics was bankrupt."

Steadman, who studied drawing from a correspondence course before attending art college for a few years in the late 1950s, is a draftsman par excellence. His work, although rooted in a comic idiom, has a German Expressionist charge. His images have become unmistakable since early in his career, when he gave up the gag cartoon conventions acquired when he was a cartoonist for *Punch*. Now each image is unique to the specific problem at hand. "I was told to find my own 'face' or style and stick with it, but that is like slaving at a job. I never thought of what I do as a job, nor do I see my assignments as empty space I have to fill. Too many artists find the right formula—like getting Nixon's face just the way they want it—and stick with it, which results in a more relaxed relationship with the subject; and that effectively ends the necessary conflict between the artist and them." Perpetuating the tried and true is just one of the conventional wisdoms that Steadman finds anathema. He rarely draws the same caricature twice—even when he hit on the perfect Gerald Ford (as a mechanical monster) or Ronald Reagan (as a vampire), he did not repeat them in subsequent images. This allows each image to be a new experience for artist and viewer alike.

Steadman's methodology is also rooted in a unique distinction between character and caricature: "You can read a face. And catching the likeness in that situation is better if the character is moving, because in that movement it is saying something. If you took the original drawing of that 'character' away and tried to redraw it, you wouldn't get it. On the other hand, caricature is then formalizing those observations into what would become the [charged portrait]. Without an idea behind it, it's just a likeness; with the character intertwined, it is [complete]."

that, even for one year, politicians as we know them would disappear from the face of the earth....By giving them the benefit of our attention and portraying them daily in the world's press, we are contributing mindlessly to their already inflated sense of self-importance. If we ignore them, I am certain that they will suffer withdrawal symptoms of such withering enormity, the effect on their egos can only be guessed at." Though the logic of Steadman's argument is impeccable, his plea fell on deaf ears, since caricaturing politicians is not just a critic's profession but the basis of a symbiotic relationship.

Early in his career, Steadman believed that cartoonists, like writers, could change the world for the better. This, he later realized, was a naïve belief that took shape during his boyhood in a small Welsh village, where he felt everyone pulled together, especially during World War II, and could be trusted to tell the truth. He had a rude awakening, however, when those halcyon days of wartime cooperation ended and the politicians (among others in power

**RALPH STEADMAN
Richard Nixon
Rolling Stone, 1973
Art Director:
Robert Kingsbury**

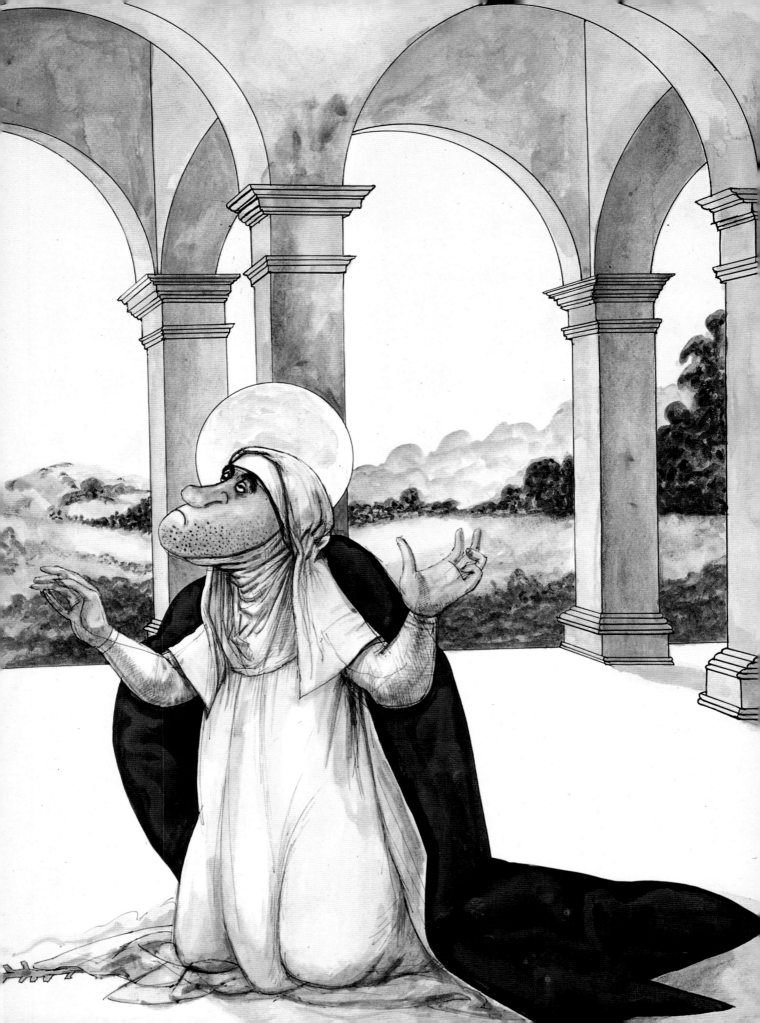

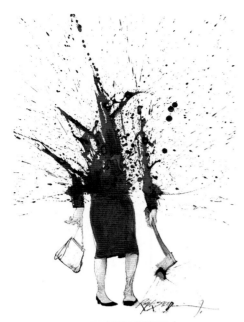

RALPH STEADMAN
Margaret Thatcher
Pan/Picador, 1991

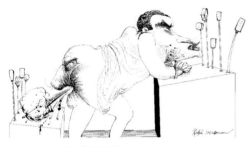

RALPH STEADMAN
Spiro Agnew and
Richard Nixon
Rolling Stone, 1972
Art Director:
Robert Kingsbury

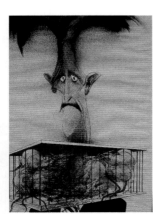

RALPH STEADMAN
George Orwell
Unpublished, 1984

For example, when Steadman covered the 1974 trial of newspaper heir Patty Hearst (who had been abducted by and in turn had fallen in with the Symbionese Liberation Army terrorist group) for *Rolling Stone*, he did not make ridiculous or savage caricature in the manner of his political drawings. Despite the grotesque visage he gave to Hearst, his response was consistent with his credo of analyzing each situation on its own merit. He saw Hearst as a pawn in a larger game. In fact, he had a vision of Hearst as Lewis Carroll's Alice, and depicted her growing larger and larger as the courtroom became smaller and smaller. "She looked pretty lonely and lost. And that was the feeling I tried to get over. I wasn't even particularly concerned that it looked exactly like her. But I did know it looked like her in spirit."

Drawing isn't the only weapon in Steadman's arsenal. His writing, which was once confined to appearing within his drawings as graffitilike statements scrawled obtrusively over his striking renderings, has expanded into the more conventional type. And in addition to his individual graphic commentaries and visual essays, Steadman has written and illustrated his own books—skewed biographies of Sigmund Freud, Leonardo da Vinci, and, most recently, God. This last subject is the subject of *The Big I Am* (Jonathan Cape, 1989), Steadman's ultimate book of politics—the politics of life. It is a brilliant interpretation of divinity that reconciles his concern for the existence of a super being and a super self. "In this book I wanted to point out that maybe God would admire someone who simply believed in himself and didn't find a need to believe in a God," he explains. *The Big I Am* uses the formalisms of cartoon and caricature, is imbued with wit and irony, and tells a story through a series of narrative and situational pictures. It even offer's an artist's conception of God. But is it caricature in the orthodox sense?

The answer is yes, for Steadman charges all his work with the same emotion that the pioneers of caricature—Carracci, Bernini, da Vinci—used to pierce the facade of gentility and hubris. All Steadman's images, even if not of real people, are character studies, explorations of hearts and minds, seen through the X-ray of caricature.

ROBERT GROSSMAN: UNDER THE SKIN

In his day, Paolo Garretto was a master of the airbrush, the artist's tool that so perfectly defined the Streamline Age and was used by so many artists during the 1920s and '30s. Although airbrushes were still in use after World War II, the airbrush style of illustration went out of fashion until sometime in the 1960s, when Robert Grossman's balloonlike caricatures suddenly began appearing in magazines. Grossman was not a newcomer to commercial art or social satire—as a kid, he worked in his father's signpainting shop and later contributed pen-and-ink comic strips to *Monocle*, an early-1960s satire magazine. For almost 30 years since, Grossman has entertained and informed, prophesied and polemicized, through cartoons, caricatures, and illustrations that bear his unmistakable imprimatur.

Grossman has lived on the outskirts of New York's Little Italy since the early 1970s, in a loft that might have been decorated by a toy manufacturer having a nervous breakdown. Amidst the artist's paraphernalia are scores of rubber dolls, plaster casts, and clay

RALPH STEADMAN
Ronald Reagan
New Statesman, 1984
Art Director:
Vicky Hutchings

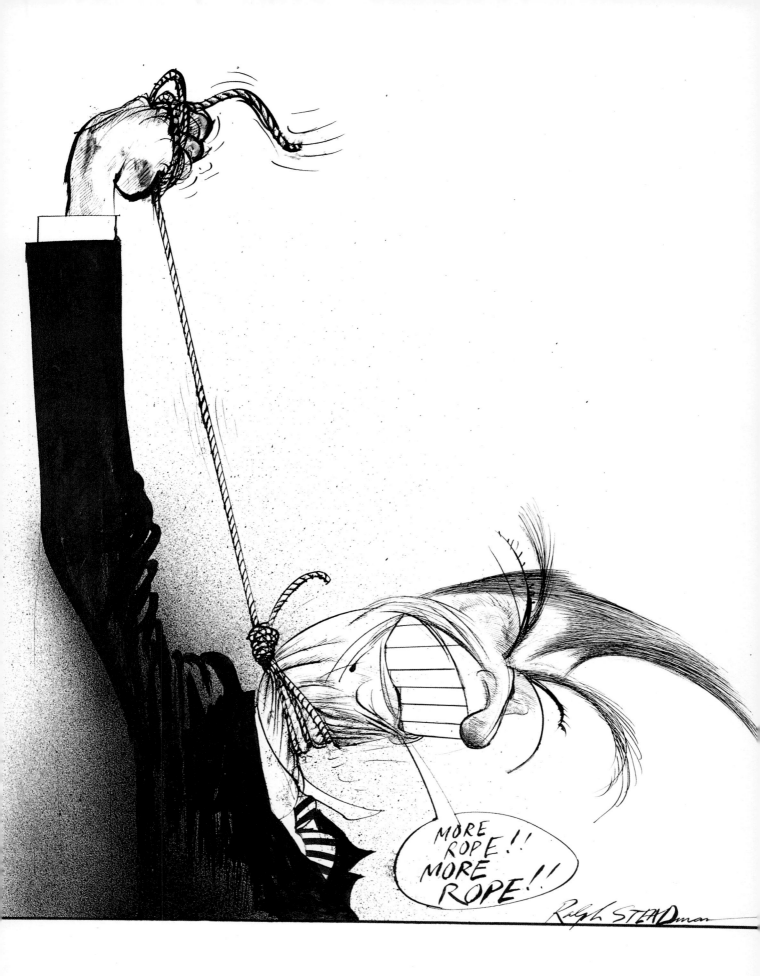

models of all sizes and shapes. This laboratory is where Grossman's comic visions are materialized. The dolls and models are the satirist's tools—the props for his unique and ambitious animated films. In addition to working in two-dimensional caricature, Grossman invented an early form of clay animation, a process of making clay models come to life on film. Since this technique is expensive, his animation is usually reserved for advertising clients, with the notable exception of his Academy Award–nominated *Georgia on My Mind*, a mild jab at President Jimmy Carter, represented by a peanut dancing and singing Ray Charles's rendition of that wonderful soul tune.

Grossman is fascinated with comic figures, absurd situations, and funny language, and is still inspired by the cartoons and comic strips of his youth. As a child in the early 1950s, he and his brothers painted large display advertisements in his father's signpainting shop, which offered an early introduction to commercial and popular culture. This was also where he made his first models, even before he could draw. "I began to understand that there was something called fine art and then there was everything else," he recalls. "I preferred the everything else." So instead of pursuing more rarefied arts, he began to make caricatures of clowns and cowboys. Not surprisingly, he continues to lampoon political and social clowns. "I believe that we relate to those things that we had a kinship with in

our youth, which is why I used to enjoy drawing former President Ronald Reagan as a cowboy, regardless of the appropriateness of the allusion."

But the fine arts were also part of Grossman's upbringing. He attended Saturday classes at the Museum of Modern Art, and when class was over he would spend hours in the museum's Surrealist painting gallery. Although this remains an obvious influence on his work, the comics, particularly by Walt Disney and Willard Mullins, had a more decisive impact. Moreover, work by Al Hirschfeld and Saul Steinberg allowed him to see how sophisticated cartooning could be. Upon graduation from Yale in 1961, Grossman went to work at the gag-cartoon mecca, the *New Yorker*, where he worked in the "slush pile" of submitted cartoons, making the first pass before sending them on to the cartoon editor. He also came up with ideas for other *New Yorker* artists, but after two years had only two of his own cartoons in print to show for his intense labors. "Jim Garrity, the cartoon editor, didn't think much of my potential as a cartoonist and encouraged me to become a writer instead," he says. Undaunted by this advice, Grossman remained firm in his conviction to be an artist, and went out on his own.

His first satiric drawing was published in 1963 in *Monocle*, which, aside from Paul Krassner's the *Realist*, was the only "alternative" or "counterculture" humor periodical being published during John Kennedy's Camelot period. One of his strips was about a black shoeshine boy who could become a superhero with the powers to fight injustice; the other concerned a fictionalized CIA plot to bomb the White House—somewhat prophetic, since it was published a few months before Kennedy's assassination. It was also around this time that Grossman's innovative airbrush style catapulted him into public view in the mainstream press. "I wanted to do something that was not being done, and continue to create pictures with content," he says, looking back. "I knew how to handle the airbrush, since I had used it as a little boy. And it seemed promising, since the only place one could see airbrushed drawing was in the slick Doublemint ads on subway car cards. Also I was interested in three-dimensionality from my early modelmaking days; the airbrush technique was akin to sculpting."

Grossman's experiment paid off. The marriage of this conventional commercial art technique with a nothing-is-sacred approach to political and social commentary proved beguiling and memorable. Viewers were seduced into his pictures by their soothing,

**ROBERT GROSSMAN
Ronald Rodent
Unpublished, 1967**

**ROBERT GROSSMAN
Geraldine Ferraro and
George Bush
The New Republic, 1984
Art Director:
Dorothy Wickenden**

**ROBERT GROSSMAN
Richard Nixon,
with Henry Kissinger
as Jiminy Cricket
The National
Lampoon, 1973
Art Director:
Michael Gross**

RONALD RODENT

ROBERT GROSSMAN
Leonard Nimoy
The Los Angeles
Times, 1966
Art Director:
Michael Salisbury

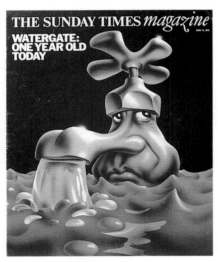

ROBERT GROSSMAN
Richard Nixon
London Sunday
Times, 1973
Art Director:
David King

ROBERT GROSSMAN
Sigmund Freud
Psychology
Today, 1986
Art Director:
Carveth Kramer

evenly sprayed, vibrant colors, and then—KABOOM—the message exploded in their faces. Grossman's most acerbic images from the Watergate era are still memorable to anyone who lived through it: Nixon with Pinocchio's long nose; Nixon as a gleaming water faucet, leaking out Watergate secrets; Emperor Nixon showing off his new clothes.

Grossman is like the proverbial imp who waits to ambush the rich old gent. Instead of lobbing snowballs at his target's top hat, however, he sprays his prey's face with ink. After Watergate subsided, Grossman was one of the few cartoonists who did not lose his momentum; in fact he became even more prolific. With Nixon out of the picture, he aimed at other beasts in the political menagerie in his comic strip "Zoo Nooz," which debuted in 1974 and originally appeared weekly in *New York* magazine before moving to *Rolling Stone* in 1977. As the feature's title suggests, Grossman anthropomorphized his satiric prey and fit his characters into their new skins perfectly: President Gerald Ford became Gerry Duck; candidate Jimmy Carter was turned into Jimmy Cocker; Ralph Nader was Ralph Badger; Mao Zedong was Chairman Meow; and Ronald Reagan, then Governor of California, was Ronnie Rodent.

Grossman's most recent foray into the political bestiary is "Cap'n Bushy," which had a three-issue run in the *Nation* in 1991. Here he cast George Bush in the role of "the greatest flying squirrel who ever lived," leading his "clean-cut cuddly forces in battle" against a veritable jungle's worth of foes, including Saddam Hussein as "Saddy the Baddy, the World's Worst Weasel"; Pat Buchanan as a vampire bat; and a pride of Democrats (Paul Tsongbird, Tom Barkin, Bill Chimpton, and so on). The possibilities are endless, and in Grossman's able hands they are endlessly witty.

SPITTING IMAGE: SAVAGE FOAM

In the late 1960s, Roger Law and Peter Fluck were friends working separately as cartoonists. Law was an astute researcher and acerbic conceptualist; Fluck, a brilliant draftsman. In 1975, they joined into a partnership and, working out of a small, deconsecrated chapel in Cambridge, England, sculpted caricatures out of plasticene. They made their figures' clothes, gave them lifelike features, and photographed them against ambitious backdrops that would put a Broadway set designer to shame. The results of this intense labor were among the most unflattering caricatures of political, social, and cultural leaders in a generation, and would ultimately take portrait caricature to a new plateau that would soon result in a radically new and popular medium of social and political satire for television and film. No matter who was depicted in these early efforts, from the British Queen to Mick Jagger, they were wickedly funny, but also curiously flawed—at least according to their makers who felt that they were "too damn static."

Law and Fluck had a dream to someday animate their sculptures for a topical satiric revue; indeed, they had proposed doing a weekly television show called *Spitting Image*, which was favorably received at Britain's Central TV. But the process of creating the models made traditional stop-action animation cost-prohibitive. Undeterred, they rigged up complex machines that would make their figures move mechanically. They even hired special effects experts to make movie magic. But after all the effort, the

ROBERT GROSSMAN
Mario Cuomo
Mother Jones, 1988
Art Director:
Louise Kollenbaum

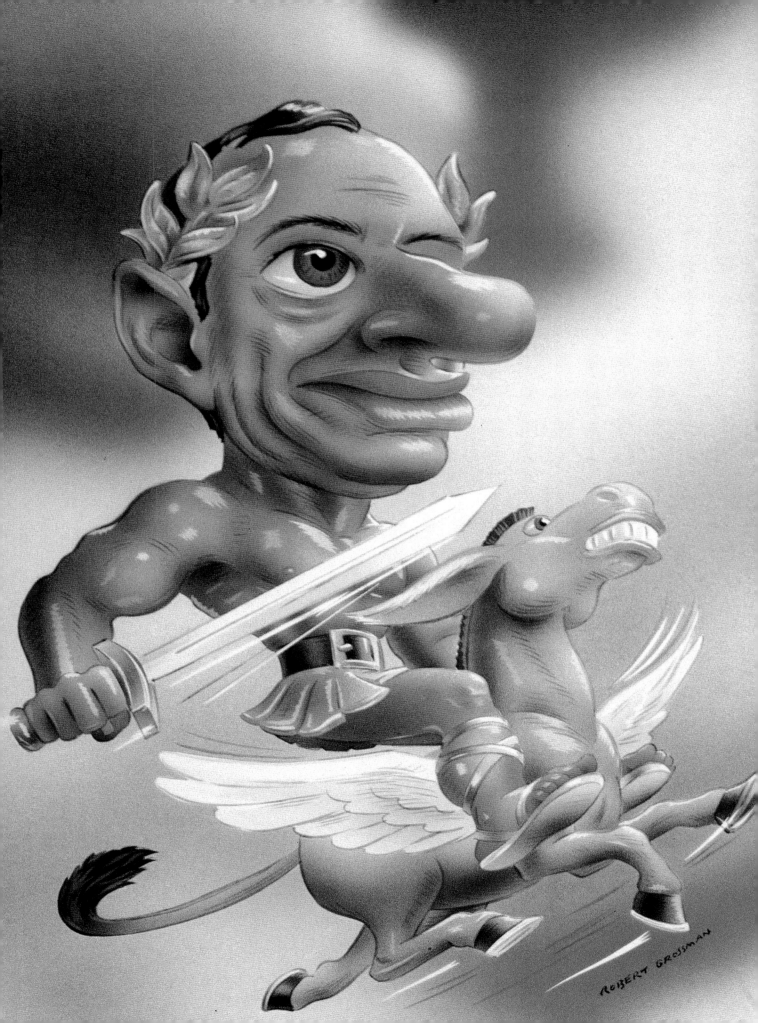

ROBERT GROSSMAN

results were inanimate and dull. "Doing the models was an interesting way to go broke," admits Law. "It's not as simple as making a drawing. Between the time it takes to conceive and fabricate a plasticene caricature, the profits are shot." The painstaking effects were simply too time-consuming to allow for topicality and too stiff looking for the needed spontaneity. Finally, the notion of animating the models was scrapped in favor of hand-manipulated puppets, which eventually made their manufacture and manipulation easier.

More trial and error followed. "There are certain golden rules that make puppetry work," says Law. "The first and foremost is simplicity. Jim Henson [knew] this and that's why the Muppets are so lifelike. Yet it took us a while to figure it out." An example of this simplification process occurred during the taping of the show's first pilot in 1983. "We made a puppet of Ronald Reagan with a parrot sewn onto his shoulder," says Law. "Reagan was simple enough, but the parrot was given complex gears just to make the eyes move. Peter decided to remove the workings and hook the eyes up to strings. It was brilliant and effective." While one puppeteer moved Reagan's head, another manipulated the parrot's eyes."

The system Fluck devised is very similar to the Muppet operating procedures in which the life-sized puppet is manned by two puppeteers. The first puppeteer's right hand is used to control the puppet's head and facial expressions, while the left arm fits into the puppet's left sleeve, making it move. A second person manipulates the eyes, and can work the right arm if necessary. The puppet's hands fit like gloves, so movement is made to appear very natural. During the early days of *Spitting Image*, some puppeteers even wore masks and body suits—usually for dancing sequences—but this practice was eventually eliminated in favor of absolute purity.

While it is exciting to see the puppets take form, Fluck and Law did not create *Spitting Image* just to become a factory of witty objects; they wanted to satirize people in the public eye in the most memorable way possible. Law points out that Britons "are weaned on this kind of stuff," thanks to the legacies of Hogarth, Gillray, and Rowlandson, as well such contemporary works as *Monty Python's Flying Circus* in the 1970s.

SPITTING IMAGE
Bette Middler
Spitting Images, 1986

The pilot was well received, but the subsequent series, which premiered in 1984, was not as loudly applauded. Of the first 12 shows, Law says, "People were queuing up to turn us off. We tried to do 28 minutes of political satire and realized that people didn't want it. Moreover, we couldn't do 28 minutes of political satire every week—all the work we did for print in a year couldn't fill ten minutes of television time." Good ideas were not materializing quickly enough. But despite the poor ratings, the audience apparently wanted it to work, as evidenced by viewer letters offering positive and negative feedback.

Luckily, Central TV's top-ranking producers recognized the show's nascent potential, and *Spitting Image* was signed up for a second season. It was during this time that the show finally came together, as the writing, direction, and overall program conception—all things that the solo two-dimensional caricaturist doesn't have to worry about—coalesced into a fully realized entity.

The show also became more "populist," by adding sports and entertainment figures to its cast of political targets. The fast-paced mix of sketches has worked, judging from the response of the 12 million regular viewers who have stayed with the show since its second season.

The success of the *Spitting Image* show (maybe too much success, since the response has forced the show's company to grow into a de facto media conglomerate, complete with books, videos, tapes, novelties, and other television series to its credit, and not always to Fluck and Law's liking) is due to a collaborative effort that includes at least six writers and a number of young caricaturists who sketch the puppets, which are then fabricated and painted. The show's "factory," located in an industrial section on the outskirts of London, also includes artists who make hairdo caricatures, clothing caricatures, voice caricatures, and even music caricatures. During a production cycle, the wheels must run in perfect harmony, On Sundays, as one show is being filmed, another is taking shape. Scripts are continually being changed and new caricatures are always being developed.

Spitting Image's caricatures range from the impishly comic to the wickedly savage. They are masterpieces of distortion, sometimes wildly exaggerated, at others decidedly true to life. But what gives these puppets their untold power is that they are truly part human. While the viewer knows they are made of foam, the gestures are so realistic that the caricatures are mentally transformed into living beings. Some are more effective than others—the more ludicrous ones are often just funny, unbelievable cartoons. But when they're perfect, like a famous scene in which Ronald Reagan and Margaret Thatcher share a passionate, sexual embrace, it is not just a silly personification of their political relationship—it's almost convincing enough to believe.

Spitting Image is England's contribution to the caricature renaissance of the 1980s. But it also illustrates one reason for caricature's ebb in the United States in recent years. In 1989, a version of *Spitting Image* was aired in four shows on NBC. The ratings where underwhelming because Americans are simply not as receptive as are the English to cartoon satire, Moreover, *Spitting Image* was defanged for the American audience—only the final show in the series had any hint of the irreverent political humor typical of the

SPITTING IMAGE
Margaret Thatcher
Spitting Image Ltd.,
1980

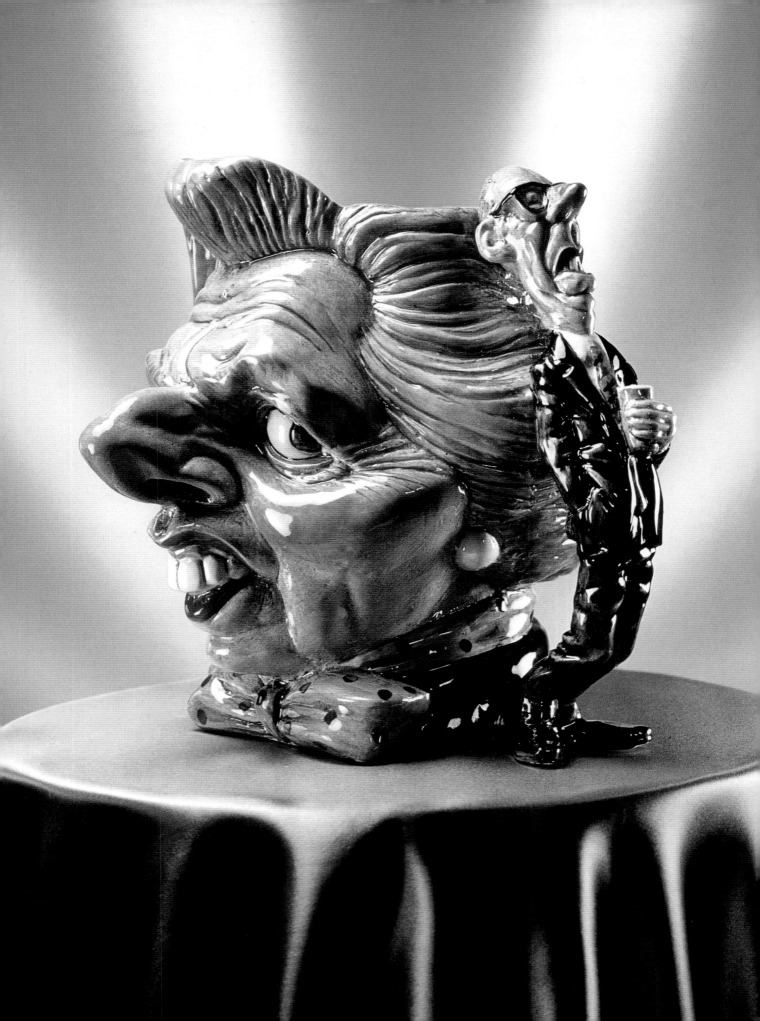

**SPITTING IMAGE
Pope John Paul II
Spitting Image Ltd.,
1988**

**SPITTING IMAGE
Mike Tyson
Spitting Images, 1986**

**SPITTING IMAGE
Mick Jagger
Spitting Images, 1986**

original. Law and Fluck are again trying to enter the American market with a new series, called *Rubber News*.

Despite *Spitting Image*'s high production values, it would be just a collection of witty puppet caricatures if not for the brilliant behind-the-scenes machinations: The writing is smart and the direction is skilled. In an era when mass electronic and digital media are making conventional two-dimensional caricature seem old hat, *Spitting Image* has given new life to the British tradition, and perhaps it will someday have a similar effect on American satire as well.

WHERE HAS THE RENAISSANCE GONE?

The masters discussed in this section are still active. Robert Osborn and Al Hirschfeld, both in their 80s, draw constantly; Hirschfeld is still the only caricaturist at the *New York Times*, and Osborn, while not connected to any publication, continues to make expressive charged portraits. Ronald Searle does not do much portrait caricature, but continues to insightfully depict the comedy of manners from his perch in France. For almost three decades, David Levine has contributed as many as six caricatures per issue to the *New York Review of Books*, and has produced over 3,000 during his tenure there. Edward Sorel does not have a weekly outlet for caricature, but is a prolific illustrator, and frequently contributes satiric comic strips to the *Nation*. Although Ralph Steadman refuses to caricature politicians, he continually writes and draws visual essays; his most recent work is a collection of distorted portraits made by manipulating the gel on Polaroid SX-70 prints. Robert Grossman looks forward to publishing more of "Cap'n Bushy," one of the few contemporary comic strips to criticize the president and his men. And Fluck and Law's *Spitting Image* continues to be popular among British audiences.

But what about caricature in general? Is the consensus among these masters that there is a paucity of new artists with unique approaches accurate, or is the form being pushed by new practitioners? While some members of the recent generation of illustrators dabbled in caricature to solve specific editorial problems, few experimented with form and content. Moreover, the political circus became a sideshow during the Carter Presidency, and a diet of benign cartoons became the standard. Despite the consistently high standard maintained by these masters, the renaissance simply petered out during the late 1970s, as other forms of cartooning and illustration—notably the non sequitur graphic humor being done by a new crop of *New Yorker* cartoonists and the neo–Art Brut illustration surfacing in magazines—became more popular. The Art Brut trend had the most deleterious effect on caricature, since bad drawing became fashionable and sought after—bad drawing may be misguidedly seen as "expressive," but it makes for bad caricature. And bad caricature trivialized the form during the period of malaise that began in the mid-1970s and lasted about a decade. Fortunately, the gradual shift from overly self-conscious Art Brut toward more traditional draftsmanship had a welcome curative effect on the genre. The next chapter examines the artists who emerged from this period. They represent the diverse approaches of the promising new wave of political, social, and entertainment caricature, from the traditional to the experimental, from the representational to the abstract.

**SPITTING IMAGE
Ron and Nancy Reagan
Spitting Images, 1986**

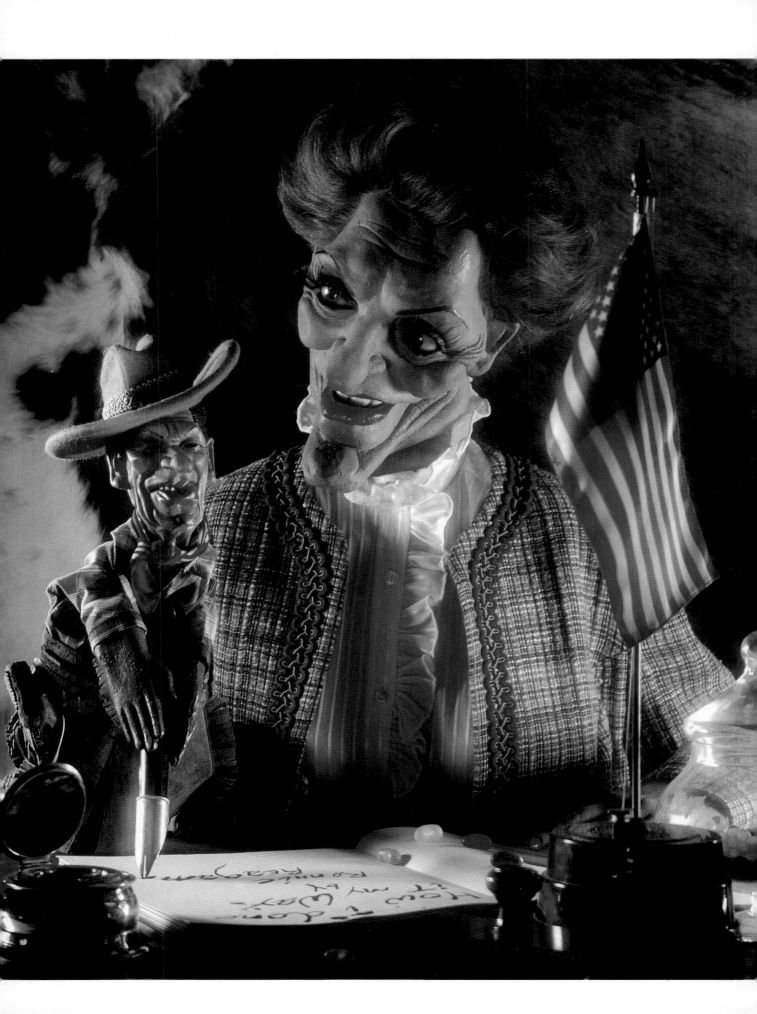

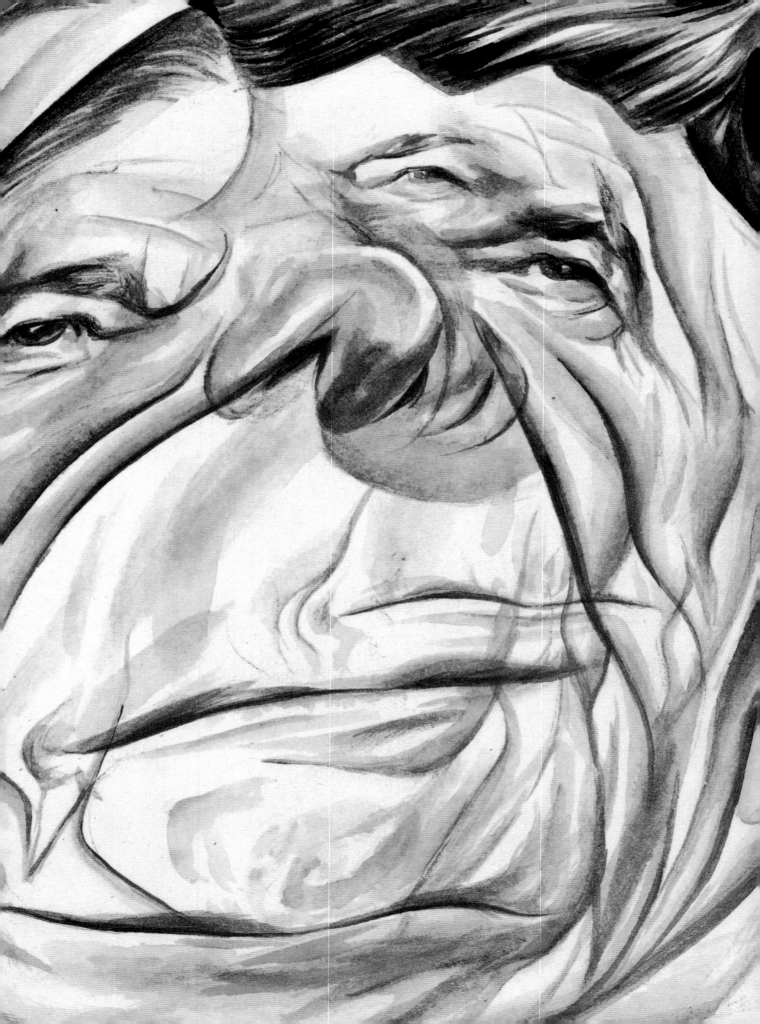

THE NEW WAVE

STEVEN BRODNER
Ronald Reagan
The Washington Post
Magazine, 1987
Art Director:
Michael Walsh

HANOCH PIVEN
Ronald Reagan
Unpublished, 1991

FRANCES JETTER
Ronald Reagan
The Progressive, 1981

Ronald Reagan's face was God's gift to cartoonists and caricaturists. Although he was basically a handsome fellow, an artist with a little imagination and talent could easily transform him into the Thing. When it came to caricature, even Teflon couldn't protect Reagan—if all else failed the caricaturist, molding that emblematic jet-black greaseball of a pompadour, could produce a variety of witty sculptures. Robert Grossman made it into the prow of a ship (i.e., the ship of state), and Ralph Steadman matted it down into Dracula's famous 'do. Various artists also turned the coif into a map of the United States, the peak of Mount Everest, and the cone of a missile. But Reagan had other lovely distinguishing physical features, like his pendulous neck and scores of deep facial ravines filled to the brim with pancake makeup. These visual highlights made him the favorite of pen-and-ink artists like David Levine, who might have easily emptied a bottle of India ink in the process of rendering the President's unique topology.

Reagan should have singlehandedly revived the art of caricature, not to mention the art of satire, in the 1980s, after cartoonists suffered through a long period of post-Watergate doldrums. But he didn't—at least not in the beginning. At the start of his Presidency, most editorial cartoonists were too busy trying to pin down their signature likenesses of Reagan to be concerned with the more conceptual aspects of caricature. Others were not certain how to handle him at all—was he a crook, like Nixon, a buffoon, like Ford, or a good old boy, like Carter? For the left he was bad news, for the right he was God, but for the average cartoonist and caricaturist he was simply a new President who had not yet revealed his true colors during his first few months in office. When he eventually played his hand and unleashed trickle-down economics, thereby threatening the lives and livelihoods of the poor and lower-middle class, only a small group of enlightened critical cartoonists and caricaturists took the threat seriously enough to make strident satiric commentary. The rest were at best loyal dissenters, cautiously nibbling but never actually biting the man at the nation's helm.

Loyal dissent can take the sting right out of satire; the President should be the critical cartoonist's nemesis, not a friend. "Is the style of much editorial cartooning today inherently trivializing? Or does the comic line set up an esthetic distance that reveals the idea behind the puppet?" asks David Kunzle in his 1977 *Art in America* article "200 Years of the Great American Freedom to Complain." In Reagan's case, most cartoonists, like many journalists, treated him

ROB DAY
Ronald Reagan
Communication
Arts, 1990
Art Director:
Patrick Coyne

with kid gloves even as his domestic policies were failing, and therefore never achieved that necessary distance. He was crowned the Great Communicator by the press, which implied that he could do no wrong. And the 1981 attempt on his life, which left him wounded and his press secretary paralyzed, forced cartoonists to turn what little satiric fire there was away from him for some time to follow. Only during Reagan's second term, when his policies seemed clearly destined to increase the national debt and expand the gap between the rich and the poor, did satirists begin to feel confident enough to step up their attacks on him. And even then, it took the revelation of the Iran-Contra scandal in 1986 to provoke cartoonists into producing truly strident and probing caricature on this President.

The greatest stumbling block for viable political caricature during this period was not Reagan himself, however, but the paucity of outlets for meaningful satire. Silly Reagan cartoons were published frequently in the mainstream press, but few were as acerbic as even some of the lesser Watergate entries. Times had certainly changed; loyal dissent bordered on collusion. While certain "opposition" publications published the occasional strong cartoon or caricature, in most cases it was clear that the artist's heart was not in it. Gone was the rage of the Nixon-inspired cartoons so frequently published in *New York, Esquire,* and *Rolling Stone* magazines. All of these once-fertile spawning grounds for strong, witty caricature had apparently given up the ghost in the late 1970s, owing to changes in editorial policy influenced by turns in fashion. Politics was out, life-style was in.

**STEVEN BRODNER
Ronald Reagan and
George Bush
fold-and-tuck faces
Esquire, 1989
Art Director:
Rip Georges**

**PHILIP BURKE
Ronald and
Nancy Reagan
Savvy Woman, 1989
Art Director:
Pamela Berry**

**ANITA KUNZ
Mikhail Gorbachev
and Ronald Reagan
as infants
Rolling Stone, 1988
Art Director:
Fred Woodward**

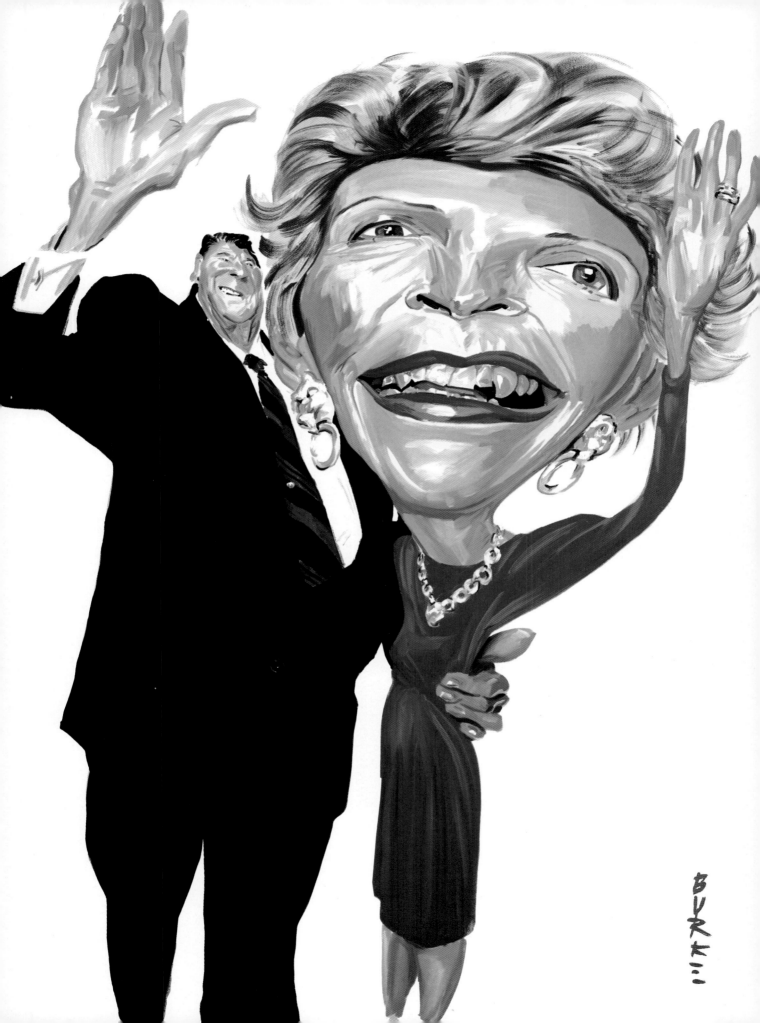

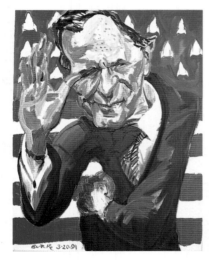

MARK ALAN STAMATY
Ronald Reagan
From "Washingtoon"
The Village Voice, 1988
Art Director:
Michael Grossman

Such left-wing periodicals as *Mother Jones*, the *Progressive*, and the *Nation* published vociferous written attacks on the Reagan administration, but failed to make similar attacks through portrait caricature. Successors to the 1960s underground papers, such as the quarterly *World War III*, a polemical comics magazine, published anti-administration situational drawings and comic strips, but did not further the art of portrait caricature in any significant way. *Raw*, which was ostensibly devoted to apolitical avant-garde comix, nonetheless published some of the most disturbingly effective caricatures of Reagan by Sue Coe. But in the final analysis, it was the conservative press, notably the *National Review* and the *American Spectator*, that published more caricatures with conviction of their respective political bêtes noires on the left than the liberal press did of theirs on the right. Only the *New York Review of Books*, which featured the work of David Levine, and the *Village Voice*, which ran weekly political comic strips by the veterans Jules Feiffer and Mark Alan Stamaty, kept any semblance of caricature alive.

SUE COE
Reagan Fruit Bat
Mother Jones, 1985
Art Director:
Louise Kollenbaum

BRIAN AJHAR
Salman Rushdie
Mirabella, 1990
Art Director:
Kelly Doe

PHILIP BURKE
George Bush
Vanity Fair, 1991
Art Director:
Charles Churchward

BARRY BLITT
Jimmy Swaggart
Entertainment Weekly,
1991
Art Directors:
Anna Kula,
Michael Grossman

DREW FRIEDMAN
Ronald Reagan
Spy, 1991
Art Director:
B. W. Honeycutt

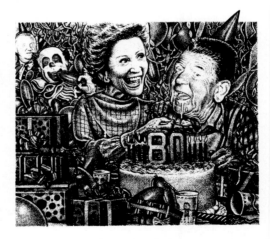

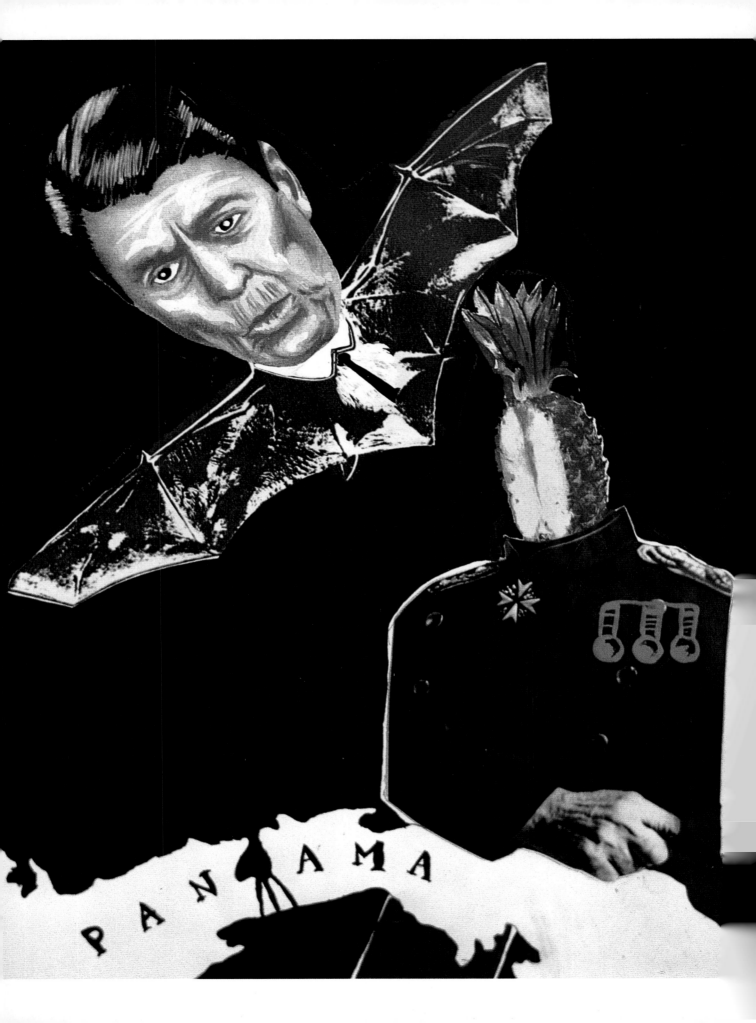

ANTHONY RUSSO
Frank Sinatra
Vanity Fair, 1985
Art Director:
Charles Churchward

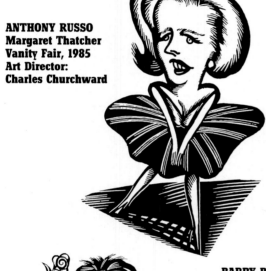

ANTHONY RUSSO
Margaret Thatcher
Vanity Fair, 1985
Art Director:
Charles Churchward

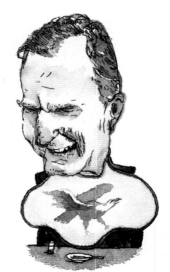

ANTHONY RUSSO
Clint Eastwood
Vanity Fair, 1985
Art Director:
Charles Churchward

NEW OUTLETS, NEW FACES

During Reagan's second term, the press gradually shifted toward more critical commentary. By the end of the term, a demonstrative caricature revival had begun, with a new generation of illustrators receiving encouragement from old and new publications. The most important of the new outlets was *Vanity Fair*, which, of course, was the wellspring of American caricature in the 1930s, until it was folded into *Vogue* in 1936. In 1982, it was brought out of mothballs with the intent of appealing to yuppies interested in intellectual chic, such as eccentric fiction, steamy exposé, celebrity profiles, and gossipy journalism. During its first year, caught between its past and present, *Vanity Fair* suffered an identity crisis. Caricaturists like Mick Haggerty and Robert Risko, whose drawing styles quoted liberally from Art Moderne, were used in an early attempt to evoke the magazine's previous incarnation. But the publication made an important step toward asserting a style of its own in 1983, when it gave a young caricaturist named Philip Burke a contract to publish his expressionistic *portraits chargés* in every issue.

Burke had been making caricatures in a variety of media, including neon, since coming to New York City from Buffalo in the mid-1970s. Although his early penchant for grotesque distortion was reminiscent of Gerald Scarfe's elastic caricatures, Burke quickly developed an original pen-and-ink style while working as freelance illustrator for the *Village Voice*. The *Voice*, a historically left-wing New York weekly, encouraged his most anarchic work, while other clients, such as the *New York Times*, discouraged these same tendencies for reasons of taste and propriety.

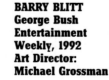

BARRY BLITT
George Bush
Entertainment
Weekly, 1992
Art Director:
Michael Grossman

C. F. PAYNE
George Bush series
Spy, 1990
Art Director:
B. W. Honeycutt

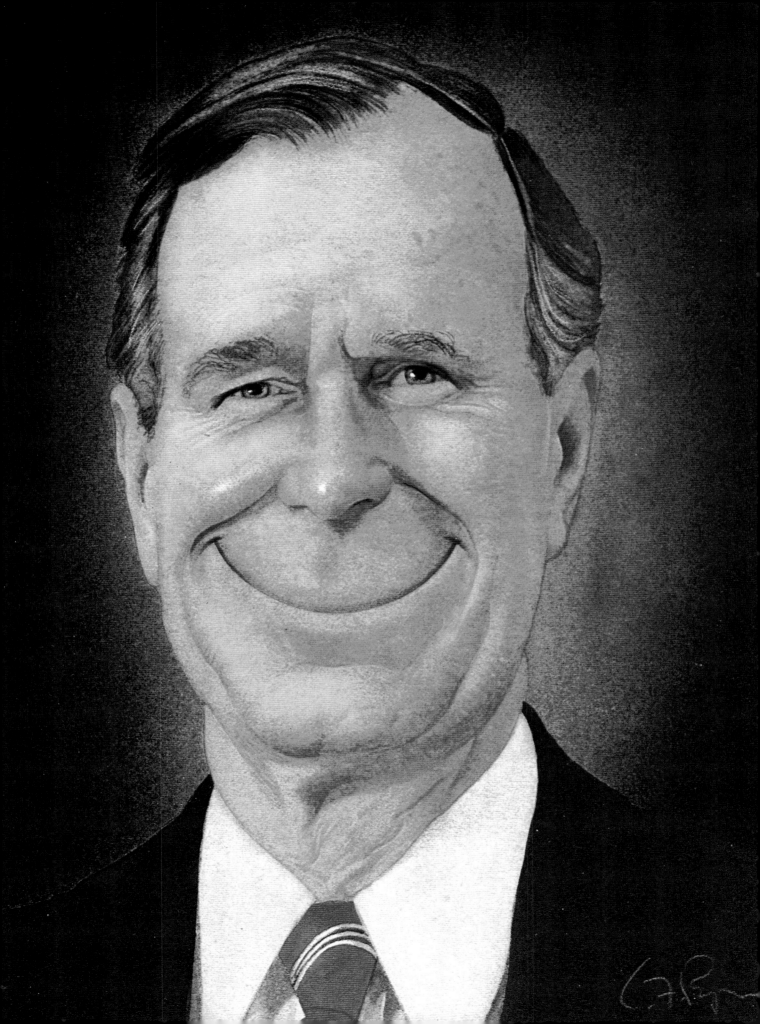

Nonetheless, Burke got enough odd jobs for his unique approach to be seen and appreciated by mainstream art directors and editors. By the time *Vanity Fair*'s editors discovered him, he was already seriously experimenting with painted caricatures, often done in his studio from life, which owed more to German Expressionism than to the popular nineteenth-century conventions of portrait caricature.

Burke's caricatures are painted drawings. He applies paint with quick brushstrokes, and his painting surfaces are built on layers of color and texture. But take away the painterly qualities and it becomes clear that Burke's rather large paintings (the caricatures he does for the contents page in every issue of *Rolling Stone* are rendered on 4-foot-high canvases) are executed with a draftsmanlike skill. His pictures are not usually based on ideas; he relies almost entirely on distortion to communicate his message. Neither an overriding concept nor a background vignette comes into play. With varying degrees of success, he

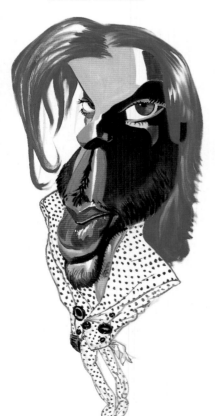

PHILIP BURKE
Manuel Noriega
Newsweek, 1990
Art Director:
John Houston

PHILIP BURKE
Prince
Entertainment
Weekly, 1991
Art Director:
Michael Grossman

PHILIP BURKE
Spike Lee
Rolling Stone, 1989
Art Director:
Fred Woodward

EVERETT PECK
Dan Quayle
Mother Jones, 1990
Art Director:
Kerry Tremain

BARRY BLITT
Margaret Thatcher
Spy, 1991
Art Director:
B. W. Honeycutt

MICHAEL WITTE
Dan Quayle
Regardie's, 1988
Art Director:
John Korpics

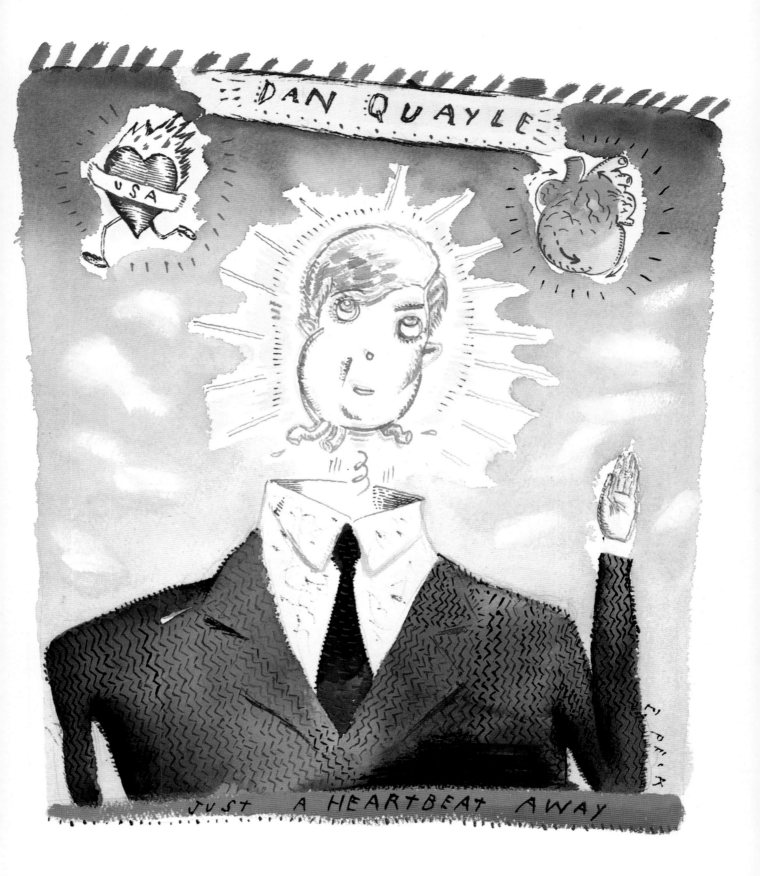

PHILIP BURKE
Brian Wilson
Rolling Stone, 1991
Art Director:
Fred Woodward

applied this approach to his work for *Vanity Fair* during his two-year contract period (which was not renewed owing to changes in editorial focus). His most noteworthy assignment was to cover a Pentagon budget hearing on Capitol Hill. In the manner of Daumier, he drew the Senate committee members and witnesses, including the head of the Joint Chiefs of Staff and Secretary of Defense, as he emotionally perceived them. The images were not critical in the orthodox sense, but were honest portrayals of the men behind the public masks. This was a benchmark, not only for Burke but for the entire field of contemporary caricature—for the first time since the Watergate scandal had ended, a national (and basically apolitical) magazine had turned over some of its valuable editorial real estate to an artist and allowed him to be a journalist. Although Burke's work was not as polemical as Levine's or Edward Sorel's (given the same assignment, they certainly would have been far more bitingly conceptual), it was a form of critical commentary by virtue of its use of unflattering distortion.

Vanity Fair's contribution to the caricature revival during this period was indicative of a greater shift throughout magazine publishing in the commissioning of more portrait caricature. *Rolling Stone*, which in the early to mid-1970s published Ralph Steadman's splatter caricatures in almost every issue, had forsaken most illustration and switched almost exclusively to studio photography during the 1980s; but when Fred Woodward became art director in 1987, caricature almost immediately returned to *Rolling Stone*'s pages, not just as incidental illustrations but as full-fledged features.

HANOCH PIVEN
Jesse Jackson
Unpublished, 1991

PHILIP BURKE
Dwight Gooden
Esquire, 1990
Art Director:
Rip Georges

PHILIP BURKE
Jimi Hendrix
Rolling Stone, 1989
Art Director:
Fred Woodward

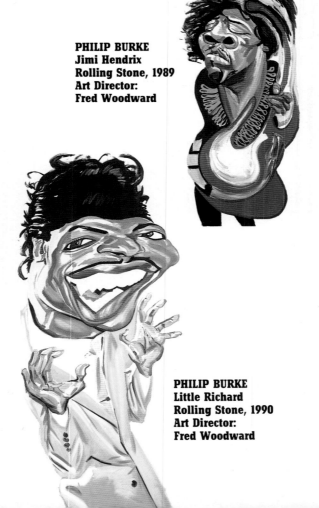

PHILIP BURKE
Little Richard
Rolling Stone, 1990
Art Director:
Fred Woodward

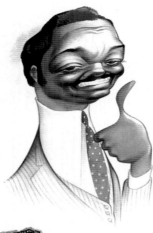

JOHN KASCHT
Jesse Jackson
Regardie's, 1990
Art Director:
John Korpics

By the time he took over *Rolling Stone*, Woodward had already presided over several important caricature developments. When he was art director for *Texas Monthly* and *Regardie's* in 1984–1987, he had developed good working relationships with conceptual illustrators, usually allowing them the freedom to create within the confines of the manuscript. Moreover, he often gave them opportunities to develop their own features, some of which involved satirizing famous cowboys and western myths (for *Texas Monthly*) or criticizing infamous business and media celebrities (for *Regardie's*). These forums gave rise to a new form of conceptual caricature that mixed conceptual illustration with distorted portraiture. In addition, these caricatures were very painterly, and did not conform to the traditions of nineteenth-century engraved or lithographic caricature, which had been the state of the art during the 1980s. These caricatures were not typical of the journalistic renderings

DAVID COWLES
Oliver North
The Village Voice, 1990
Art Director:
Bob Newman

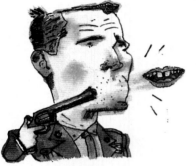

BARRY BLITT
Oliver North
Entertainment
Weekly, 1991
Art Director:
Michael Grossman

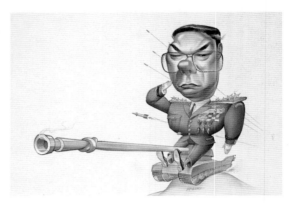

JOHN KASCHT
Colin Powell
GQ, 1990
Art Directors:
Robert Priest,
Charlene Benson

C. F. PAYNE
William Rehnquist
The New York Times
Magazine, 1989
Art Director:
Janet Froelich

PHILIP BURKE
Norman Mailer
Rolling Stone, 1991
Art Director:
Fred Woodward

ANITA KUNZ
**Rod Stewart
Rolling Stone, 1988
Art Director:
Fred Woodward**

ANITA KUNZ
**Aretha Franklin
Rolling Stone, 1987
Art Director:
Fred Woodward**

drawn on the spot or during the heat of a deadline—they were deliberately composed paintings that used caricature as one of many other methods of communication.

When Woodward took over at *Rolling Stone*, he instituted a visual page called "The History of Rock 'n' Roll." Distorted and satiric portraiture was a regular feature of this page, and conceptual illustrators could push the limits of distortion as they saw fit. Many of the contemporary artists featured in this book received their first caricature assignments for the "History" page. Although this feature is now defunct, the artists are still being commissioned to make caricatures for other departments, including the record and film reviews, making *Rolling Stone* a wellspring for New Wave artists.

Because of the media-related outlets in which the new wave of caricaturists most frequently ply their trade, they do many more caricatures of social icons than of political subjects. Entertainment magazines, in fact, have been at the forefront of reviving contemporary caricature, with *US* and *Entertainment Weekly*, most notably, keeping many good caricaturists quite busy. Although the magazines' visuals are primarily photographic, portrait caricature—ranging from traditional nineteenth-century-type work to stylized Deco approaches—is regularly used as spot art. While these drawings fail to push the limits of the form very far, the mere fact that caricature is used, instead of the typically mundane press photographs, reinforces the fact that caricature is a viable option in publishing today.

**ANITA KUNZ
Oliver North
Playboy, 1987
Art Director:
Kerig Pope**

**BARRY BLITT
David Dinkins
The New York
Observer, 1992
Art Director:
Irene Ledwith**

**C. F. PAYNE
Nancy Reagan
as Henry VIII
Regardie's, 1986
Art Director:
Fred Woodward**

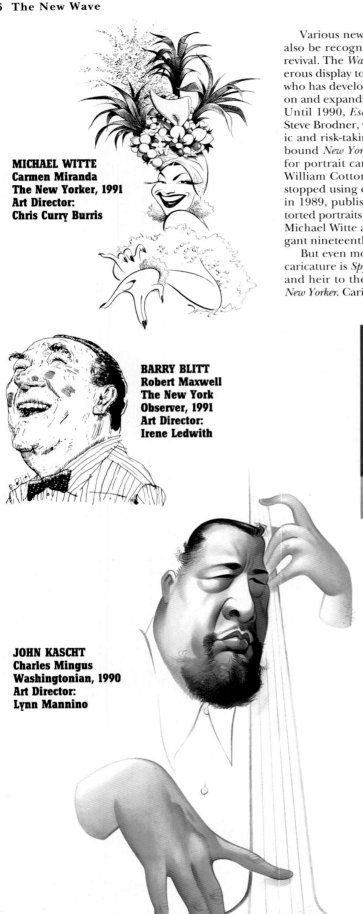

MICHAEL WITTE
Carmen Miranda
The New Yorker, 1991
Art Director:
Chris Curry Burris

Various newspapers and other magazines should also be recognized for contributing to the current revival. The *Washington Times,* for instance, gives generous display to its cultural caricaturist, John Kascht, who has developed into an excellent stylist, building on and expanding the nineteenth-century traditions. Until 1990, *Esquire* published a regular feature by Steve Brodner, who is both a politically motivated critic and risk-taking experimenter. Even the tradition-bound *New Yorker,* which in the 1930s was an outlet for portrait caricaturists Al Freuh, Paolo Garretto, William Cotton, and Miguel Covarrubias before it stopped using caricature in the 1960s, came around in 1989, publishing an increased diet of mildly distorted portraits by illustrators and cartoonists, notably Michael Witte and Mark Summers, who both do elegant nineteenth-century-style vignettes.

But even more central to the revival of American caricature is *Spy,* the voice of contemporary cynicism and heir to the urbanity of the old *Esquire* and the *New Yorker.* Caricature large and small, vehement and

STEVEN BRODNER
Ed Meese
Playboy, 1986
Art Directors:
Tom Staebler,
Kerig Pope

BARRY BLITT
Robert Maxwell
The New York
Observer, 1991
Art Director:
Irene Ledwith

JOHN KASCHT
Frank Sinatra
The Washington
Times, 1990
Art Director:
Dolores Motichka

JOHN KASCHT
Charles Mingus
Washingtonian, 1990
Art Director:
Lynn Mannino

MARK ULRIKSEN
Ed Meese
Unpublished, 1984

ROBERT DE MICHIELL
Johnny Depp
The New Yorker, 1991
Art Director:
Chris Curry Burris

mild, has been a fixture on *Spy*'s pages since it began in 1986. Drew Friedman, a *Raw* alumnus, has a monthly feature in which a distorted—though believably real—portrait is the centerpiece. In addition, a stable of regular freelance caricaturists is used to illuminate the magazine's columns. Barry Blitt, David Cowles, and Robert de Michiell all contribute portrait caricatures, which while not venomously acerbic are nevertheless little gems of mild distortion.

THE CUT-AND-PASTE AESTHETIC

The publishing world's acknowledgment that caricature is a viable alternative to photography and conceptual illustration has had a positive influence on young artists, many of whom are being encouraged to explore new approaches. For a long time, Levine and Sorel represented the paradigmatic approaches of contemporary caricature, and imitations of their work (often poor) are still common in American and European newspapers and magazines. But by the late 1980s, more nontraditional approaches, like cut-and-paste collage, began surfacing.

Actually, these realms had been explored long before. Collage has been a historically revolutionary art form, as artists dating back to Picasso have cut, torn, recomposed, and pasted found objects for the purpose of busting the canon of traditional art. This idea was uniquely practiced in the 1920s by two German Dadaists, Hannah Höch and Raoul Hausmann, who made some of the earliest distorted portraits of their nation's distinctive character types in collages of printed photographs. The form was also used in the 1930s by Surrealists, such as Salvador Dali and

ANITA KUNZ
Vladimir Lenin
Regardie's, 1990
Art Director:
John Korpics

DREW FRIEDMAN
Sitcom Characters in
Search of
Enlightenment
Warts and All, 1990
Art Director:
Art Spiegelman

RENÉE KLEIN
Richard Nixon
The Boston Globe
Magazine
Art Director:
Lucy Bartholomay

ROBERT DE MICHIELL
Martha Graham
The New Yorker, 1989
Art Director:
Chris Curry Burris

DAVID COWLES
Ted Danson
US: The Entertainment
Magazine, 1990
Art Director:
Jolene Cuyler

Max Ernst, in pictures that jumbled common perceptions of reality and fantasy. And even as recently as the early 1970s, a self-styled artist and documentarian, A. J. Weberman, sculpted and collaged portraits of well-known politicians and entertainers out of the refuse he snatched from their garbage cans. These distorted portraits made from tin cans, supermarket packaging, and torn documents curiously resembled their models' true characters more effectively than many drawn caricatures, perhaps because collage offers a sense of immediacy that even the most spontaneous figurative sketch does not always provide.

Collage is a difficult form to master. The skilled collagist does not merely toss random pieces of decoupage or cut papers on a board and expect a startling image to materialize; serendipity, though important, is not always a virtue in this form. The polemical collagists Höch and Hausmann deliberately planned their images to achieve a seemingly ad hoc result. Other successful 1920s experiments with

STEPHEN KRONINGER
Saddam Hussein
Lear's, 1990
Art Director:
Steven Webster

MARCIA STIEGER
Madonna, Elvis
Presley, and Liz Taylor
Special Report, Whittle
Publications, 1990
Art Director:
Doug Renfro

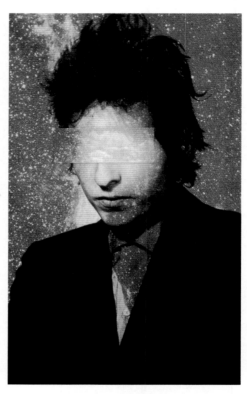

MALCOLM TARLOFSKY
Bob Dylan
Rolling Stone, 1991
Art Director:
Fred Woodward

HANOCH PIVEN
Yasir Arafat
Unpublished, 1991

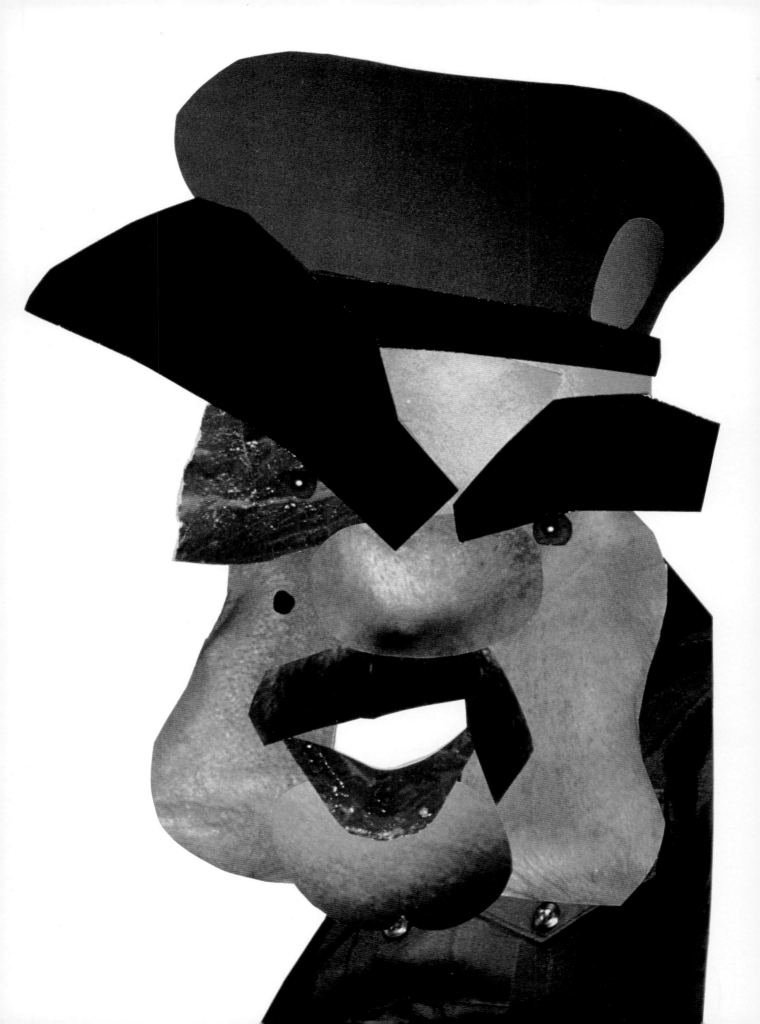

STEPHEN KRONINGER
Ronald Reagan
The New York
Times, 1989
Art Director:
Michael Valenti

collage as portrait caricature were carried out by George Grosz and John Heartfield in Dada pictures that were made by the two great artists acting in concert. But it was Heartfield alone who made truly memorable political statements through the medium of montage. His covers for the communist magazine *AIZ* were fierce attacks on Nazi leaders, created either by sandwiching two or more negatives together or cutting and pasting disparate imagery to achieve a single, metaphorical photographic image. Not all his images were portraits—some were situations—but those that attacked individuals were made by combining real photographs of Nazi officials and placing them into horrendous metaphorical contexts. Other artists since Heartfield have used the montage medium as both a formal exercise and a political statement, but few have shown the same virtuosity as propagandists. Even today, with new digital technologies that can seamlessly transform photographs into total fiction, no computer-assisted artists have come close to Heartfield's conceptual acuity.

Following in the tradition of these modern masters, Stephen Kroninger, an illustrator for various alternative and mainstream publications, has boldly pushed the limits of collage from its current status as a rather quaint, often cliché-ridden method of contemporary illustration and turned it into a new weapon in the caricaturist's arsenal. In caricatures of Saddam Hussein (see page 91) and Leona Helmsley (left), Kroninger exhibits that in the right hands, otherwise benign fragments of media minutiae can be reconstituted into unforgiving portraits; his Woody Allen portrait (page 117) shows that these same elements can also be used to make a sympathetic and

PHIL HULING
Ivan Boesky
Regardie's, 1989
Art Director:
John Korpics

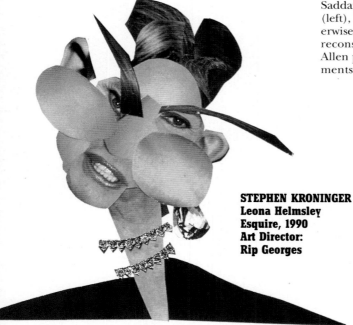

STEPHEN KRONINGER
Leona Helmsley
Esquire, 1990
Art Director:
Rip Georges

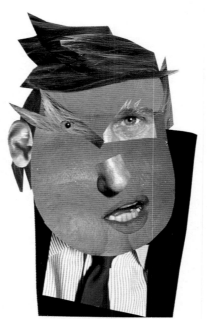

STEPHEN KRONINGER
Donald Trump
Lear's, 1990
Art Director:
Steven Webster

STEPHEN KRONINGER
Andrew Dice Clay
Entertainment
Weekly, 1990
Art Directors:
Michael Grossman,
Greg Mastrianni

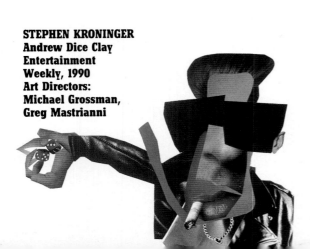

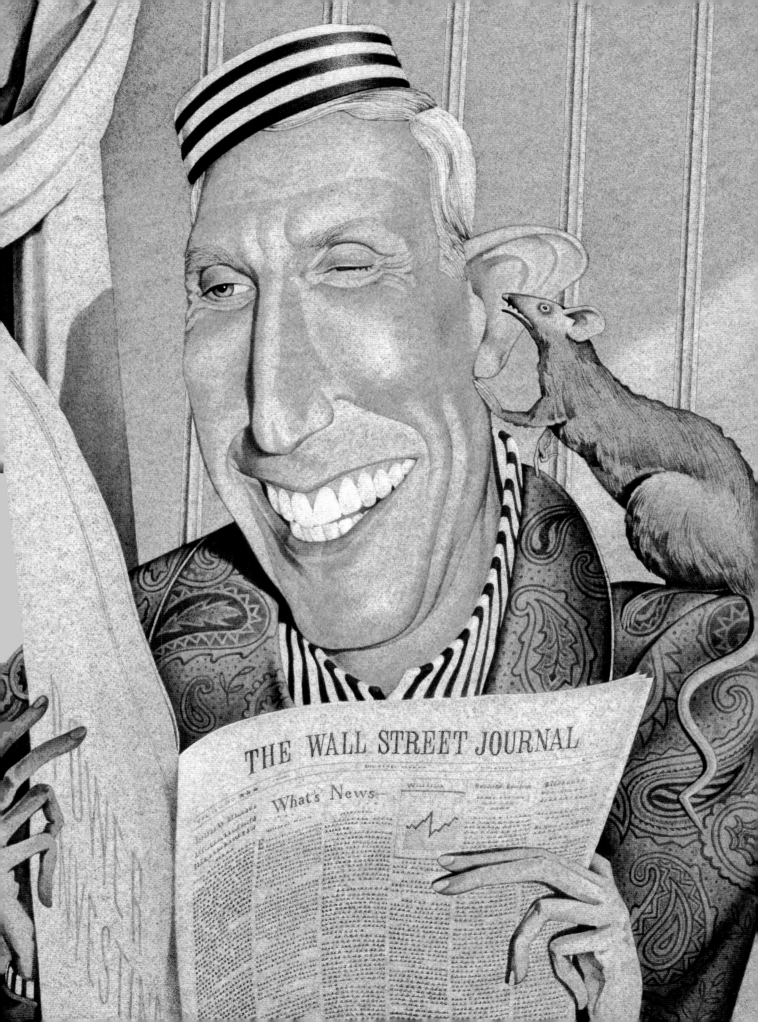

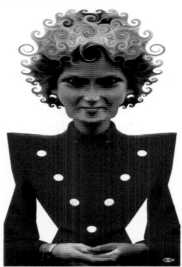

LOUIS FISHAUF
Princess Di
Macweek, 1991
Art Director:
Eleanor Leishman

STEVEN BRODNER
George Bush
The New York Times
Magazine, 1990
Art Directors:
Janet Froelich,
Barbara Richer

witty rendering. Using the same media but less vitriol, Renée Klein's Oprah Winfrey (page 129) and Warren Linn's Michael Jackson (page 137) also demonstrate collage's viability for portrait caricature. Louis Fishauf takes collage in another direction by combining photograph and airbrush in an eerie rendering of Princess Di (left). And Hanoch Piven takes things a step further by adding three-dimensional objects to his paintings, again in the manner of the Dadaists. For his Jesse Jackson (page 81), Pivin made the civil rights leader's mouth from a real radio speaker and his eyes from radio tuning knobs, symbolizing Jackson's oratorical skills. Although some might argue that collage is not as artful as a drafted caricature, collage's virtue—even its strength—is its rawness.

HUMAN EXPERIMENTS

Experimenting on human form is endemic to all caricature. During the Nixon years, British caricaturist Ralph Steadman ceaselessly pushed the limits of facial distortion by stretching the features of his subjects beyond the proscribed requirements for recognition.

MICHAEL WITTE
Donald Trump
Rolling Stone, 1988
Art Director:
Fred Woodward

BLAIR DRAWSON
Ronald Reagan and
Mikhail Gorbachev
Playboy, 1985
Art Directors:
Tom Staebler,
Kerig Pope

BARRY BLITT
Mikhail Gorbachev
Spy, 1991
Art Director:
B. W. Honeycutt

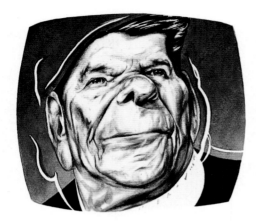

How far he could stretch or congeal a famous face depended on how true he stayed to at least one unmistakable physical feature. In Nixon's case, for example, as long as the President's emlematic ski-slope nose and widow's peak remained somewhat intact, all other features could be distorted beyond recognition. Occasionally, however, the features became so totally abstracted that identification on any level was impossible; this type of heavily distorted piece, whatever other virtues it might have, is problematic as an effective political caricature.

Steven Brodner, who began as a caricaturist in the late 1970s by imitating the work of Thomas Nast and ultimately developed his own distinctive style, also attempts to push facial distortion to its most ridiculous extremities, both as a formal exercise and emotional response to his subject. The formal exercise goes back to the earliest practice of distorted portraiture, recalling the Renaissance artist's need to experiment; the emotional reaction is an honest, visceral response to the subject at hand, as is the case with Brodner's Ronald Reagan series (left). While the political caricaturist should have a gut-level reaction to the more venal members of the body politic, sometimes such severe distortion, as in the case of Steadman's more extreme examples, is self-defeating. Indeed, only a skilled portraitist can take these sorts of radical liberties and remain true to the subject. For Brodner and Steadman, such human experimentation is effective only if the subject's body is not totally mutilated in the process.

C. F. PAYNE
Pete Rose
Whittle
Communications, 1990
Art Director:
Sally Ham

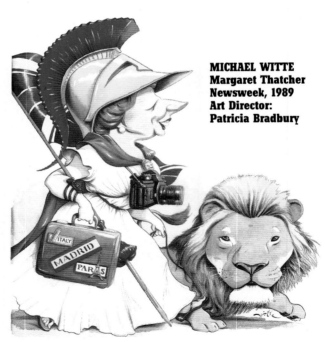

MICHAEL WITTE
Margaret Thatcher
Newsweek, 1989
Art Director:
Patricia Bradbury

STEVEN BRODNER
Ronald Reagan series
Mother Jones, 1987
Art Director:
Kerry Tremain

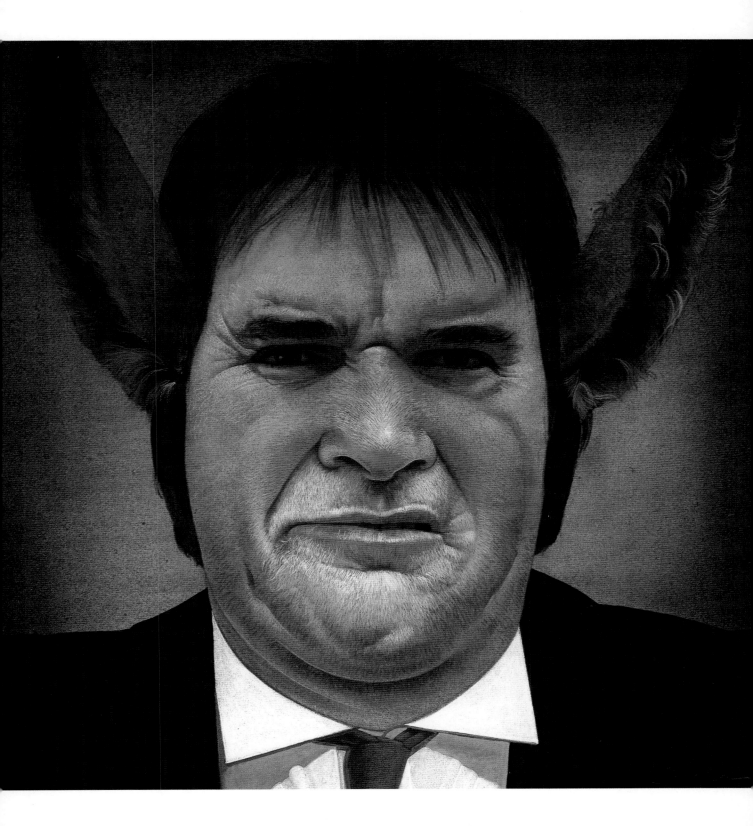

Sometimes, however, radical surgery is its own best reward, such as when the abstraction is so clever that deciphering it provokes the viewer's sense of revelation. In short, if it works, it works! Such is the case with Terry Allen's caricatures of Jack Nicholson (page 113) and Todd Rundgren (page 151). Both are composed of Cubist elements, are drenched in carnival colors, and function like jigsaw puzzles that must be mentally configured within a relatively short amount of time. Even if certain cues are needed—a headline or caption, say—this type of caricature can be deemed a success if the ultimate response is one of total acceptance. If the converse is true, however—if the viewer remains stymied even after the identity of the subject is revealed—then the caricature has certainly failed.

Editors and art directors obviously prefer the more literal caricature, just as they prefer more literal illustration, because it is not as challenging to the reader. Nevertheless, experimental caricatures offer another dimension of experience—a serious artist's

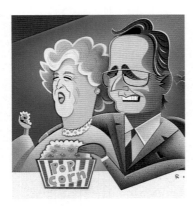

ROBERT RISKO
George and
Barbara Bush
Time, 1988
Art Director:
Rudy Hoglund

STEVEN BRODNER
Jesse Helms
Playboy, 1986
Art Director:
Kerig Pope

JOHN KASCHT
Jesse Helms
Washingtonian, 1990
Art Director:
Lynn Mannino

DUGALD STERMER
Pope John Paul II
series
West, 1987
Art Director:
Bambi Mecklin

SUE COE
Bush AIDS $ & L
Red Hot and Blue,
1990
Art Director:
John Carlin

courageous attempt to push the form, even if it fails, should be appreciated more than the safe solution. Unfortunately, the mass media is not a hothouse for experimentation. Although Allen's caricatures were done for Rolling Stone, most experiments are tolerated only in smaller-circulation publications.

BLOOD AND GUTS

Many artists today practice caricature for the fun of it, and create enjoyable images that are truly fun to decipher. The most powerful expressions, however, are created by those who use portrait caricature to vent their frustrations with politics, society, or culture. One can spot the perfunctory from the heartfelt in a second—the former lacks conviction, the latter is angry to a fault.

The angriest, no-holds-barred *portrait chargés* being produced today are made by Sue Coe, a virtuoso of rage in the tradition of Grosz and Heartfield, with whom she shares a self-styled critical conscience. Although Coe is a skilled drafter, she often eschews conventional aesthetic excellence or purity in favor of effective communication.

One such example, Coe's *Reagan Fruit Bat* (page 75), is neither a pretty drawing nor a flattering portrait: A cadaverous head of Ronald Reagan is grafted onto a bat flying over the map of Panama, as the General Manuel Noriega, represented by an officer's body with a pineapple head, looks on. There is no attempt at overt humor or irony in this metaphoric indictment of the President's policy of greed in the service of national interest. Reagan is frightening, Noriega is disturbing, and the entire image is chilling in what it reveals about American priorities.

SANDRA HENDLER
Elvis Presley
Topic, 1987
Art Director:
Philip Brooker

SUE COE
George Bush and
David Duke
The Progressive, 1992
Art Director:
Patrick J. B. Flynn

SUE COE
The Constitution
The People's Weekly
World, 1988
Art Director:
Seymour Joseph

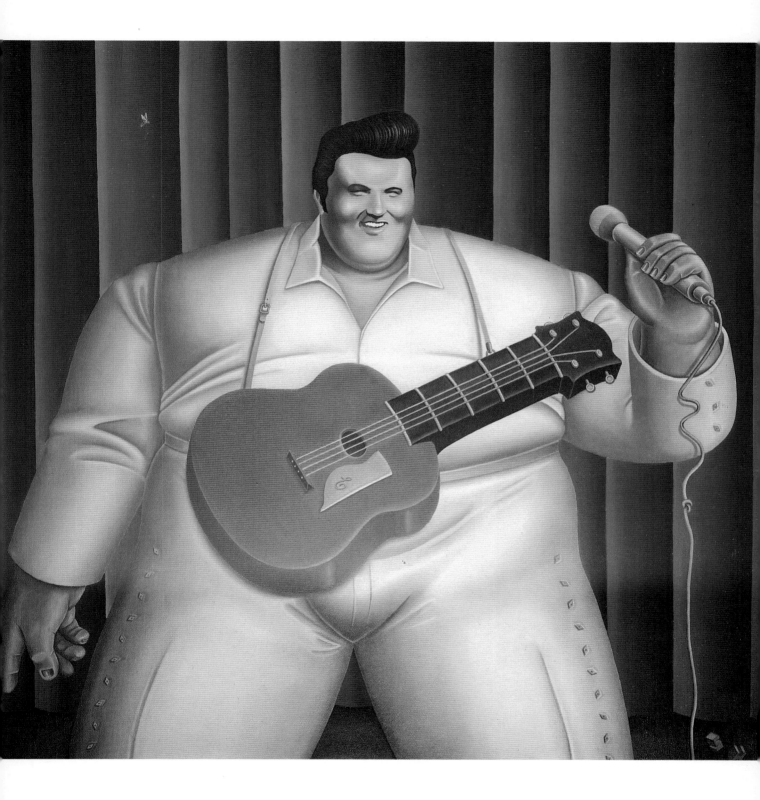

Coe is often purposefully heavy-handed in order to leave no doubts, no hint of ambiguity, about her message. In her political caricatures, she rejects allusion, because she does not want her viewers to be confused or misinterpret. In *The Contra..ct* (below), Reagan takes a Christlike pose revealing stigmata that are the emblems of his political sins; in *Bush, Duke, Presidential Timber. The Root of the Tree Is Rotten* (page 100), she equates the comparatively moderate President Bush to the white-supremacist David Duke through the symbols of money and hate.

Coe often draws her portraits from actual photographs, making only slight distortions in the process. In *Bush AIDS $ & L* (page 100), she exaggerates the President's shoulders but renders his face as nature intended it; only the harshness of the light source makes it an unflattering portrait. In Coe's graphic commentary on the William Kennedy Smith rape trial (left), she renders everyone in the courtroom just as they appeared in the trial's television

SUE COE
Ronald Reagan and
Edwin Meese
The New York
Times, 1987
Art Director:
Jerelle Kraus

BLAIR DRAWSON
Elvis Presley
Texas Monthly, 1986
Art Director:
Fred Woodward

SUE COE
William Kennedy Smith
Unpublished, 1992

SUE COE
Reagan The Contra..ct
Police State, 1987

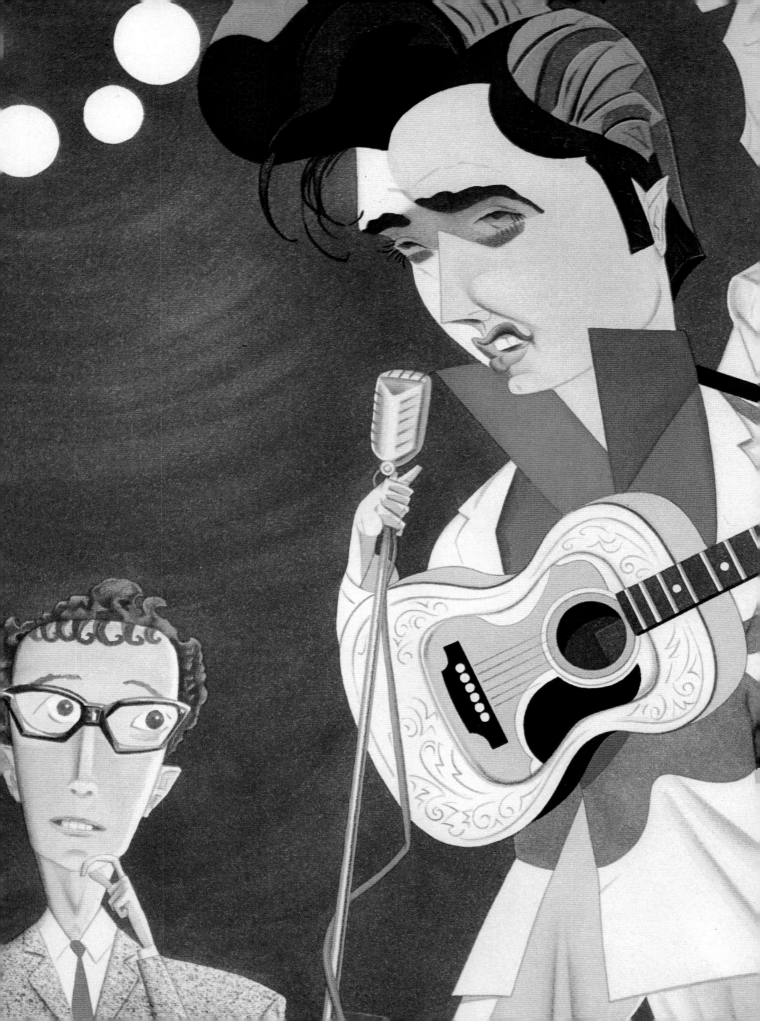

ALAN E. COBER
Bad Boys – Last of the
Coffee Achievers
Manhattan, Inc., 1987
Art Director:
Nancy Butkus

STEVEN BRODNER
John Gotti and
Al D'Amato
Spy, 1991
Art Director:
B. W. Honeycutt

FRANCES JETTER
Geraldo Rivera
Entertainment
Weekly, 1991
Art Director:
Michael Grossman

coverage, but as this portrait suggests (and as is inscribed in a seal above the bench), "Money talks, criminals walk."

Critics have said that Coe's political portrayals are sometimes naïve, too ideologically black and white to be taken seriously. But even if this is sometimes true, her tunnel vision is often balanced out by the irrefutable truths she exposes in the events she documents. Coe uses her caricatures in the service of propaganda, but in doing so she also chronicles her social and political milieu with the same exactitude as did Daumier, Nast, and Grosz.

A trend toward depicting blood and guts in illustration (perhaps better described simply as a trend toward Neo-Expressionism) developed as a result of the frequent appearances of artists like Coe in mainstream publications during the mid-1970s. *Esquire*, art-directed by Robert Priest during this period, was a primary outlet for illustrators practicing this kind of raw, hard-edged approach, which was inspired by German Expressionism, Dada, and the New Objectivity of the 1920s. Another proponent of this approach is Frances Jetter, who makes linocut illustrations from a recipe of roughly two parts gut and one part wit. Another exponent is one of Coe's many acolytes, Sara Schwartz, whose colored-pencil-and-watercolor illustration depicting the murder of Marvin Gaye (page 149) shows the face of horror in an expressionistic composition that recalls the angular scenery in the classic 1919 German horror film *The Cabinet of Dr. Caligari.*

BETH BARTHOLOMEW
Elvis Presley
Unpublished, 1991

SARA SCHWARTZ
Madonna
The National
Lampoon, 1990
Art Director:
Adrienne Baron

IN PURSUIT OF FOLLY

In contrast to these harsh polemical images are the milder caricatures by Michael Paraskevas in his "Know Your Friends, Know Your Enemies (Subject to Change)" series (this page), a collection of playing cards that comment on the Persian Gulf War. The likenesses of the major warring participants are well rendered in a loose caricatural style that is decidedly less polemical and angry than Coe's portraits. Paraskevas renders all his subjects—ally and enemy alike—with an even hand, save for Generals Colin Powell and Norman Schwarzkopf and Egyptian President Hosni Mubarak, who are given slightly more sympathetic features than the rest. The basically non-committal style of caricature in "Know Your Friends" reads as an indictment of all and, therefore, an indictment of nobody. While this type of work clearly has less polemical goals than much of the other work discussed herein, it is nonetheless successful on its own terms. The political critique is there, but it is secondary to the humorous drawings.

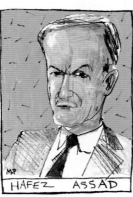

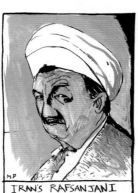

BARRY BLITT
Norman Schwarzkopf
Entertainment
Weekly, 1991
Art Director:
Michael Grossman

ROB DAY
Frank Sinatra
Exposure, 1990
Art Director:
Randy Dunbar

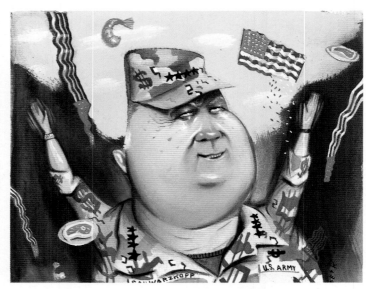

MICHAEL PARASKEVAS
Stormin' Norman,
Hafez Assad,
Hashemi Rafsanjani
"Know Your Friends,
Know Your Enemies"
self-promotional cards
1991

EVERETT PECK
Norman Schwarzkopf
The New York Times
Magazine, 1991
Art Director:
Janet Froelich

STEVEN BRODNER
Saddam Hussein
The New York
Times, 1990
Art Director:
John Cayea

BARRY BLITT
The Reverend
Al Sharpton
Entertainment
Weekly, 1991
Art Director:
Michael Grossman

Not all lighthearted renderings are unoffensive; a great deal depends on intent. When Paraskevas made these caricatures, not much dissenting or satiric graphic commentary was being produced about the Gulf War; any attempt at irony was a welcome change from the typical press reports so expertly manipulated by the government. Indeed, if any political caricature is funny and simultaneously offers even a modicum of truth, then it has done its job. Such is the case with Everett Peck's *Dan Quayle...Just a Heartbeat Away* (page 79), which takes a serious subject—a controversial Vice President's proximity to ultimate power—and makes it into a slapstick gag while forcing the viewer to confront a very frightening proposition.

Similarly, the light-lined and lighthearted caricatures by Barry Blitt in *Spy*, while not always acerbic, are beguilingly seductive. These lilliputian images, almost always used as marginal spots, may seem innocuous at first glance, but some of the more satiric ones, such as George Bush with a bib (page 76), Norman Schwarzkopf in boxer trunks (page 106), and Reverend Jimmy Swaggart with a Devil's tail (page 74), are as caustic as any of the more ambitious caricatures shown here.

CHARLES BURNS
Frank Sinatra
The Village Voice, 1987
Art Director:
Michael Grossman

POST-MODERN DISTORTION

Post-Modernism is a broad-based ethos of contemporary art and architecture that asserts that Modernism's formal purity ignored shades of color and variations on form. Post-Modernism encourages reappreciation of, and borrowing from, the past, and combining old discoveries with new ones to achieve an essential contemporary work. Perhaps this movement

ROBERT DE MICHIELL
Cast of "Monty Python"
The New Yorker, 1991
Art Director:
Chris Curry Burris

DAVID COWLES
David Letterman
Washington
Times, 1992
Art Director:
Dolores Motichka

ROBERT DE MICHIELL
Jack Nicholson
Esquire, 1990
Art Director:
Terry Koppel

explains why some caricaturists have returned to classical drawing and painting, which owe more to the Italian Renaissance than do the previous generation's interest in Victoriana. Although this trend might just be a coincidence in the art of caricature, the pluralism practiced in design and illustration today has nonetheless encouraged a general shift towards Neo-Classicism.

Moreover, caricature is no longer practiced exclusively by the full-time or "professional" caricaturist. Illustrators who would not categorize themselves as cartoonists or caricaturists are now using distorted portraiture to communicate editorial ideas. These caricatures are usually more detailed and intricate than most conventional cartoons, which generally rely on graphic shorthand. And these works are comparatively more intellectually detailed, often with more than one layer of meaning. Although the orthodox cartoonist might argue that this should be described as illustration, not caricature, any drawing

ANTHONY RUSSO
Jack Nicholson
Esquire, 1990
Art Director:
Terry Koppel

DAVID COWLES
Cast of "60 Minutes"
Entertainment
Weekly, 1990
Art Directors:
Michael Grossman,
Robert Lawhorn

LAURIE ROSENWALD
Rickie Lee Jones
The New Yorker, 1990
Art Director:
Chris Curry Burris

JAY LINCOLN
Keith Richards
Unpublished, 1991

ROBERT DE MICHIELL
Vanilla Ice
The New Yorker, 1991
Art Director:
Chris Curry Burris

PHILIP BURKE
Axl Rose
Rolling Stone, 1991
Art Director:
Fred Woodward

C. F. PAYNE
David Byrne
Rolling Stone, 1989
Art Director:
Fred Woodward

or painting that incorporates the distorted portrait as a major component can and should be referred to as caricature. More importantly, the addition of this type of work in magazines has definitely made the industry more felicitous toward all other forms of caricature.

C. F. Payne's elegant illustrations, rendered in colored pencil and watercolor, exemplify this approach. Although they lack spontaneity, because Payne works on assignment rather than responding to his gut instincts, they are no less effective than cartoon caricature. Like most contemporary caricaturists, he works from photographs, not from life, but his comic ideas are fresh. Payne is particularly skilled at capturing and exaggerating nuance, and at isolating key comic moments and gestures. For example, no other artist has satirized musician David Byrne's inherently comic "big suit" as humorously as Payne has done in the vignette with Byrne's tailor (left). Payne's gag says something about the silliness of the costume, while his subtle caricature captures an essence of this cultural icon. Likewise, Payne's series of portraits of George Bush (pages 76–77), in which the President is portrayed as a rap singer, the Beaver, and the ubiquitous "happy face" symbol, are so believably rendered that they push the line between real and distorted portrait. A more obvious distortion is his characterization of rock guitarist Slash (page 155), whose uncensored, off-color remarks during the televised 1991 Grammy Awards show inspired Payne to transform him into the proverbial bad little boy being punished by having his mouth washed out with soap. The artist's attention to detail is exquisite—just look at the soap film on Slash's upper lip.

TERRY ALLEN
Jack Nicholson
Esquire, 1990
Art Director:
Terry Koppel

C. F. PAYNE
Bill Haley
Rolling Stone, 1989
Art Director:
Fred Woodward

C. F. PAYNE
Gene Simmons
Rolling Stone, 1990
Art Director:
Fred Woodward

C. F. PAYNE
William F. Buckley
Spy, 1990
Art Director:
B. W. Honeycutt

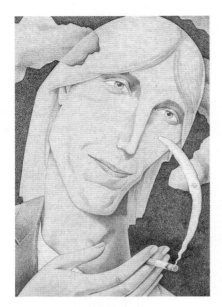

Dugald Stermer is not a caricaturist by trade, but his skill as a portraitist has led him to produce a few subtly distorted depictions. His meticulous, Renaissance-quality drawing style, executed with colored pencils, requires skill and patience, so he usually prefers a straight, no-nonsense representation to radical or slapstick interpretation. Like Payne, however, he is so skillful at achieving likenesses that when he does choose to manipulate features as the basis for satiric situations, the results are compelling by virtue of their fidelity to the original. Such is the case with his series of portraits of Pope John Paul II (pages 98–99), in which the pontiff is placed in the guise of a radical, a construction worker, a diplomat, an intellectual, and as the prelate himself. These images effectively comment on the various roles that the Pope has played as a religious and world leader.

Phil Huling is likewise an illustrator first and caricaturist second, but his sense of the absurd and ability to render likenesses with an appropriate degree

LAURA LEVINE
Buddy Holly
Unpublished, 1990

PHIL HULING
Tom Petty
Rolling Stone, 1989
Art Director:
Fred Woodward

ROBERT DE MICHIELL
Roseanne Barr and
John Goodman
GQ, 1989
Art Director:
Mark Danzig

WARREN LINN
Abbott and Costello
Scott, Foresman
& Co., 1976
Art Director:
Bob Amft

DUGALD STERMER
George Bush
The New York
Times, 1991
Art Director:
Michael Valenti

Buddy Holley

ANITA KUNZ
Chubby Checker
Rolling Stone, 1989
Art Director:
Fred Woodward

ANITA KUNZ
Sinead O'Connor
Rolling Stone, 1990
Art Director:
Fred Woodward

ANITA KUNZ
Mikhail Gorbachev
The Atlantic
Monthly, 1987
Art Director:
Judy Garlan

of exaggeration imbues his otherwise straight portraits with caricatural magic. In his portrayal of Ivan Boesky, the convicted Wall Street financier (page 93), he effectively presents the subject as the "Philosopher of Greed" by elongating his fingers and stretching his face just far enough to achieve a tragicomic effect.

Anita Kunz is another editorial illustrator who stumbled into caricature by accident and now uses distorted portraiture to maximize her satiric ideas. Her paintings are rendered in cake watercolor and white gouache, yet take on the appearance of oils. Though she is an accomplished painter, her power comes from her skill in reducing the most famous people into childlike representations: Transforming Oliver North the architect of the Iran-Contra scandal, into a child's toy (page 85) does not trivialize his serious breech of American law, but underscores the arrogance of his actions; similarly, making Vladimir Lenin into Humpty Dumpty (page 89) does not reduce 80 years of Soviet communism into a fairy tale, but rather symbolizes the fragility and ultimate demise of the Soviet Union. Even the elongation of comedian Jay Leno's characteristic lower jaw (page 127) into a rather unpleasant goiter is not just a gratuitous joke, but a comment on Leno's singular facial characteristics, which have given him an identifiable personality trait.

Blair Drawson takes pride in reducing monumental people into fairy-tale representations too. Given his skill with likenesses, he is just as adept at making the grand distortion of, say, Elvis Presley (page 103) as a mild one of David Bowie (page 153). But Drawson's penchant for the bizarre forces the viewer to

STEPHEN KRONINGER
Woody Allen
Entertainment
Weekly, 1991
Art Directors:
Michael Grossman,
Greg Mastrianni

ANITA KUNZ
The Monkees
Rolling Stone, 1989
Art Director:
Fred Woodward

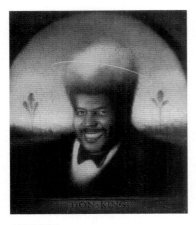

ROB DAY
Don King
The Cleveland
Plain Dealer, 1988
Art Director:
Gerard Sealy

see his characters, whether totally or partially exaggerated, through a jaundiced, critical eye—his portraits take the glamour out of the glamorous. His painterly skills may be built upon a classical foundation, but his images are reminiscent of such twentieth-century painters as Richard Lindner and George Tooker. Conversely, Rob Day has assimilated the style of the Italian Renaissance, and has created ironic portraits of celebrities transported back to that time. His paintings of Ronald Reagan (page 71) and Frank Sinatra (page 107) are not distorted in the radical sense of caricature, yet the entire compositions function as parodies of how these men might have been rendered in that heroic light. But Day's Sinatra is not really portrayed as a saint, and Reagan does not really come off as the wise nobleman—each is portrayed as cunning and self-possessed.

If Hieronymus Bosch made caricatures, they might look like what Janet Woolley has been painting for a variety of British and American magazines.

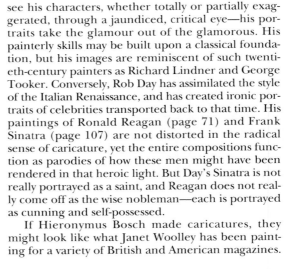

ROBERT RISKO
Spike Lee
Rolling Stone, 1991
Art Director:
Fred Woodward

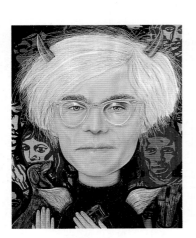

JANET WOOLLEY
Andy Warhol
Savvy, 1988
Art Director:
Pamela Berry

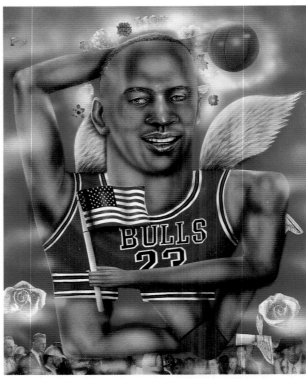

JANET WOOLLEY
Michael Jordan
Esquire, 1990
Art Director:
Terry Koppel

JOHN KASCHT
Sammy Davis Jr.
Northeast, 1989
Art Director:
Roxanne Stachelek

SANDRA HENDLER
Andrew Dice Clay
Esquire, 1991
Art Director:
Rip Georges

JOHN KASCHT
Spike Lee
Whittle
Communications, 1989
Art Director:
Sheri Blankenship

LILLA ROGERS
Tracy Chapman
and Bob Dylan
Musician, 1989
Art Director:
Pat Mitchell

Woolley's method is a marriage of exquisite anatomical rendering cut with a funhouse sensibility. Her distortions seem to come about as if her subjects had first been photographed through anamorphic lenses, and then had their bodies drawn, quartered, and reconfigured with certain integral parts missing. Her subjects' heads tend be elephantine in relation their bodies. In her caricature of James Brown (page 139), for example, the head was grafted onto what seems like a puppet's frame. To add even more symbolic weight to her illustrations, Woolley collages preprinted imagery and found minutia whenever possible.

The quotation of historical form is not unique to this current Post-Modern era, and neither is borrowing artistic mannerisms new to caricature. Some artists are more overt than others; some digest another period's or individual's style and make it part of their personality. Many stylistic felons are ignored in this book, because they have taken a style in its entirety without interpreting it in any unique or personal way. But subjectively speaking, the exceptional borrowers are not ignored here when the result is a commentary or parody on another artist's style, rather than petty theft for commercial gain. Sandra Hendler's Elvis (page 101) is an example of using a contemporary artist's signature—in this case, that of Spanish painter Fernando Bottero (who has been copied by a number of contemporary illustrators)—to best advantage. What better way to caricature the King in his last years than to subject him to Bottero's balloon-like distortion.

MICHAEL THIBODEAU
Spike Lee
Unpublished, 1990

BRIAN AJHAR
Mike Tyson and
Robin Givens
Rolling Stone, 1988
Art Director:
Fred Woodward

ROBERT DE MICHIELL
Billy Idol
The New Yorker, 1990
Art Director:
Chris Curry Burris

DAVID COWLES
Cher
US: The Entertainment
Magazine, 1990
Art Director:
Jolene Cuyler

ART DECO CARICATURE

Consistent with the Post-Modern preference for "something borrowed, something new," revivals of once-passé commercial styles of design and illustration are underway. Among the most frequently reapplied today is the stylistic manifestation from the late 1920s and 1930s variously known as Art Moderne, Streamline, and Art Deco. Although this style encompassed a variety of graphic approaches, certain traits were common to all. Unlike Art Nouveau, which involved sinuous and curvilinear form, Art Deco was more hard-edged and rectilinear. Deco borrowed from (yet softened the austerity of) Modernism, adapted the graphic traits of Cubism, and incorporated Mayan, Egyptian, and Native American decorative motifs. In its Streamline form, which was a metaphor for the future, the airbrush was commonly used to give weight and mass to two-dimensional form. The paradigmatic Deco products—fashion, furniture, posters, packaging—are identifiable today because they embody many of these essential ingredients. Likewise, the caricature masters of the period—Paolo Garretto, Miguel Covarrubias—conformed to standards of the day.

EVERETT PECK
Andy Warhol
Regardie's, 1990
Art Director:
John Korpics

ROBERT RISKO
Sam Donaldson and
Diane Sawyer
Mirabella, 1990
Art Director:
Karen Lee Grant

DAVID COWLES
Spy Celebrities
Spy, 1991
Art Director:
B. W. Honeycutt

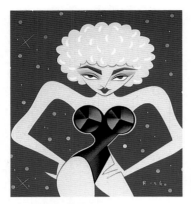

ROBERT RISKO
Madonna
USA Today
Magazine, 1990
Art Director:
Nancy Steiny

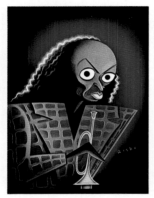

ROBERT RISKO
Miles Davis
Interview, 1989
Art Director:
Henry Connell

DAVID COWLES
MC Hammer
Entertainment
Weekly, 1991
Art Director:
Michael Grossman,
Miriam Campiz

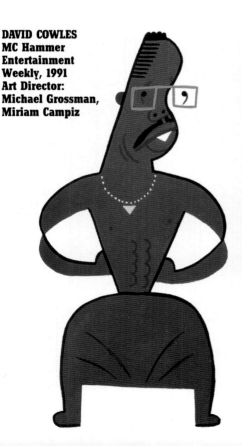

Today the influence of these venerated masters crops up in cultural and, to a lesser extent, political caricature. Five illustrators in this book have immersed themselves in this vocabulary and synthesized Art Decoisms in the development of their personal styles. Robert Risko reveals a blend of Garretto and Al Hirschfeld in airbrush and line drawings that seem simultaneously nostalgic and contemporary. Ironically, when Garretto attempted to make a comeback in the 1980s, his style appeared old-fashioned when he drew celebrities like the Beatles, Elton John, and Margaret Thatcher. But Risko, using the same basic forms, manages to make Miles Davis (left), Mick Jagger (page 143), and George and Barbara Bush (page 98) look current, while still evoking that singular period when lighthearted, stylized caricature was in vogue. Likewise, Robert de Michiell uses Deco mannerisms as a formal means of accentuating the key traits of contemporary celebrities. In both cases, the caricatures are essentially flattering.

Covarrubias informs David Cowles's caricatures, particularly those rooted in the Cubist vocabulary. And Cowles, like Covarrubias, is skilled at getting likenesses from the manipulation of various geometric forms. His rendering of Oliver North (page 83) initially seems lighthearted, but on second look it becomes a savage likeness. It is also expertly designed, with every odd detail—which, taken out of context, would never reveal the subject's identity—fused in such a way that it is unmistakably Colonel North. One

STEVEN BRODNER
David Letterman
Entertainment
Weekly, 1991
Art Directors:
Michael Grossman,
Robert Lawhorn

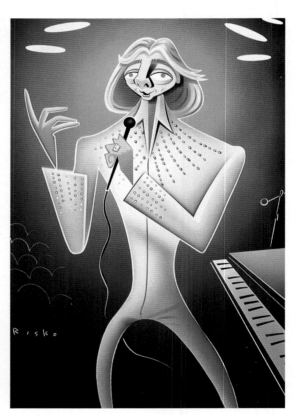

ROBERT RISKO
Barry Manilow
Rolling Stone, 1990
Art Director:
Fred Woodward

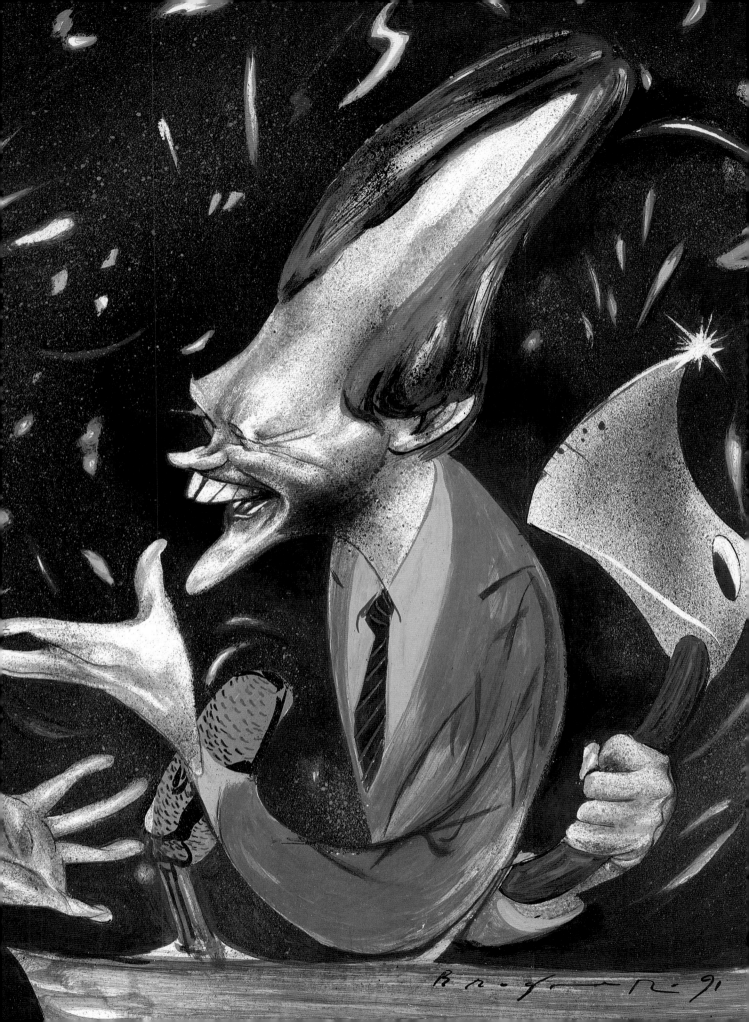

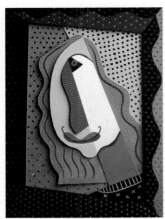

DAVID COWLES
Barbra Streisand
Miami Herald, 1991
Art Director:
Rhonda Prast

might suspect that the final effect is just a fortuitous accident, but Cowles's three-dimensional caricature of Barbra Streisand (left), rendered in variously colored cut paper, belies that theory. Some faces are perfectly cubistic, while others, like Madonna (page 148), require more physiognomic fidelity.

Terry Allen is at once the most derivative and the most experimental of the Deco-era revivalists. While he draws inspiration from Garretto, he has pushed the limits of the airbrush and cubistic space in his caricatures of Jack Nicholson (page 113) and Todd Rundgren (page 151). Allen's all-star jam session (below) is a gaggle of distortion in which he focuses the essential traits of each of the subjects through streamlining their basic physical forms. In these and other works, Allen pushes his caricatures to the point of forcing the viewer to take a Rorschach test. While such an approach is risky in a genre that essentially demands fairly rapid viewer recognition, the use of a simple caption or other identifying cue provides enough instant contextualization, so that a reader

ANITA KUNZ
Jay Leno
GQ, 1989
Art Director:
Robert Priest

DAVID COWLES
Arsenio Hall
Unpublished, 1991

TERRY ALLEN
All-Star Jam Session
Stereo Review, 1990
Art Director:
Sue Llewellyn

DAVID COWLES
Eric Clapton
Guitar World, 1991
Art Director:
Jesse Reyes

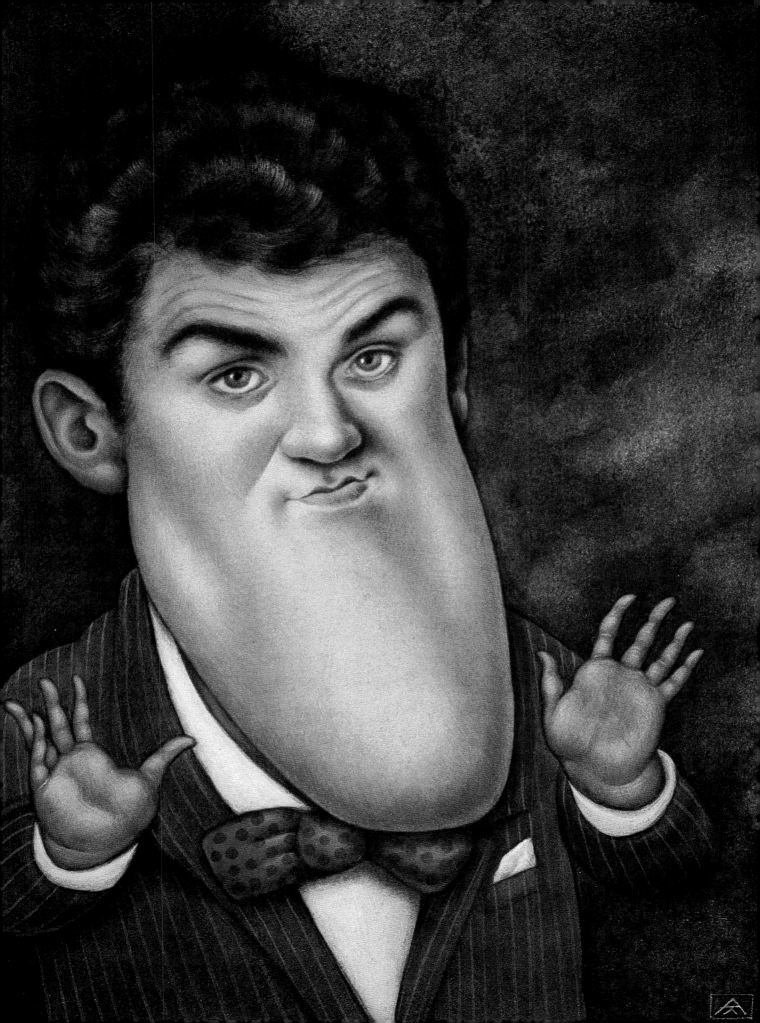

MARK ALAN STAMATY
Ronald Reagan
From "Washingtoon"
The Village Voice, 1990
Art Director:
Michael Grossman

who "doesn't get it" on first glance can still experience the same sense of revelation as one who does.

Jose Cruz's work is a total synthesis of Art Moderne and Post-Modernism. The typical Decoisms in his caricature of Cyndi Lauper (page 133) are enlivened with such vibrant colors and raucous textures that the piece becomes the graphic arts equivalent of Mardi Gras. This image, like those of Cowles and Allen, was clearly designed with precision—Cruz leaves nothing to chance. But the likeness is fresh and exciting, and captures the essence of Lauper's stagecraft.

CARTOON CARICATURE

Since 1981 Mark Alan Stamaty has been writing and drawing "Washingtoon," a satiric comic strip that appears weekly in the *Washington Post* and the *Village Voice*. It features a cast of imaginary political characters, including Bob Forehead, who is the embodiment of the fence-sitting, back-sliding Congressmen that have become typical of the American political system. The strip also features a few real-life pols who require no symbolic stand-ins because they caricature themselves so perfectly, including Presidents Reagan and Bush, who Stamaty has caricatured in a rough, shorthand manner that makes it easy for him to quickly redraw them as many times as is necessary during the course of a strip. In "Washingtoon," the writing must take precedence over the drawing to

RENÉE KLEIN
Oprah Winfrey
The Boston Globe
Magazine, 1988
Art Director:
Lucy Bartholomay

CHARLES BURNS
Peter Garrett
Rolling Stone, 1990
Art Director:
Fred Woodward

DREW FRIEDMAN
Dan Quayle
Spy, 1989
Art Director:
B. W. Honeycutt

LAURIE ROSENWALD
Willem de Kooning
The New Yorker, 1990
Art Director:
Chris Curry Burris

CHARLES BURNS
Madonna
Rolling Stone, 1990
Art Director:
Fred Woodward

ensure an effective result; in fact, Stamaty takes as many shortcuts with the drawing as possible in order to focus on ideas and meet his grueling deadlines. Nevertheless, Stamaty has created a Reagan (page 128) and Bush that, though not always perfect likenesses, are recognizable enough to serve his caustic narrative.

Charles Burns is known for comic strips, which satirically borrow from the conventions of the horror comics of the 1950s and '60s. His meticulous pen-and-ink style is starkly beautiful. When he makes his rare forays into caricature, he adopts the visual language common to romance comics, as evidenced by his Madonna portrait (left). In this image, Burns appropriates form in the same way that Roy Lichtenstein did for his pop-art paintings in the 1960s, but he is also commenting on Madonna's nostalgic makeovers. And in Burns's caricature of Frank Sinatra (page 109), he uses comics convention to reveal the internal wolf that makes Ol' Blue Eyes really tick.

STEVEN BRODNER
Madonna
GQ, 1991
Art Director:
Robert Priest

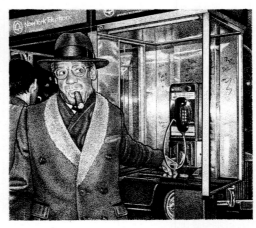

DREW FRIEDMAN
Bill Cosby
Spy, 1989
Art Director:
B. W. Honeycutt

BARRY BLITT
John Wayne
Spencer Francey
Design, 1988
Art Director:
Jennifer Coghill

JOHN KASCHT
Prince
GQ, 1991
Art Directors:
Robert Priest,
Charlene Benson

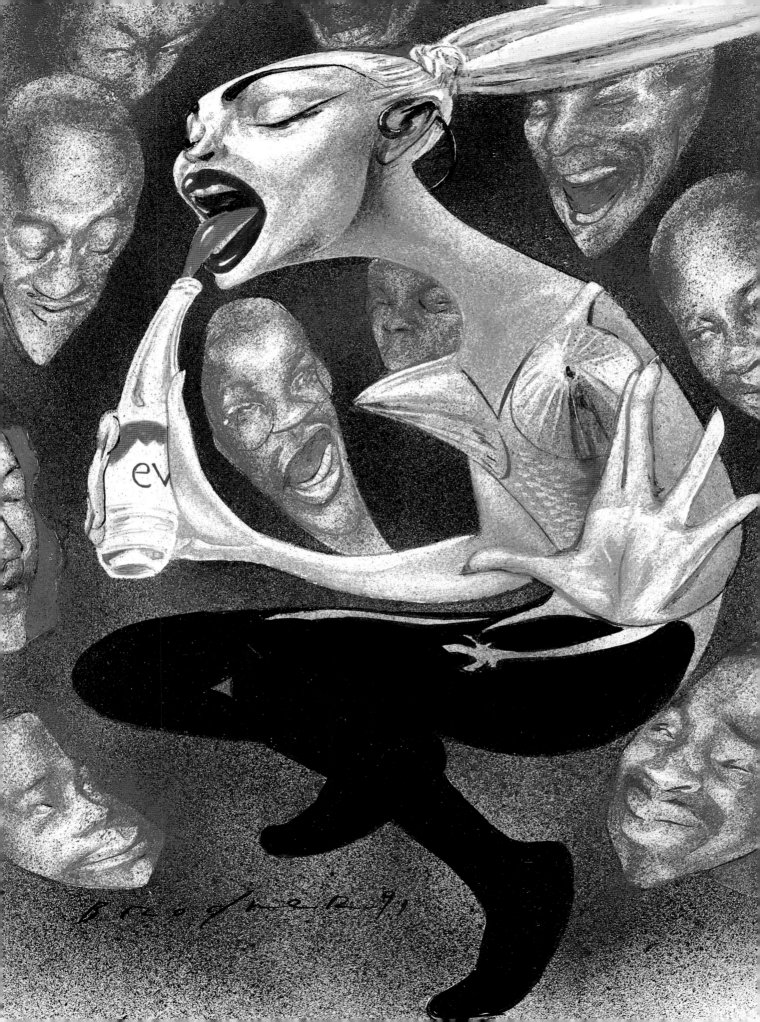

LAURA LEVINE
Fats Domino
Unpublished, 1990

LAURA LEVINE
James Brown
Unpublished, 1990

BETH BARTHOLOMEW
The Reverend
Al Sharpton
Unpublished, 1991

PRIMITIVE DISTORTION

Not all caricature is premeditated. Certain "straight" portraits that did not set out to be caricatures can, by virtue of their naïve or Art Brut qualities, be construed as caricature. Some of the most beguilingly honest distortions come from artists who follow their intuition rather than the accepted rules of art. Laura Levine's interpretations of Fats Domino (left) and Buddy Holly (page 115) are not primitive in the orthodox sense, since the artist is not some unknown talent who has been locked away in a shack for the better portion of her adult life producing unheralded works of genius. In fact, Levine is a professional photographer who tired of the literalism in her photographic work and tried a new artistic path. With no art schooling to guide her, she addressed the formal problems of portraiture in the only way she knew how—through pure intuition. The results are simplified, unpretentious, almost childlike renditions of rock, soul, and blues icons. The primitive nature of these images should not suggest that they are without serious merit—to call them artless would be a grave error. Like the other artists in this primitive category, Levine may have chosen primitivism because of either necessity or impulse, but she clearly employs it by design.

Beth Bartholomew's portraits are the only sewn caricatures in this book. Her work is influenced by folk art, and is therefore not intended to be purposefully critical, or even distorted, but the medium

JOSE CRUZ
Cyndi Lauper
Rolling Stone, 1986
Art Director:
Derek Ungless

LAURA LEVINE
Patsy Cline
Unpublished, 1990

PATTY DRYDEN
Ella Fitzgerald
The George and
Ira Gershwin
Songbook, 1978
Art Director:
Basil Pao

itself does not allow for true fidelity to her subjects. Bartholomew made her elder, plump Elvis (page 105) into an icon and placed him in his own little reliquary—in a sense, a caricature of how Elvis is revered in America. To portray a controversial activist like the Reverend Al Sharpton (134), the artist portrayed him in his hospital bed after he was shot in a real-life fracas; the nailed frame might be seen a commentary on Sharpton's dubious position as hero–instigator.

Josh Gosfield has developed a primitive style that owes as much to folk art as it does to the current tendencies for graffiti-like representation in art. His portrait of musician Wynonie Harris (page 147), rendered in oil, recalls both the early Modernists (e.g., Stuart Davis) and the American regionalists, with a tip of the hat to typical Mexican and Caribbean storefront signs. In his portrait of the Who (below), he renders his subjects in the manner of a first-year art student who might attempt to make a serious

PHILIP BURKE
Sinead O'Connor
Los Angeles
Times, 1990
Art Director:
Tracey Croe

JOSH GOSFIELD
The Who
Rolling Stone, 1990
Art Director:
Fred Woodward

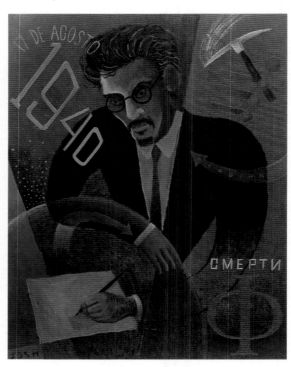

JOSH GOSFIELD
Leon Trotsky
Unpublished, 1987

PATTY DRYDEN
Louis Armstrong
Stardust, 1988
Art Director:
Chris Austopchuk

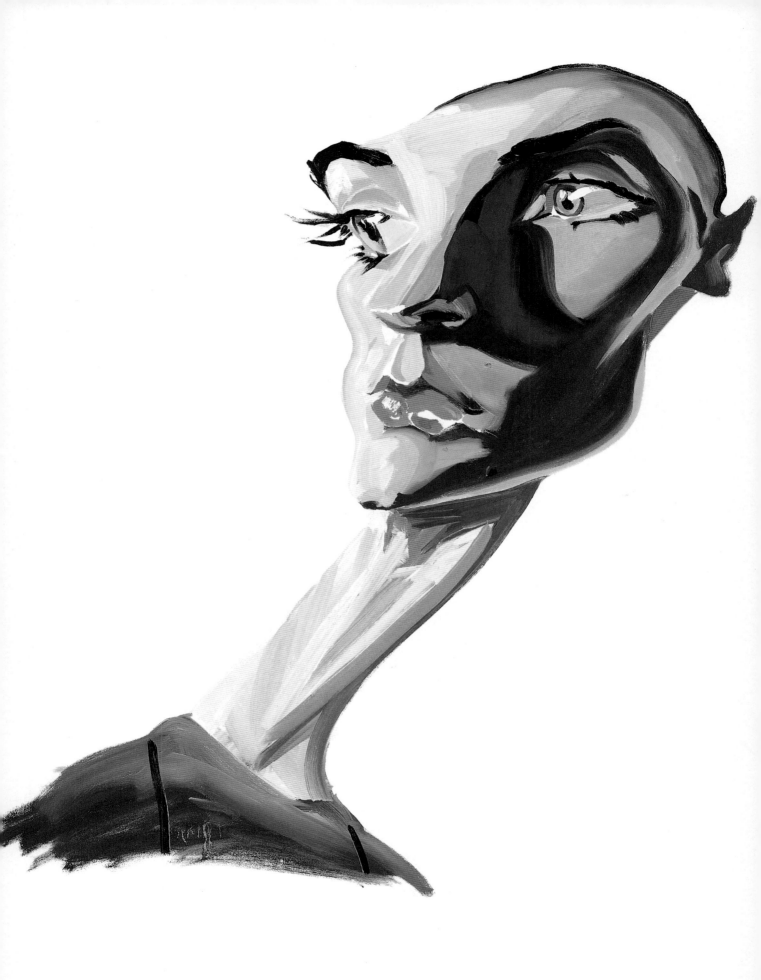

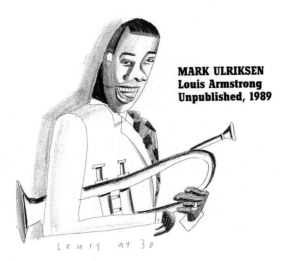

MARK ULRIKSEN
Louis Armstrong
Unpublished, 1989

portrait but ends up with inadvertent distortion. While Gosfield's work speaks more to issues of style than who or what the subject has to impart, the result is still an alluring illustrative portrait.

The Post-Modern trend in illustration toward Art Brut approaches has given rise to a trend in distorted portraits by illustrators who are not caricaturists but occasionally make portraits. Daniel Nevins's collage-painting of Bob Dylan (left) answers the traditional demands of *portrait chargé* by being a faithful distortion of a well-known personality. Although not naïve in the folk-art tradition, the distortion emerges as a function of the illustration style itself, which is self-consciously primitive. Similarly, Lilla Rogers's portraits of Dylan and Tracy Chapman (page 120) are not caricatures in the strict sense—they're distorted "look-alikes," dictated by her Art Brut sensibility. And Mark Ulriksen's drawings of the Beatles (below) and Louis Armstrong (left), Anthony Russo's Jack Nicholson (page 111), and Laurie Rosenwald's Willem de Kooning (page 128) and Alfred Hitchcock (page 152) are not really Art Brut, but use a similar mechanism by employing rough impressions to evoke a sense of spontaneity and immediacy.

WARREN LINN
Michael Jackson
Movieline, 1992
Art Director:
Scott Miller

TWEAKING FEATURES

Most illustrators do not turn the human form inside out in the quest for the perfect caricature. Subtle and discreet is the way to describe an entire genre of mild caricature in which features are only tweaked to achieve a certain effect. Patty Dryden's rendition of Lou Reed (below) is only a caricature by virtue of her

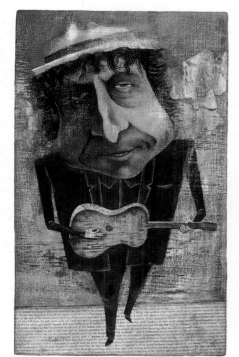

PATTY DRYDEN
Lou Reed
Rolling Stone, 1982
Art Director:
Stephen Doyle

DANIEL NEVINS
Bob Dylan
Unpublished, 1991

MARK ULRIKSEN
The Beatles
Unpublished, 1990

JOE CIARDELLO
Bertrand Russell
Unpublished, 1991

stylized reduction of physical features into a flat, iconic portrait. On a slightly more abstract note, Alan E. Cober's portraits are rarely precise replicas, but neither are they violent attacks on his subjects' physiognomies. Cober's method of drawing is to simplify the human form by ignoring the rules of anatomy. While the results are not as primitive as the work of, say, Gosfield or Levine, his figures are sometimes intentionally foreshortened, as if the artist were rendering them while looking down from a ladder; sometimes the appendages are miniaturized or exaggerated, as if he were putting two different bodies together. Yet Cober's typical portraits, such those of astronaut Alan B. Shepard and singer Jimmy Dean (both below), are remarkably true to life.

In much the same way, both Joe Ciardello and Jack Unruh capture the essential qualities of their subjects with a minimum of distortion. Unruh's mild, linear *portrait chargé* of Muddy Waters (page 140) and Ciardello's of Charles Mingus (bottom left) succeed

JANET WOOLLEY
James Brown
Entertainment
Weekly, 1991
Art Directors:
Michael Grossman,
Greg Mastrianni

ALAN E. COBER
Alan B. Shepard
Texas Monthly, 1986
Art Director:
Fred Woodward

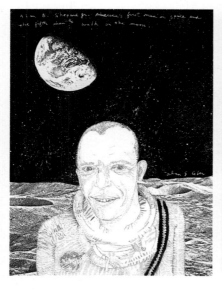

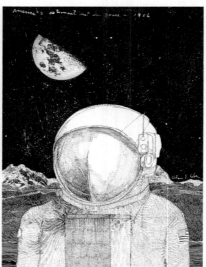

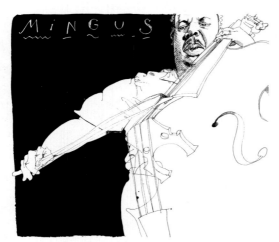

JOE CIARDELLO
Charles Mingus
Like Jazz, 1992
Art Director:
Patrick J.B. Flynn

ALAN E. COBER
Jimmy Dean
Texas Monthly, 1983
Art Director:
Fred Woodward

JACK UNRUH
Muddy Waters
Rolling Stone, 1990
Art Director:
Fred Woodward

because they are drawn with compassion, but at the same time the subjects are being discreetly tweaked. Neither drawing was rendered for the purpose of obscuring recognizability, but they weren't meant to be straight portraits either. The result is a respectful, expressionistic representation.

Mark Summers rejects this kind of sketchy approach but accomplishes the same end in scratchboard portraits reminiscent of nineteenth-century wood engravings. A typical Summers piece subtly distorts a key feature to dramatize the subject. With Tom Wolfe (below), Summers ever so slightly changed the scale of the subject's head to his body, enlarging the head just enough to draw attention to Wolfe's characteristically dapper pose. He did the same with the Rolling Stones, in a technique that suggests that the band members' heads were detached and then grafted onto slightly smaller torsos. In Summers's head-and-shoulders drawing of Charles de Gaulle, however, the artist craftily stretched his subject's neck and tightened his collar, forcing a slight bulge at the neckline, just to keep this image from becoming a mundane portrait.

While Summers shows no malice in his work, Drew Friedman does, and defaces his subjects with only a modicum of distortion and a maximum of absurdity. For his regular "Private Lives of Public Figures" feature in *Spy*, Friedman uses a pen-and-ink stipple-point technique to render relatively lifelike portraits of his subjects, whom he places in ridiculous

PHILIP BURKE
Ice Cube
Rolling Stone, 1990
Art Director:
Fred Woodward

MARK SUMMERS
The Rolling Stones
The New Yorker, 1990
Art Director:
Chris Curry Burris

MARK SUMMERS
Tom Wolfe
The New York Times
Book Review, 1987
Art Director:
Steven Heller

MARK SUMMERS
Charles de Gaulle
The New York Times
Book Review, 1991
Art Director:
Steven Heller

situations. In his depiction of America's second family (page 128), the Vice President and Mrs. Quayle and their kids laugh at the Sunday funnies in candid poses calculated to be insulting. Another drawing finds a very credible representation of Bill Cosby slyly dipping his fingers into a pay phone's coin return (page 130), while the caption dryly observes that Cosby is "never to busy to consider a financial opportunity." Friedman's ability to transform even the most believable visage into a tool of malice is made clear in his rendering of Ronald Reagan's eightieth-birthday party, in which Nancy laughs as she feeds the former President some cake, which drips from his mouth like foam from a rabid dog. Through his expert likenesses, Friedman creates a beguilingly topsy-turvy world.

READ MY FACE

Some might argue that caricature is relatively easy—easier than straight portraiture, in fact, thanks to the license afforded the caricaturist (a luxury the portraitist cannot enjoy). But caricature is a challenge to do with any degree of originality, because the genre's

MICHAEL WITTE
Charles Dickens
The New Yorker, 1991
Art Director:
Chris Curry Burris

ROBERT RISKO
Mick Jagger
Interview, 1986
Art Director:
Marc Balet

the thinking man's moron

BARRY BLITT
Arnold Schwarzenegger
Unpublished, 1991

JOHN KASCHT
Katherine Hepburn
The Washington
Times, 1990
Art Director:
Dolores Motichka

JOHN KASCHT
Bruce Springsteen
The Washington
Times, 1988
Art Director:
Joe Scopin

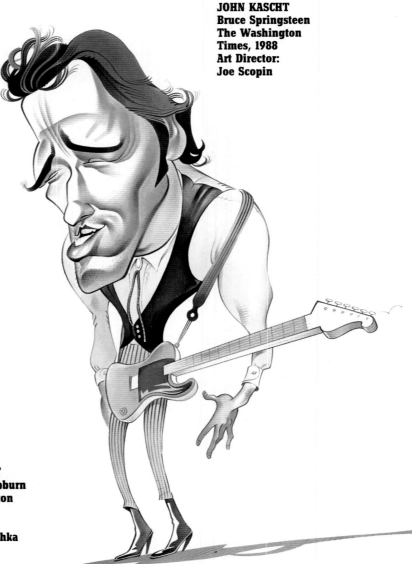

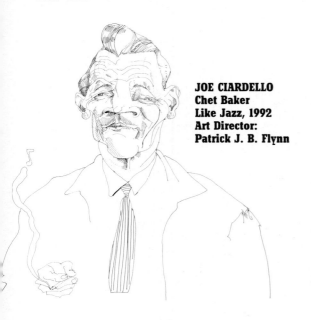

JOE CIARDELLO
Chet Baker
Like Jazz, 1992
Art Director:
Patrick J. B. Flynn

MICHAEL WITTE
Chuck Berry
The New Yorker, 1990
Art Director:
Chris Curry Burris

MICHAEL WITTE
Michelle Pfeiffer and
Al Pacino
The New Yorker, 1991
Art Director:
Chris Curry Burris

various conventions are so well established. Having now examined some of the innovations devised by the new wave of caricaturists, let's examine how some members of the new generation have taken on the more traditional approaches.

Michael Witte has a long track record as an illustrator. Since the late 1980s, he has devoted much of his attention to serious caricature. His elegant, curvilinear approach owes a debt to the nineteenth-century English masters. Yet his caricature of Donald Trump (page 95) is an amalgam of Victorian and Art Deco mannerisms. The linear flourishes in his caricatures of New Kids on the Block (page 154), Carmen Miranda (page 86), and Joe DiMaggio (below) are also reminiscent of early Al Hirschfeld. Yet Witte has assimilated these traditions into a distinct personal style that may evoke the Golden Age of Caricature, but speaks to the here and now. The same is true for Brian Ajhar's pencil rendering of Mike Tyson and Robin Givens (page 120), which synthesizes a variety of traditional cartoon approaches into a personal style.

John Kascht appears to reflexively use the big-head–little-body conceit in many of his drawings, while in others he allows the subject to lead the way to the right solution. Kascht is a traditionalist: His airbrush and watercolor distorted portraits are as extreme or mild as the subject demands, yet in the tradition of the newspaper cartoonist, his work is funny but rarely insulting. Kascht will exaggerate a physical feature or piece of clothing in order to

JOHN KASCHT
Mick Jagger
The Press, 1990
Art Director:
John Ealy

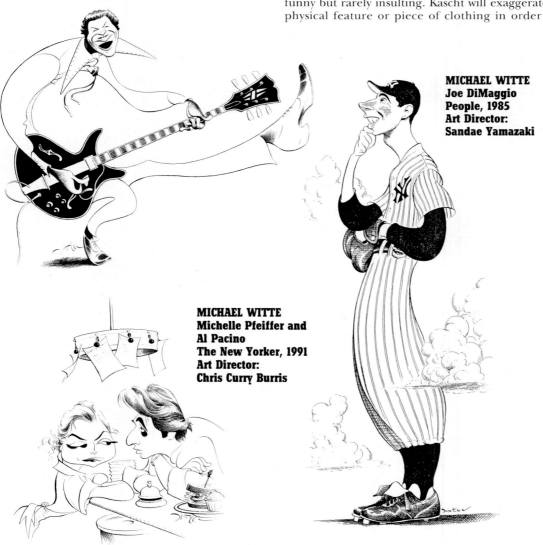

MICHAEL WITTE
Joe DiMaggio
People, 1985
Art Director:
Sandae Yamazaki

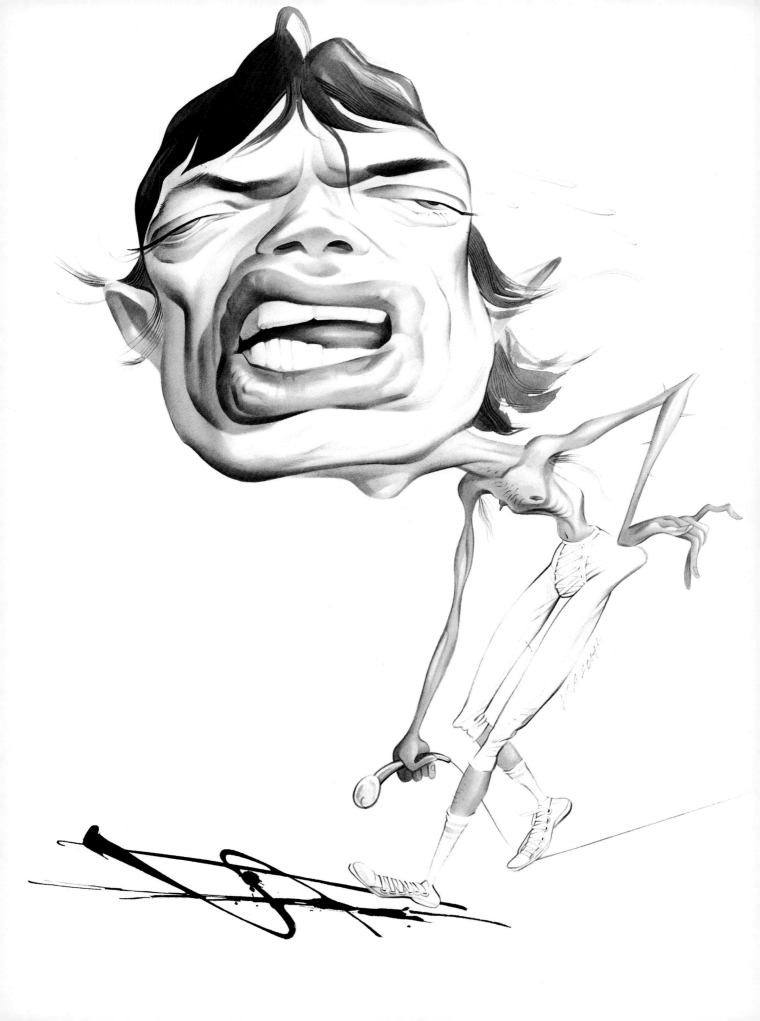

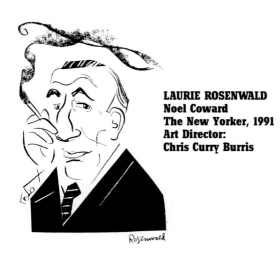

LAURIE ROSENWALD
Noel Coward
The New Yorker, 1991
Art Director:
Chris Curry Burris

achieve a strong aesthetic effect, but his caricatures are solutions to more formal problems of image making than graphic commentaries, as evidenced by his tame portrayal of Senator Jesse Helms (page 98). His most violent distortion was reserved for Mick Jagger (page 145), whose own self-caricatural stance was even further exaggerated by Kascht's deft hand.

Some artists are better suited than others to making radical distortion. In certain hands the distortions are silly, while in others there is a natural tendency to make the incredible quite credible. Jay Lincoln's caricatures of Jagger (page 152) and Madonna (page 148) place these stars in front of the funhouse mirror, and his drawing of Robert De Niro (page 152) stretches and pulls its famous face—not from any critical standpoint, but for comic effect.

Caty Bartholomew does not use many of the typical conventions to create her witty likenesses, but her

JOSH GOSFIELD
Wynonie Harris
Unpublished, 1986

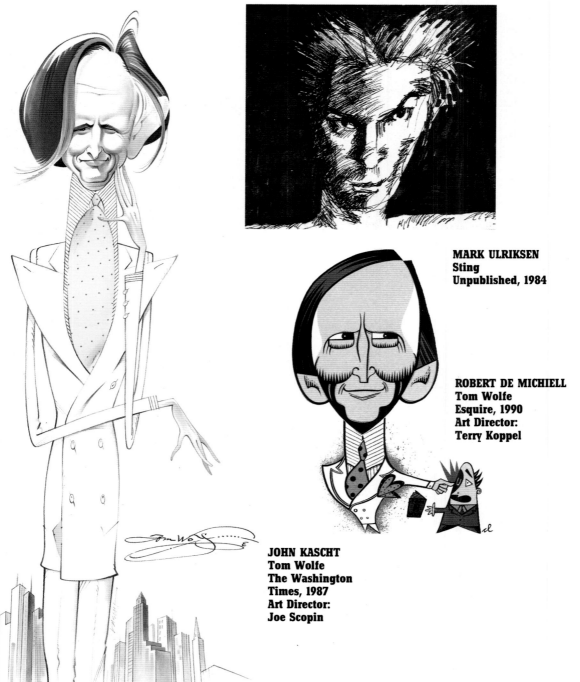

MARK ULRIKSEN
Sting
Unpublished, 1984

ROBERT DE MICHIELL
Tom Wolfe
Esquire, 1990
Art Director:
Terry Koppel

JOHN KASCHT
Tom Wolfe
The Washington
Times, 1987
Art Director:
Joe Scopin

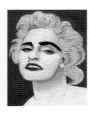
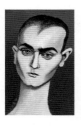
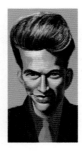

works are nevertheless caricatures by virtue of their subtle distortion. While the treatment of Arsenio Hall's head (left) is an obvious exaggeration, her David Letterman and George Bush are humorous because of the deftness of her painting style, which captures the essence of each personality without straining for a joke. The simplicity of Bartholomew's Spike Lee can be compared to the grotesquery of Michael Thibodeau's Lee caricature (page 121) to show how two different artists read the same face. Neither rendering is particularly demeaning—at least in the sense that the subject is being studied, not insulted—yet Bartholomew downplays Lee's distinctive facial characteristics, while Thibodeau exaggerates at every opportunity. Ultimately, however, both treatments are sensitive: Bartholomew's for its grace, Thibodeau's for its balanced distortion.

SARA SCHWARTZ
Marvin Gaye
Art Direction, 1985
Art Director:
Amy Sussman

WHICH LEGENDS ARE CARICATURED MOST?

Political caricature is making a comeback. The White House, Congress, and even the Supreme Court are such wellsprings of folly today that editors and readers are willing to have these people unmasked and satirically punished for their assorted transgressions. Presidents have been particularly easy targets for caricaturists for almost 200 years, but George Bush, curiously enough, has not been as caricatured with as much venom as other chief executives. Perhaps his nondescript appearance defies reflection in the savage mirror. In any case, at the height of this current revival, only a handful of caricaturists have really put Bush squarely in their sights.

CATY BARTHOLOMEW
Self-promotional pins of Spike Lee, Madonna, Sinead O'Connor, Harry Connick Jr., Arsenio Hall, and David Letterman
1991

DAVID COWLES
Madonna
Los Angeles Times Magazine, 1991
Art Director:
Steve Banks

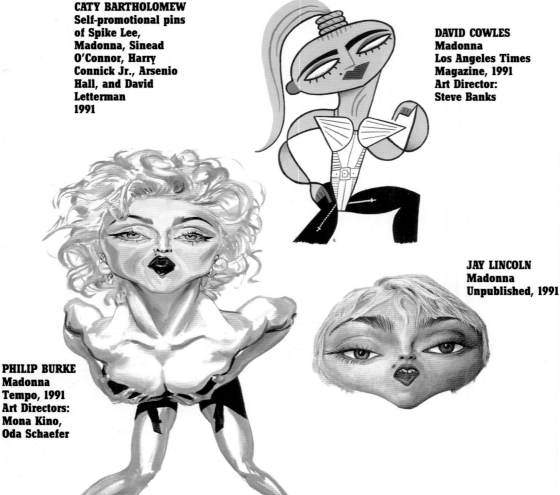

JAY LINCOLN
Madonna
Unpublished, 1991

PHILIP BURKE
Madonna
Tempo, 1991
Art Directors:
Mona Kino,
Oda Schaefer

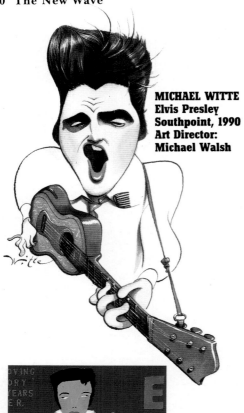

MICHAEL WITTE
Elvis Presley
Southpoint, 1990
Art Director:
Michael Walsh

The New Wave is actively pursuing culture heroes, however, and for all the obvious reasons: Stars and starlets are luminescent targets, and they're always fun to draw. Yet there is another reason, which parallels the increase in entertainment-oriented "journalism," or *infotainment*, as it's often called: More television shows (including an entire cable network) are now devoted to coverage of the stars, and more mainstream magazines have allotted space for personality profiles. Since the same celebrities tend to be featured at the same time in different magazines, usually because the stars make themselves available to various media outlets during carefully orchestrated press blitzes timed to coincide with their latest projects, editors must find different ways of presenting the celebrities. Caricature has become a means of making a unique editorial statement in the midst of the press bonanza. How often can Madonna, Mick Jagger, and Elvis be caricatured? From the evidence here, the possibilities are endless.

TERRY ALLEN
Todd Rundgren
Rolling Stone, 1989
Art Director:
Fred Woodward

MARK ULRIKSEN
Elvis Presley
Unpublished, 1985

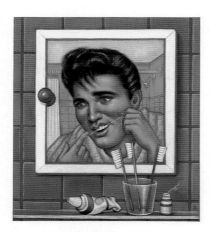

LAURA LEVINE
Elvis Presley
Unpublished, 1987

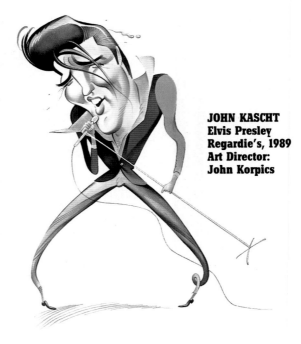

JOHN KASCHT
Elvis Presley
Regardie's, 1989
Art Director:
John Korpics

ANITA KUNZ
Elvis Presley
Rolling Stone, 1988
Art Director:
Fred Woodward

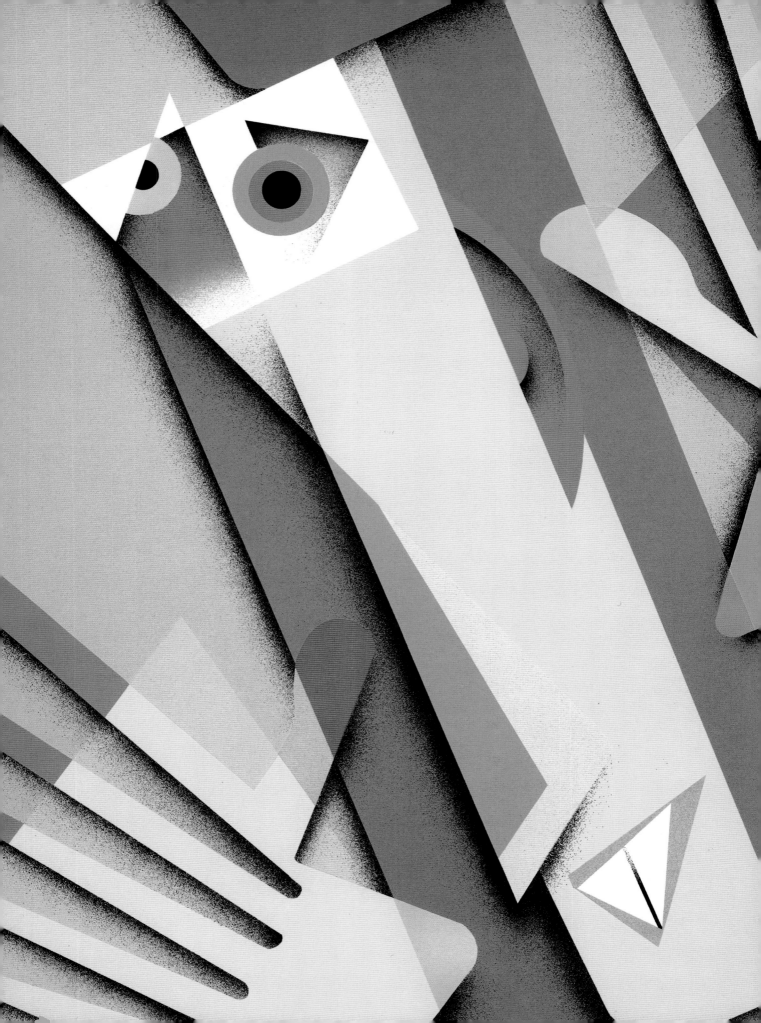

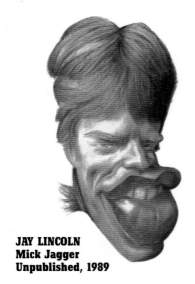

JAY LINCOLN
Mick Jagger
Unpublished, 1989

A new cultural pariah, the white-collar criminal, has also become fodder for the new caricaturist—and what wonderful targets they are, too. Ivan Boesky and Leona Helmsley are just two of the legion of tax evaders, perjurers, and frauds that characterize this era of insider trading, junk bonds, and Savings and Loan disaster. They lend themselves well to critical caricaturists.

What is the future of caricature? If you focus only on caricature's position on the media totem pole, it's easy to be skeptical—cartoon and caricature were once the foremost critical visual arts, while today they have been effectively replaced by television, film, and video. Nevertheless a powerful and intelligent caricature can still command attention, capture imagination, and influence opinion, just as it did in Daumier's day, or Nast's, or Grosz's. If a subject is deftly drawn to capture the distinctive trait that highlights the character's flaw or folly, then that caricature will become an indelible icon. Charles Philipon succeeded in making King Louis Philippe forevermore a pear; Thomas Nast irrevocably transformed William Marcy Tweed into Mr. Moneybags; David Levine imbued Richard Nixon with Captain Queeg's nervous tics; and Ralph Steadman made it difficult to look at Ronald Reagan without thinking of Dracula.

Moreover, caricature has shown an ability to change with the times. Combining the production

BLAIR DRAWSON
David Bowie
Rolling Stone, 1989
Art Director:
Fred Woodward

PATTY DRYDEN
Mick Jagger
Musician, 1985
Art Director:
Gary Koepke

JOE CIARDELLO
Keith Richards
and Mick Jagger
7 Days, 1989
Art Director:
Scott Menchin

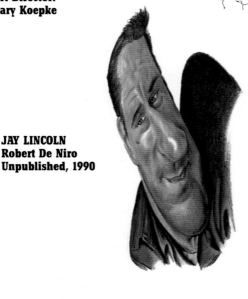

JAY LINCOLN
Robert De Niro
Unpublished, 1990

LAURIE ROSENWALD
Alfred Hitchcock
The New Yorker, 1990
Art Director:
Chris Curry Burris

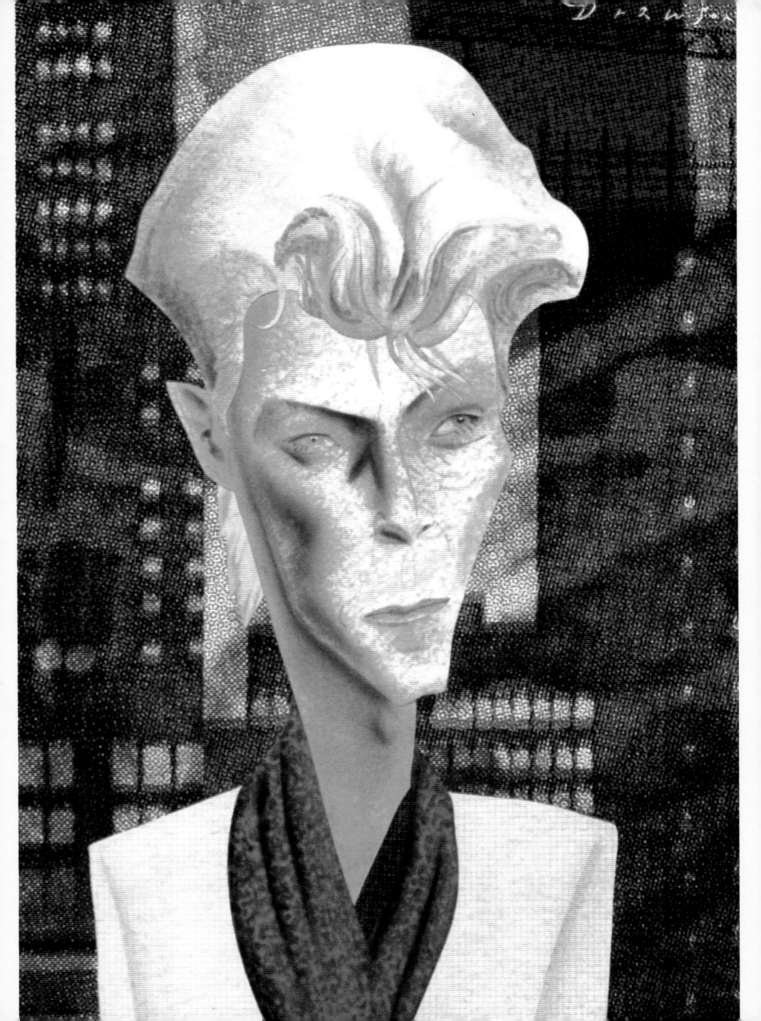

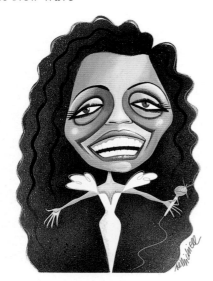

ROBERT DE MICHIELL
Diana Ross
The New Yorker, 1989
Art Director:
Chris Curry Burris

DAVID COWLES
Bill Murray
Entertainment Weekly,
1992
Art Directors:
Anna Kula,
Michael Grossman

C. F. PAYNE
Slash
Rolling Stone, 1990
Art Director:
Fred Woodward

values of television with the expressive power of art, *Spitting Image* has memorably pilloried many of today's high-profile characters while at the same time bringing caricature into the electronic age. Hence, even in the modern world, caricature is still the first line of defense against folly. Despite the ebbs and flows in the field itself, the few exceptional practitioners that inevitably emerge from each generation provide us with a means of seeing our heroes and antiheroes in metaphorical terms that our minds translate in concrete forms. And in this twilight of the twentieth century, the effective caricaturist is a valuable tool in plowing through the muck and mire of the information age.

Then perhaps today more than ever, as long as there is folly and vanity in the world, the caricaturist is necessary. As long as spying on the famous and infamous remains a popular spectator sport, the caricaturist will be kept busy. As long as editors and art directors see the value of this critical and entertaining art in their publications, the caricaturist will be kept employed. And as long as witty and acerbic artists are encouraged to make humor and satire, there will always be caricature.

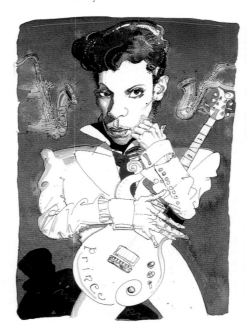

JOE CIARDELLO
Prince
Jazziz, 1991
Art Director:
Tim Pedersen

MICHAEL WITTE
The New Kids
on the Block
The New Yorker, 1989
Art Director:
Chris Curry Burris

INDEX

Page references in *italic* refer to illustrations.